BERLIN

Between The Wars

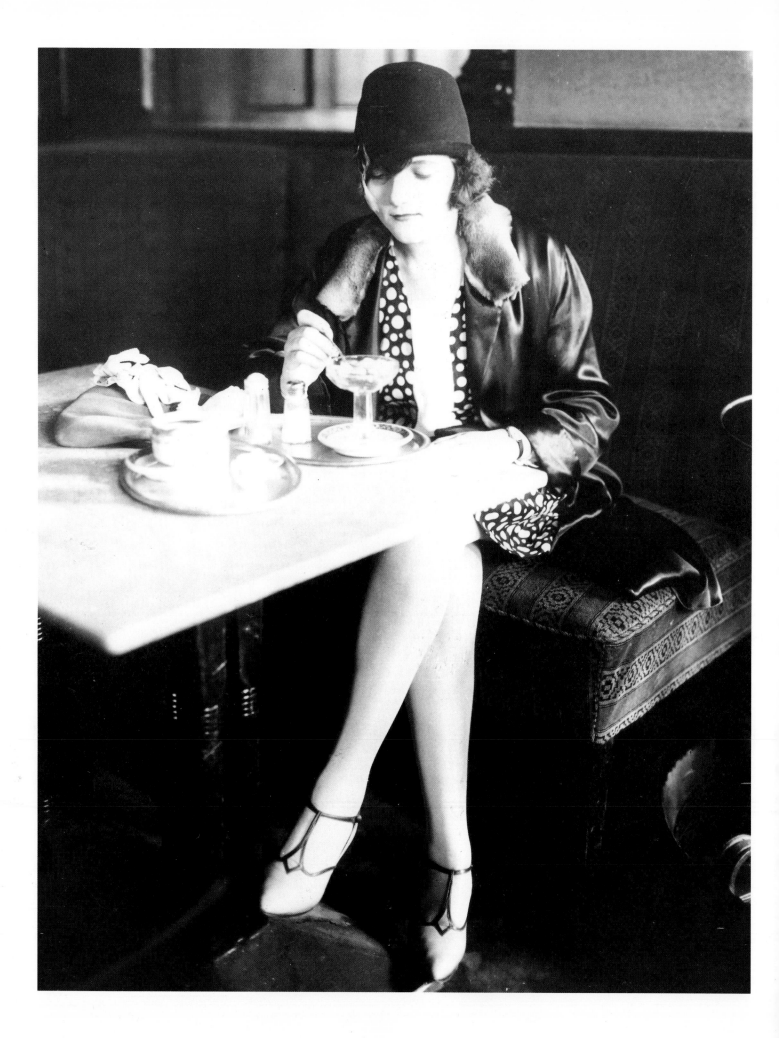

BERLIN
BETWEEN THE WARS

Thomas Friedrich
Foreword by
Stephen Spender

The Vendome Press

ACKNOWLEDGMENTS

The author and publishers gratefully acknowledge the following archives for their help and for permission to reproduce the photographs in the book:

AGENTUR FÜR BILDER ZUR ZEITGESCHICHTE, BERLIN (ABZ): *pages* 37; 42 *above*; 138 *below*; 174 *below*; 221; 236; 237.

ARCHIV DER AGENTUR DEUTSCHER NATIONALPRESSE (ADN): *pages* 52 *above and below*; 73; 156; 218 *above*; 224 *above*; 225; 228 *below*; 234.

ARCHIV FÜR KUNST UND GESCHICHTE (AKG): *pages* 10–11; 79 *below*; 85; 89 *above*; 103 *below*; 133 *below*; 135; 146; 178 *above*.

BERLINISCHE GALERIE, PHOTOGRAPHISCHE SAMMLUNG, BERLIN (BG): *pages* 20; 27 *left*; 41 *below*; 75 *top*; 90; 119 *above*; 137 *above*; 141 *below*; 142 *below*; 145 *above*; 147 *above*; 151 *below*; 179; 198 *above*.

BILDARCHIV PREUSSISCHER KULTURBESITZ (BPK): *pages* 2; 12; 21; 25; 40; 43; 44; 45 *above*; 46; 51; 53; 54 *above*; 55 *above*; 57 *below*; 66; 68 *above and below*; 71 *below*; 72; 74 *below*; 79 *above*; 82; 83 *above*; 84 *below*; 86 *below left*; 87 *above*; 91; 94; 95; 99 *below*; 102; 103 *above*; 106; 108; 113; 114; 118; 120; 121; 122 *below*; 123; 124; 125 *below*; 126 *above and below*; 127; 128; 132 *above*; 133 *above*; 134 *below*; 136; 137 *above and below*; 139; 140; 141 *above*; 142 *above*; 143, 144 *above and below*; 147 *below*; 152 *above and below*; 153 *above and below*; 161; 162; 166 *above and below*; 167; 168; 169 *above and below*; 170 *above*; 173 *above and below*; 174 *above*; 175; 176; 177 *above*; 178 *below*; 181 *below*; 182 *above*; 183 *above and below*; 184; 188; 189 *above and below*; 190; 191; 193 *above*; 194 *above and below*; 195 *above and below*; 196 *below*; 197 *above and below*; 198 *below*; 199; 205; 208; 209; 211; 215; 216 *above and below*; 217; 218 *below*; 219 *below*; 220 *above and below*; 222; 223; 224 *below*; 226 *above and below*; 227; 230; 232 *below*; 233; 235 *above and below*.

LANDESBILDSTELLE (LBS): *pages* 13; 15; 16; 17; 18; 19; 22; 23; 27 *right*; 28; 29 *above and below*; 30; 32; 33; 38 *above and below*; 39; 42; 45 *below*; 47 *above and below*; 48; 49 *below*; 50; 59; 63; 67; 69; 70; 71 *above*; 75 *centre and below*; 76; 77 *above and below*; 78; 80 *above and below*; 81; 83 *below*; 84 *above*; 86 *below right*; 87 *below*; 89 *below*; 92; 93 *above and below*; 96–7; 98 *left and centre*; 99 *above*; 101; 104–5; 117; 122 *above*; 145 *below*; 157; 158; 163; 164 *below*; 165; 171 *below*; 177 *below*; 180 *above*; 181 *above*; 186; 192 *above and below*; 200 *above and below*; 206–7; 210; 212; 228 *above*; 229; 231; 232 *above*; 235.

ULLSTEIN FOTOARCHIV (ULLSTEIN): *pages* 34; 41 *above*; 54 *below*; 55 *below*; 74; 90; 110; 116; 119 *below*; 125 *above*; 129; 130 *above*; 131; 132 *below*; 134 *above*; 138 *above*; 148–9; 150; 151 *above*; 160; 164 *above*; 170 *below*; 171 *above*; 172; 180 *below*; 182 *below*; 185; 187; 193 *below*; 196 *above*; 201; 203 *above and below*; 204 *above and below*; 219 *above*.

The author would also like to thank personally the following: Hilde Baumann, who has assisted me with some of the picture research; Janos Frecot, who has built up the photographic collection of the Berlinische Galerie and to whom all those interested in Berlin's photographic history are indebted; Peter Hielscher, who gave me some important leads; Dieter Kerbs, the doyenne of research into Berlin's press photography and connoisseur of the history of photography, for his willing cooperation; above all, though, Hiedrun Klein of the Bildarchiv Preussischer Kulturbesitz, who has not only followed this project with great interest, but has been significantly involved in the picture selection and has stood by his advice and assistance up to the last.

Frontispiece: In the Romanisches Café, a favourite haunt of theatre people, c. 1925. (BPK)

Published in the USA in 1991 by The Vendome Press,
515, Madison Avenue, New York, NY 10022
Distributed in the USA by Rizzoli International Publications Inc,
300 Park Avenue South, New York, NY 10010

Library of Congress Cataloging-in-Publication Data

Friedrich, Thomas.
 Berlin between the wars/by Thomas Friedrich.
 p. cm.
 ISBN 0–86565–126–4: $45.00
 1. Berlin (Germany) – History – 1918–1945. I. Title.
DD879.F75 1991
943.1'55085 – dc20 91-14378
 CIP
This book was designed and produced by John Calmann and King Ltd, London

Translated by Stewart Spencer
Designed by Karen Stafford, Design Quarter Ltd.
Typeset by Wyvern Typesetting Ltd, Bristol
Printed in Singapore by Toppan Printing Company Ltd

Contents

Map 6

Foreword 8

The Imperial Legacy 10

Revolution and Crisis 30

A Tour of the City 56

Art and Culture 106

Everyday Life 154

The End of the Republic 206

Further reading 238

Index 238

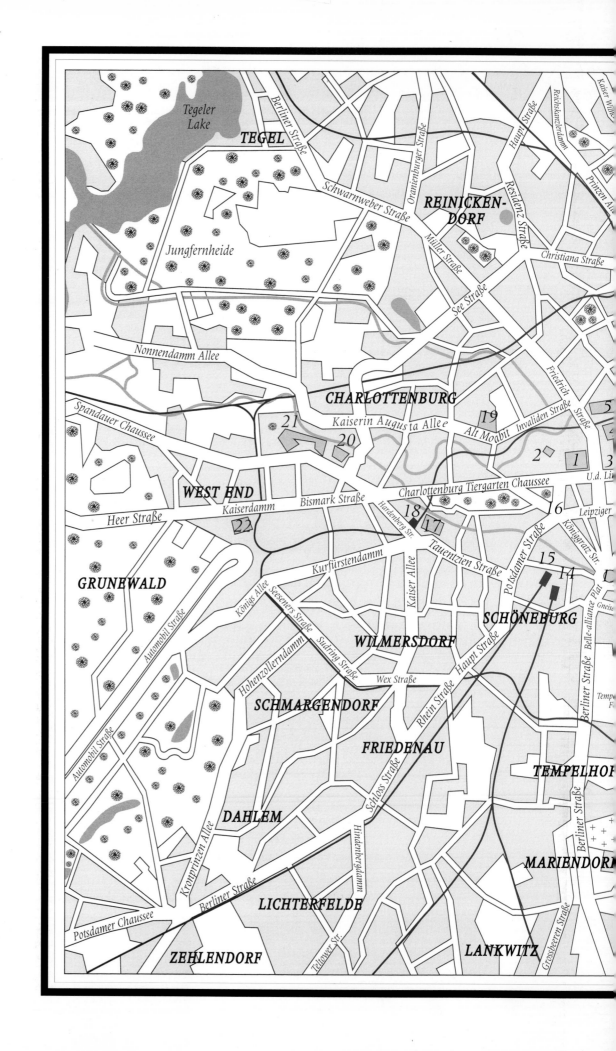

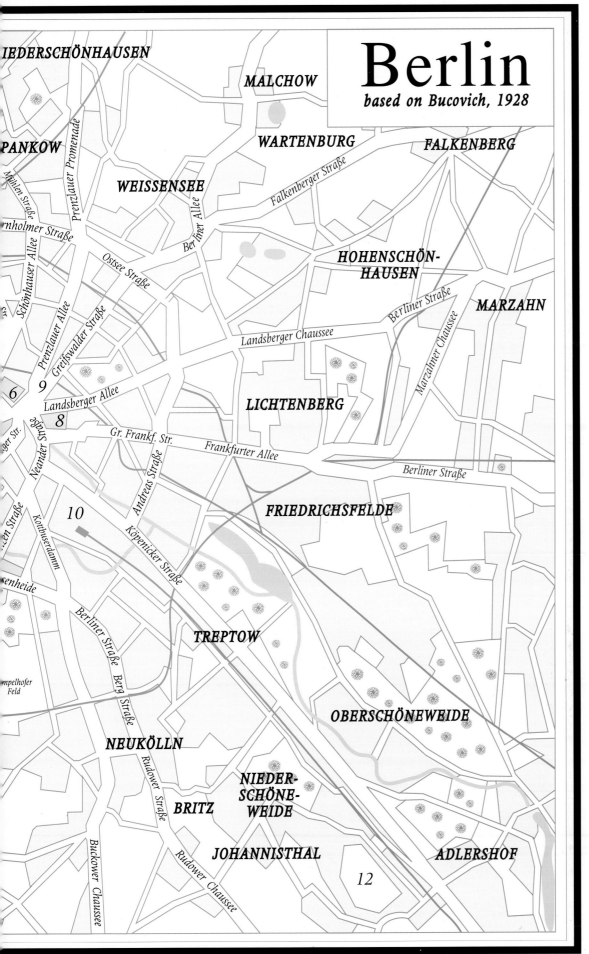

Berlin

based on Bucovich, 1928

NIEDERSCHÖNHAUSEN

MALCHOW

PANKOW

WARTENBURG

FALKENBERG

WEISSENSEE

Falkenberger Straße

HOHENSCHÖN-
HAUSEN

Berliner Straße

MARZAHN

Mühlen Straße

Prenzlauer Promenade

nholmer Straße

Schönhauser Allee

Ostsee Straße

Berliner Allee

Landsberger Chaussee

Marzahner Chaussee

Prenzlauer Allee

Greifswalder Straße

LICHTENBERG

Str.

6 9

Landsberger Allee

8

Gr. Frankf. Str.

Frankfurter Allee

Berliner Straße

nger Str.

Neander Straße

Andreas Straße

10

FRIEDRICHSFELDE

en Straße

Kottbuserdamm

Köpenicker Straße

senheide

Berliner Straße Berg Straße

TREPTOW

mpelhofer
Feld

OBERSCHÖNEWEIDE

NEUKÖLLN

Rudower Straße

BRITZ

NIEDER-
SCHÖNE-
WEIDE

JOHANNISTHAL

ADLERSHOF

Buckower Chaussee

Rudower Chaussee

12

1 Reichstag
2 Victory Column
3 Brandenburg Gate
4 Old Museum
5 Kaiser Friedrich Museum
6 Cathedral
7 Royal Palace
8 Town Hall
9 Alexander Platz
10 Görlitz Station
11 Kaiser Friedrich Memorial Church
12 Airport
13 Peace Column
14 Anhalt Station
15 Potsdam Station
16 Potsdamer Platz
17 Kaiser Wilhelm Memorial Church
18 Zoo Station
19 Courts of Justice
20 Town Hall
21 Chalottenburg Palace
22 Radio Tower

Foreword

Looking at the photographs in this volume, I have the impression of public events being written on the faces and bodies of Berliners between 1918 and 1933 against a background of constantly shifting street scenery.

During these fifteen years Berliners were submitted to a whole series of disasters, beginning in November 1918 with the allied victory and ending in February 1933 with the coming to power of Hitler – prelude to what seemed final disaster, yet which led to an American resurrection.

The young republic was hamstrung by the determination of political leaders of the victorious powers – particularly those of Britain and France – that Germany should never arise again as a great military power capable of dominating Europe. The instrument for carrying out this policy was the Treaty of Versailles, imposing on Germany the ruinous burden of reparations. At the same time, however, in the attempt to ensure Germany against Bolshevik revolution, the structure of the German High Command was left almost intact.

The consequences of depriving the pacifistic and liberal leaders of the Weimar Republic of the means of survival are evident here in scenes of political upheaval; of leftist revolution and of rightist revolt; of inflation, hunger and soup kitchens; strikes, bankruptcies and political murders.

These events were written across the lives of Berliners, leaving them, perhaps, with very little else. Yet it would be wrong to think of Berliners as passive victims of violent political change. These photographs also show the tremendous energy they put into day-to-day life, for example sporting events such as the famous six-day bicycle race. After 1918 Berlin became quite notoriously a centre for avant-garde ideas, Expressionist art, functional architecture, the new psychology. The avant garde was greatly influenced by modernist experimentation in the Russia of the Twenties: Soviet art, theatre, cinema and advertising – 'Agit-prop'. With thousands of Russian immigrants, Berlin was a centre for meetings between East and West as, indeed, it became for other international meetings in the arts and sciences.

When, in the early Thirties, before Hitler came to power, I lived for several months in Berlin, it struck me that there was a kind of shared democracy among young Berliners which was based on their uncertainties. There was a sense of camaraderie in circumstances produced by events outside Berlin. This was partly, perhaps, a consequence of inflation, when the mark became worth less than the paper on which it was printed – reinforced doubtless by the slump, following on the 1929 Wall Street Crash, and resulting in massive unemployment.

Berlin was a democracy of the poor where everyone seemed to know everything about everyone else. There was a kind of cynicism which was nevertheless humorous and comradely. The coarse wit of Berliners provided a kind of market place of values which were rude but warm, and it makes sense to say that most Berliners were deeply egalitarian, 'Reds', at some level of humanity beyond political parties. Berlin remained always the least Nazi of all German cities.

A joke current at that time was that if a Berliner who was a virgin walked past a lion situated, I think, in front of the Reichstag, the lion would roar. Berlin was a city proud to have lost – or never to have had – its virginity.

Perhaps for some Berliners this vulgar joke added point to President Kennedy having said when he visited Berlin in 1963 – 'Ich bin ein Berliner'. But that he should have said it at all, throws light on the difference between Berlin and other European capitals. For an American president, even in time of crisis, to say 'je suis Parisien', or 'I am a Londoner' would be to set up a claim to belonging to a tradition and culture with a historic past, monuments connecting with ancient times. But Berlin is a city that has broken with such traditions as, in the time of Frederick the Great and throughout the nineteenth century, it ever had. It is a succession of false starts and abrupt endings. It is a centre not in the sense of enshrining past tradition, but as a geographical and ever-changing political situation. And as such today, it has enormous significance because it is where East meets West. Berlin is not a tradition. It is a situation and it will go on changing. And it is Berliners.

So what one feels about these photographs is the intense contemporaneity of the faces and gestures of the people photographed with the moment, the situation, pictured. There is a kind of rootlessness about Berlin. Yet, where and when could Berlin have struck roots? The First World War destroyed all connection of post-war Berlin with the Potsdam of Frederick the Great. The period between the wars was – as these images show – one of perpetual scene-shifting. Hitler's Reich reduced most of Berlin to heaps of ruins. The Cold War turned it into a glittering shop window exhibiting its garish Western consumer goods in face of the impoverished communist East. And one must add to this that the Nazis destroyed the Jewish culture which throughout the period of the Weimar Republic represented the one continuous line of cultural development in theatre, cinema, music, literature and art.

Yet in face of all these misgivings, today it is within an ever-changing situation, not past traditions, that relations between East and West will evolve. And Germany reunited needs such an ever-shifting world-stage centre. The Berliners are good at coping with situations.

STEPHEN SPENDER

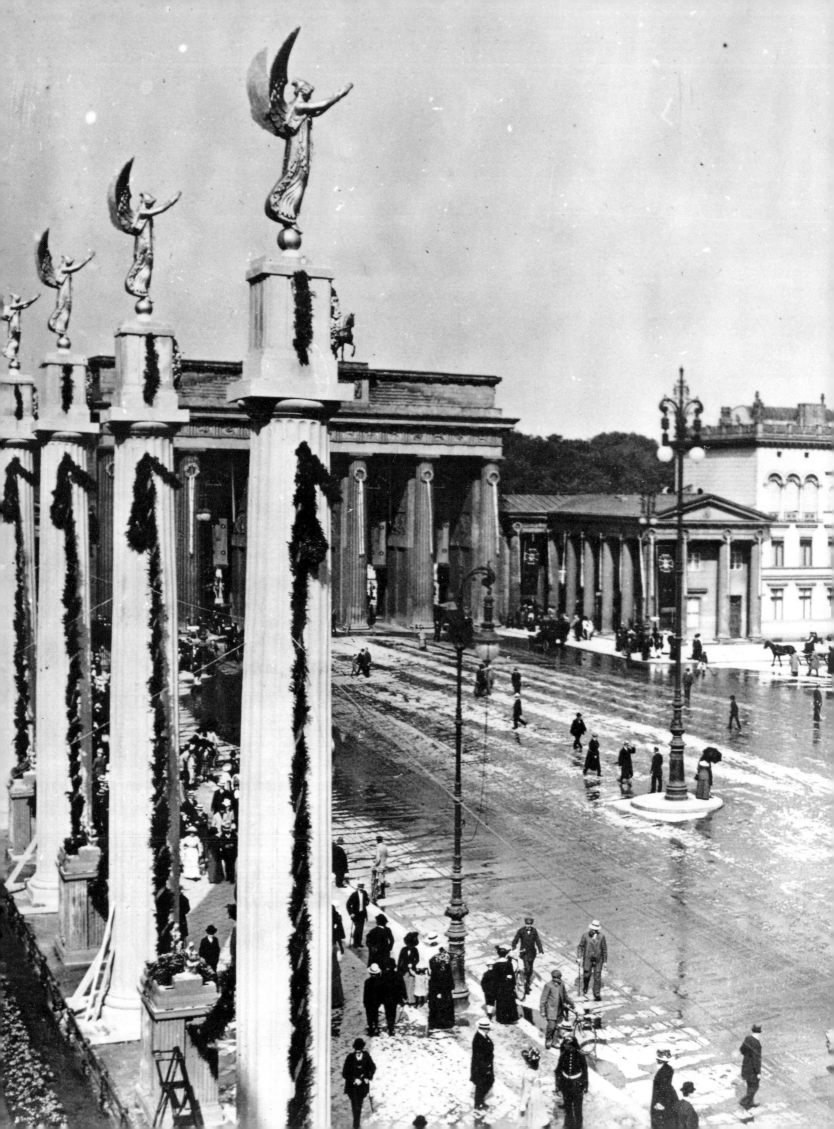

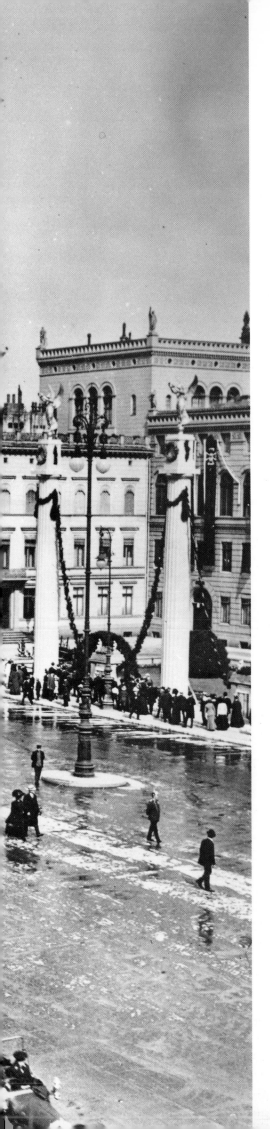

The Imperial Legacy

IT WAS SATURDAY, 1 AUGUST 1914. The whole of Berlin's city centre, from the Brandenburg Gate to the Royal Palace, was crowded with hundreds of thousands of people, while the cafés and restaurants, too, were packed all the way from Potsdamer Platz to the distant Alexanderplatz, where the city's business quarter had burgeoned during decades gone by. At one o'clock, as the Fourth Regiment of Guards passed in parade along Unter den Linden, the city's magnificent tree-lined avenue, the police contingent escorting them succumbed to the general euphoria. Patriotic songs were sung, chief among which were 'Die Wacht am Rhein' ('Watch on the Rhine') and the Prussian national anthem, 'Heil dir im Siegerkranz' ('Hail to thee, crowned in victory'). As the afternoon wore on, the tension in the crowd rose to fever pitch: 'Would there be war?'

Shortly after five o'clock the gates of the palace swung open, disgorging a fleet of limousines containing army officers, who called out to the crowd that there was to be a general mobilization. Within seconds the news had spread to the rest of Berlin, and by six o'clock the first special editions were already appearing on the streets, their banner headlines announcing war. In the cathedral facing the palace, a service was in progress, attended by thousands of worshippers. While prayers were being said for the war, in the nearby Lustgarten they were shouting for the Kaiser. On the eastern side of the palace, overlooking the Spree, the balcony windows opened, as on the day before, and the Kaiser, with his wife at his side, stepped forward into view. By now the crowd had swelled to over a hundred thousand. To their rapturous acclaim Kaiser Wilhelm II advanced towards them, 'the steel of his helmet catching the rays of the setting sun', as one reporter noted carefully. At once an expectant silence fell on the throng. The speech which Wilhelm II delivered from the palace balcony was brief, but his words have gone down in history:

> I thank you from the bottom of my heart for the expression of your love and loyalty. In the forthcoming battle I know there will no longer be any factions within my nation. There are only Germans among us, and whichever factions may have turned against me in the conflict of opinion, I forgive them all with all my heart. We must now stand together like brothers, and God will help the German sword to victory.

'Each of these eloquent phrases', the report went on, met with tumultuous cheers. For not only had the Kaiser summed up to perfection his own political creed, with its paternalistic willingness to forgive the opposition

Previous page: Pariser Platz and the Brandenburg Gate, festively decorated to mark the twenty-fifth anniversary of Kaiser Wilhelm II's accession to the throne, 15 June 1913. (AKG)

In front of the Royal Palace, 1 August 1914. Thousands of Berliners acclaim Kaiser Wilhelm II, as he addresses them from the palace balcony, appealing to the nationalist mood as he had done the previous day from the very same balcony. (BPK)

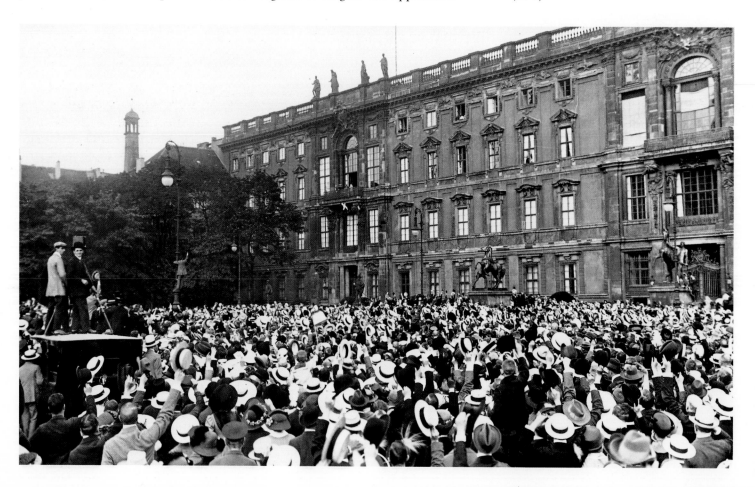

The Tiergarten on 1 August 1914, where a special edition of the Vossische Zeitung *has just been distributed, with the news that general mobilization has been ordered in Germany. (LBS)*

parties their views, he had also caught the mood of the crowds that hung on his every word in the evening sunlight outside the imperial palace. 'No more factions, only Germans': with a single phrase all feelings of anti-democratic resentment and contempt for every 'parliamentary squabble' were supplanted by an outward-directed aggression that Germany urgently needed.

Never, it seemed, was there greater agreement between Kaiser and Nation than in August 1914. The war, it was thought, would be over in months, if not within weeks; and, needless to add, it would end in victory for the Germans and their allies. 'See you again on the boulevards', German soldiers wrote on the sides of the railway carriages that transported them to the front, convinced they would soon be parading victoriously through Paris. 'Glorious times lie ahead', the Kaiser had promised his people, a promise, which – apart from a few determined opponents of the war, gathered around Karl Liebknecht and Rosa Luxemburg, on the far left wing of German social democracy – the masses were more than ever inclined to accept. And Berlin itself believed that, as the German imperial capital, the city would gain far more from the war's successful conclusion than any other German town. After all, the quarter of a century between Wilhelm II's accession in 1888 and the outbreak of the war had witnessed untold changes in Berlin, a transformation which later writers saw as the city's headlong rise to an international capital.

In the 1870s visitors to Berlin had noticed many provincial features which even the local inhabitants could not overlook. Although with the foundation of the German Reich in 1871 Prussia's foremost city had become the imperial capital – something which, though logical, was far from popular in much of the Reich – Berlin had not automatically become an international metropolis. Between 1800 and 1871 its population had more than quadrupled; indeed, from the early 1860s its annual growth had become something of a population explosion. By 1877 the million mark had been passed. However, initially at least, growth and geographic expansion brought no fundamental change in the basic character of the place, even though they entailed a notable increase in social problems, including a shortage of housing that verged at times on the catastrophic. It was not until after 1873, when the

effects of an economic slump, exacerbated by a worldwide economic crisis, had worked through the system, that the town suddenly began to take on the characteristics of a city of international standing. By 1905, when its population passed the two-million mark, Berlin could already stand comparison with cities such as Paris, London and New York. A guide to the city, published in 1915, was certainly not exaggerating when it quoted current views on Berlin, describing it as a 'modern Babel', but also, in many eyes, as 'the most American city in continental Europe'. As early as 1898, a critical observer of the city's transformation, the industrialist Walther Rathenau had called Berlin, the 'Chicago on the Spree', a view which Mark Twain endorsed a few years later.

The process of transformation was certainly impressive, but its effect on many was confusing and even disturbing – the reference to a 'modern Babel' reflected deeply reactionary, anti-modern feelings. Although this process had not begun until after Wilhelm II's accession, it was only under his reign that its impact was really felt in full. It was hard not to draw the conclusion that Wilhelm's reign and Berlin's phenomenal growth not only coincided but, in certain respects, that the two were in fact identical – two sides, as it were, of the same coin. The Kaiser was certainly right when, in 1895, he told a meeting of council leaders that nowhere else in the world had a town's development been so influenced by the nation's princes, in so 'interesting' a way (as he himself expressed it) as Berlin. In fact, the modern city is, to a certain extent, a product of conscious and well-laid plans on the part of the Prussian–Brandenburg ruling house, the Hohenzollerns. In reminding the councillors of this fact, Wilhelm was no doubt also anxious to stress that, if the occasion arose, he could treat them as his forebears had done.

During the early centuries of its existence, Berlin had been largely neglected by its sovereign lords. The town was probably founded around the year 1200, not as a fishing community, in spite of a long-standing legend to that effect, but as a colonial centre and merchant settlement. It developed, uniquely, from twin towns, with 'Berlin' growing up to the east of one of the principal branches of the Spree, while 'Cölln' sprang up to the west. As a trading centre without any previous history, the settlement owed its foundation in part to its geographical situation as the northernmost crossing on the Spree, and also to the fact that important trade routes intersected here. But, although these factors played a decisive role in the rapid growth of Berlin/Cölln as Brandenburg's leading trading centre, the town acquired no significance beyond the region, which did not change for centuries to come. By the end of the sixteenth century, the town still numbered only some seven or eight thousand inhabitants (though others estimate it as twelve thousand) – a respectable figure, no doubt, but little more than that. Nor did the city's marginal status within the wider context of Europe alter when, in 1415, a member of the Hohenzollerns, Burgrave Friedrich of Nuremburg, was appointed Elector of Brandenburg, an act of imperial enfeoffment which marked the beginning of five hundred years of Hohenzollern rule over the Brandenburg Marches. Not until 250 years later, however, with the founding of the Prussian state, was the change of ruler to have any direct bearing on Berlin's development as a city.

In 1307 the first attempt was made to combine the councils of Cölln and Berlin, the two towns being jointly administered from a single town hall, built on the 'Lange Brücke' (Long Bridge) over the Spree. However, the council's high-handed actions irked their new rulers and in 1448 the town's short-lived autonomy was brought to an end as the Elector Friedrich II broke

the Berliners' recalcitrance and, with it, the townspeople's claims to self-determination, using every means within his grasp. Although no blood was spilt, relations between the town and its ruler remained rather tense for many years to come. Shortly before abolishing civic liberties, the Elector had left the Berliners in no two minds concerning his claims to power when he himself had personally laid the foundation stone for a fortified castle overlooking the Spree. The fortress was finished in 1451 and Berlin became the seat of the Hohenzollerns, though not until 1486 did the Elector Johann Cicero establish a permanent court within the city walls. With its function as a seat of power, Berlin was now inextricably linked, for better or worse, with its Hohenzollern rulers.

The decline and disunity suffered by Germany, as the Middle Ages came to an end and the modern age began, were felt no less in Berlin than they were elsewhere. By the end of the Thirty Years' War in 1648 the population had fallen to barely six thousand and hundreds of homes lay in ruins. The Elector Friedrich Wilhelm, known as the 'Great Elector' and generally seen as the founder of the Prussian state, introduced a standing army to replace the existing mercenary forces, thereby laying the foundations of Hohenzollern power but also helping Berlin to expand far beyond the

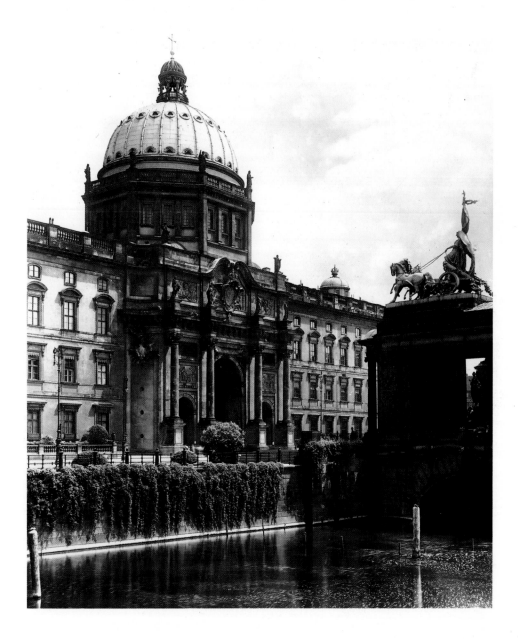

The main entrance on the west side of the Royal Palace in Berlin, generally known as the Eosander Door after Eosander von Götha, who was Andreas Schlüter's successor as director of the palace buildings from 1706 to 1713. On the right of the photograph, which dates from c. 1922, is part of the national monument to Kaiser Wilhelm I, erected in 1897 after a design by Reinhold Begas. (LBS)

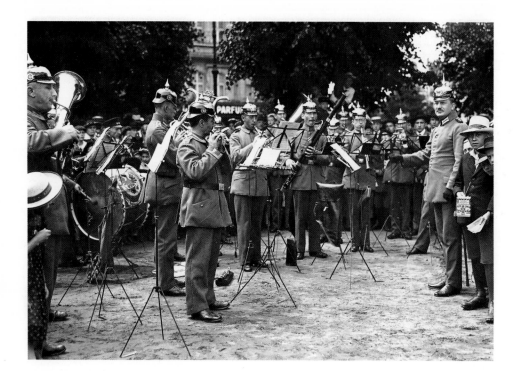

A typical military band giving a concert during the war. This one is in aid of a submarine, 1917. (LBS)

dimensions achieved before the Thirty Years' War. The city became a fortress, a garrison town on which its rulers kept a well-trained eye. And so it was that the introduction of the Prussian military system provided the decisive impulse for the expansion of Berlin. From the Great Elector's accession to power in 1640, there was no longer any mistaking who was responsible for the changing face of Berlin and for laying the foundations of the city's modern splendour. As early as 1647 he gave instructions for work to begin on its great new principal artery, later known as Unter den Linden, systematically extending the seat of his royal power. It was he, for example, to whom we owe the initiative for building two new suburbs, Friedrichswerder and Dorotheenstadt, both of which, for a time, enjoyed municipal privileges. Friedrich Wilhelm also ensured a rapid growth in the city's population by a well-directed immigration programme, including accommodation for thousands of Huguenot refugees who, fleeing from French repression, sought refuge in Berlin following the Revocation of the Edict of Nantes in 1685.

Under his successor, the Elector Friedrich III, the city's expansion proceeded apace. In 1695 work began on the Zeughaus or Arsenal, completed in 1706, while the building of Schloß Charlottenburg (1695–99) was followed a few years later by the complete reconstruction of the city's Royal Palace under Andreas Schlüter and, later, Eosander von Götha. In 1701 Friedrich had himself crowned King of Prussia in Königsberg – 'König in Preußen' was the title by which he styled himself. Berlin was now a royal residence and, by the end of Friedrich's reign, its population was ten times greater than a mere six decades earlier, at the end of the Thirty Years' War. While still Elector, King Friedrich I had also planned a third new quarter, the Friedrichstadt, and this, together with Friedrichswerder and Dorotheenstadt, was amalgamated with Cölln and Berlin in 1709 to form a single administration.

In contrast to his father's obsessive regard for baroque ostentation, King Friedrich Wilhelm I – the 'Soldier King', as his subjects called him – began his reign in 1713 on a note of stringent economy, using the money saved in

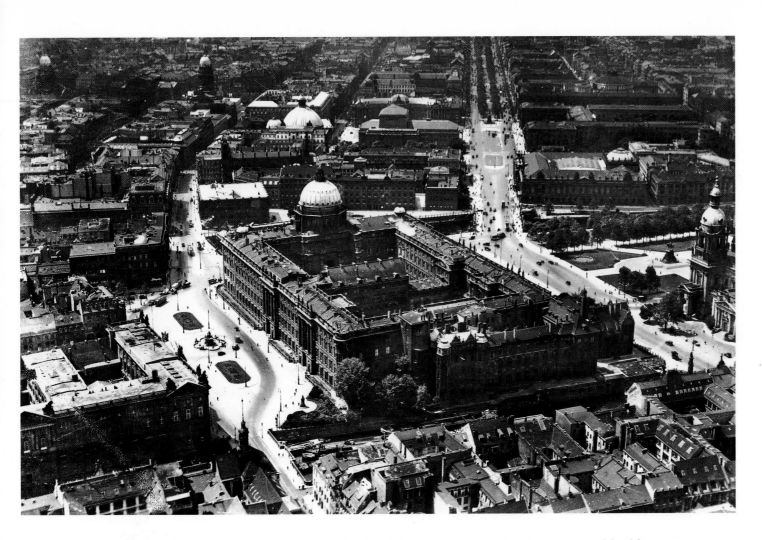

Aerial view of the Royal Palace, seen from the east, c. 1930. In the upper right-hand corner the avenue Unter den Linden can be seen. Parts of the palace, one of the most magnificent examples of German Baroque architecture, were severely damaged during World War II and the whole building was torn down in 1950 on the orders of the leaders of the Socialist Unity Party of the GDR. (LBS)

this way to further his aims of expanding the army and building up an economy that would help him provide for his troops. He thus set about refining the mercantile policies adopted by his predecessors, including the systematic, state-controlled foundation and relocation of a number of new trades and recruitment of foreign workers, especially craftsmen from Bohemia. It was in order to accommodate both these and the rapidly growing number of 'military personnel' in Berlin (from 7645 in 1721 to 18,257 by 1735 – and this in a city of only 79,000), that he began in 1732 to extend Dorotheenstadt to the west and Friedrichstadt to both the west and south. From this period dates the grid of streets that would later come to typify the inner town as well. A new city wall enclosed these suburbs to the west and south of Berlin. At the wall's three gates, a toll was collected from all who passed through in either direction, an indirect tax on everyday consumer items, known as the 'Akzise', which was channelled directly into the military coffers. An increase in the population brought an increase in expenditure on such goods, which led in turn to the growth of the Prussian army. So it was scarcely surprising that the Soldier King did not flinch from using this force when it came to peopling his seat of power and building houses in the Friedrichstadt suburb.

Under Friedrich Wilhelm I, three monumental squares, baroque in style, were built at each of the new town gates. They took their names from their original shapes: 'Rondell' at the southern end of the Friedrichstraße, 'Achteck' at the end of the arterial road that led to Potsdam and 'Quarré' at the western extremity of Unter den Linden. After the Wars of Liberation (1813–15) they were renamed Belle-Alliance-Platz (now Mehringplatz),

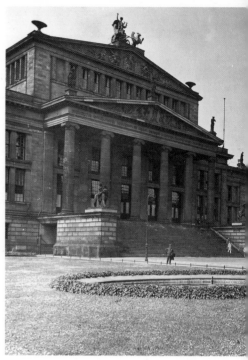

forming the southern end of the Friedrichstraße at the Hallesches Tor (Halle Gate), Leipziger Platz at the Potsdam Gate and Pariser Platz at the Brandenburg Gate. For around a century all three squares marked the edge of the city until a sudden increase in size caused the old town walls to be breached. Like so much else in Berlin, these squares had a dual purpose, used, on occasion, as army exercise grounds – much as the walls themselves were designed not only to help in levying taxes but also to stop army deserters from fleeing. As the Friedrichstadt quarter continued to grow, the Wilhelmstraße, a new and elegant boulevard, was created, along whose northern section a row of town mansions was built for the local nobility. In the nineteenth century these houses were turned into government offices – ministries for the most part – so that 'Wilhelmstraße' gradually became known as the seat of officialdom, the German equivalent of London's Whitehall.

Under Frederick the Great (1740–1786), the city's geographical expansion finally came to an end, any changes instead affecting the development of the inner town. While the number of houses rose by fifty per cent, the number of the city's inhabitants went up by barely 150,000. A number of the buildings that later determined the face of the inner town date from this time: first and foremost, Knobelsdorff's opera house; Prince Heinrich of Prussia's private residence (later the home of the Humboldt University); the towers on the Gendarmenmarkt; the Spittel and Royal Arcades; the Royal Library, and the Ephraim Palace. Frederick's political aims were twofold, involving, on the one hand, the continued prosecution of Prussia's policy of belligerent aggression and, on the other, support for a specifically Prussian variant of the Enlightenment, not only through the creation of an active intellectual life in the city but, more especially, through the foundation of the Royal Academy of Sciences in 1744. Not only did Frederick build up Prussia's economic strength, but also – for better or worse – her political status as a European power. Berlin joined the ranks of the European capitals, if belatedly, achieving a position that was not considered altogether advantageous by its inhabitants. The state of Prussia, originally

View of Wilhelmstrasse, c. 1921. In the foreground is the Presidential Palace, behind it the Foreign Office. The northern half of Wilhelmstrasse was dominated by government buildings, both of the Reich and of the Prussian State. (LBS)

Above centre: The Gendarmenmarkt at the heart of Friedrichstadt, 1925. To the left is the Schauspielhaus (Playhouse), rebuilt in 1820/21 to a design by Karl Friedrich Schinkel, while the French Cathedral can be seen on the right. The latter was built between 1701 and 1705 to designs by Karl von Gontard, although the domed tower was not added until 1781–5. It is counterbalanced on the southern side of the square by the German Cathedral. Like the Schauspielhaus, both towers have been rebuilt in recent years and once again form part of the city's distinctive skyline. (LBS)

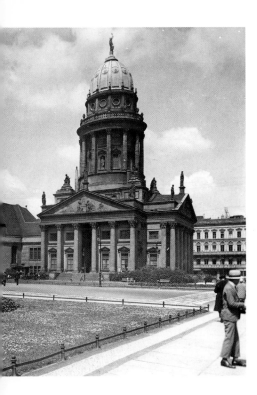

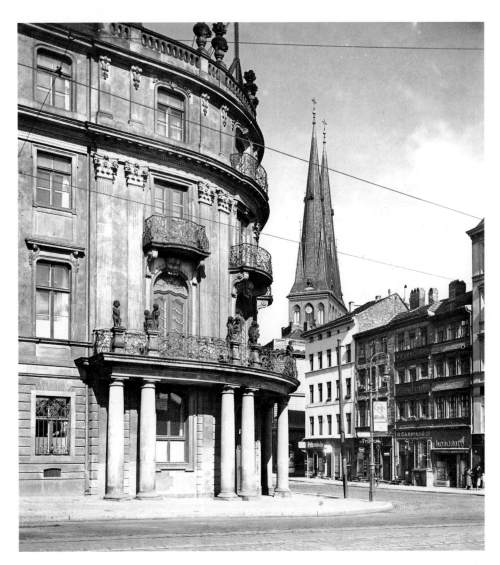

Right: The Ephraim Palace on the corner of Poststraße and Mühlendamm, c. 1930. Built for Veitel Ephraim, coinmaker and court jeweller to Frederick the Great, this Rococo townhouse dates from 1762 to 1765. In the background, on the right, are the twin spires of St Nicholas's Church, the oldest church in Berlin. (LBS)

poor, could function only by straining all its resources. This was related to the absence, even as late as the nineteenth century, of an economically powerful middle class, a characteristic feature of Prussia, and hence of Berlin. And since state initiative often had to make up for a lack of private initiative, the Prussian capital's social life was determined, in even its everyday aspects, by the state apparatus's principal agents, the bureaucrats and the military.

Whereas absolutist rule had guaranteed Prussia's rise to prominence and, with it, the capital's growing significance, it soon became clear on Frederick's death that the move towards modernization, which the monarchy had partly countenanced and partly encouraged, could no longer be sustained. The inherited system showed signs of decay. Nonetheless, it was during the early years of the reign of Friedrich Wilhelm II that a building was erected which, even today, remains the city's most potent symbol, the Brandenburg Gate. Its predecessor, a smaller and architecturally much less significant structure, had been demolished in 1788 and three years later the present imposing arch rose up in its place, with Schadow's Quadriga of Victory – a chariot drawn by four horses sculpted in copper – added in 1794. In October 1806 Napoleon Bonaparte entered the city through the Brandenburg Gate, having defeated Prussia and its *ancien régime*. The Corsican leader gave orders for the Quadriga to be removed and, duly dismantled, it was shipped via Hamburg to Paris, an act which symbolized the humiliation of Prussia's ruling house. Since then almost every important event in the

history both of Berlin itself and of Prussia as a whole has been bound up with the Brandenburg Gate, transforming it into a German 'gate of destiny'.

Prussia's defeat at the hands of Napoleon had the initial effect of mobilizing all the energies that were latent in the Prussian middle classes and in that section of the nobility which was willing to accept reform. The introduction of municipal government following the urban decrees of 1808; the founding of the university in 1809/10; the proclamation of freedom of trade in 1810; the edict emancipating Prussian Jews in 1812, and, on a rather more general level, the effects of the Wars of Liberation seemed to herald an age of reform and renewal. But the Carlsbad Decrees of 1819 ushered in a phase of bitter repression: the forces of reform were everywhere suppressed, their leading figures silenced or even removed from office. For the city's urban development programme, by contrast, the decades that followed Prussia's defeat were to prove a stroke of good fortune, thanks to the painter and architect, Karl Friedrich Schinkel (1781–1841). Schinkel was able to reconcile the expression of a newly emergent nationalist ethos with the overriding need for thrift, a need that was forced on Berlin by Prussia's economic plight following the wars with Napoleon. He was also adept at adapting the neo-classical style to the needs of Berlin, importing classical elements into the city's traditional landscape, as is clear not only from those of his buildings which still exist but also from others destroyed in the twentieth century: the Neue Wache (New Guard House) in Unter den Linden, the Werdersche Church, the Theatre on the Gendarmenmarkt, the Old Museum opening onto the Lustgarten, and the Architectural Academy built on the banks of the Spree.

View of the Lustgarten from the southeast, with the Old Museum in the background, 1931. The Old Museum was designed by Karl Friedrich Schinkel and built between 1822 and 1828. To the right is the National Gallery, built between 1866 and 1876 to a design by Strack. Together, these buildings form the southern and eastern extremity of the Museum Island, with its host of other museums and galleries, including, most notably, the Pergamon Museum. (BG/Max Missmann)

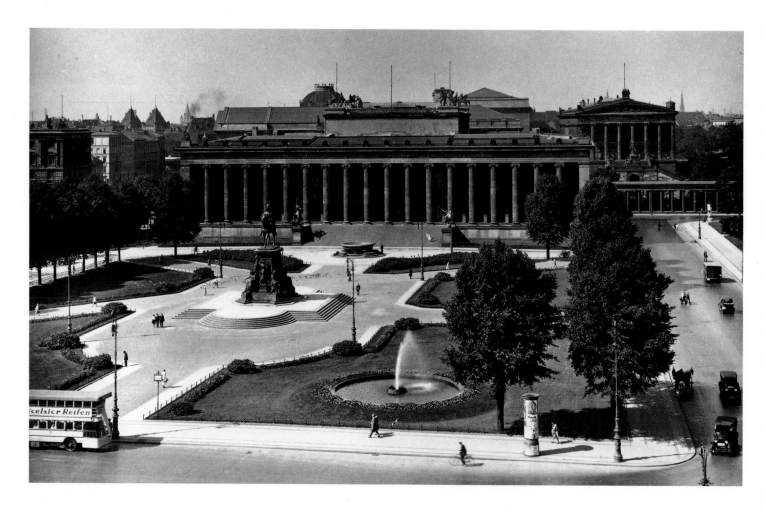

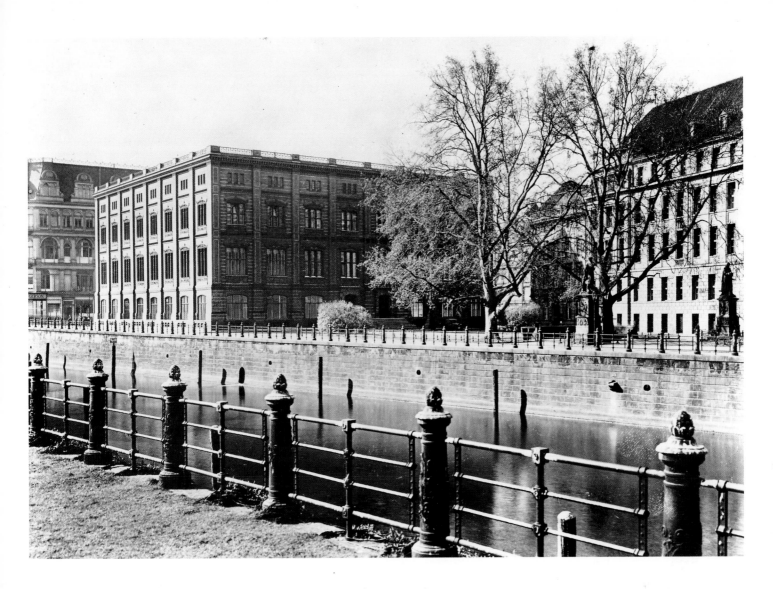

View across the Spree of the Academy of Architecture, built in 1832 to designs by Karl Friedrich Schinkel. At the time of this photograph (c. 1930) the building housed the National Gallery's portrait collection. Partially destroyed during the Second World War, it was demolished in 1962. (BPK)

A new turning point in the city's history came in 1838, when Prussia's very first railway line was officially opened, linking the two royal seats of Potsdam and Berlin. Within only a matter of years it was followed by other lines – the Anhalt Line in 1841, the Frankfurt and Stettin Line in 1842 and the Hamburg Line in 1846. By the mid-1840s Berlin was the busiest junction on north Germany's railway network. The city suddenly found itself far better placed than any other German town, an advantage it owed to its position at the heart of Germany's railway network and to the development of its mercantile role up to 1835. At the same time, the railways ensured a rapid and constantly growing market for the city's trade and industry, linking Berlin with key agricultural regions and also with leading industrial areas and ports. And the city's position right at the heart of a complex system of waterways was to be of additional benefit in this context. As a result Berlin enjoyed a headstart during the 1830s and 1840s as industrialization swept the country. The driving force behind Berlin's industrialization was mechanical engineering, which, closely bound up with the growth of the railway network from the end of the 1830s onwards, employed by far the greatest number of workers of any local industry. In changing over from manufacture to industrial machine production and metalworking, the mechanical engineering firms in the city were able to exploit Berlin's unusual combination of a high concentration of qualified workers and a relatively modern structure in methods of production.

The phenomenal number of workers needed not only to man the city's metalworking plants but also in other branches of industry led to an exponential increase in population from the end of the 1830s onwards, so that, whereas the population had been barely a quarter of a million in 1830, it had already doubled by 1860 and by 1870 had passed the three-quarter million mark. To the north, east and south-east of the city, a 270° segment grew up, directly linked to the heart of Berlin, in which area the working classes were forced to live in conditions that, as a rule, were poor and often oppressive. The city's immoderate growth, which had begun well before the founding of the Reich in 1871, drove the socially disadvantaged into monolithic suburbs – the 'largest block of tenement houses in the world' was one commentator's term for them – and forced the richer inhabitants to move away to the west, beyond Leipziger Platz and Potsdamer Platz. On the other hand, however, the city's elevation to the status of imperial capital added to its attractiveness and encouraged a further bout of intensive growth. Berlin by now was bursting at the seams. Like a magnet it drew businesses, institutions and, as always, crowds of newcomers. By 1913 there were already more than four million people living in Berlin and its immediate vicinity, almost half of them outside the municipality's actual area, in suburbs, villages, newly founded residential areas and independent towns such as Charlottenburg, Schöneberg and Köpenick, the largest of which – Charlottenburg – had a population of 320,000 in 1913. Berlin thus became the third largest city in Europe, after London and Paris and, in the words of the 1914 Baedeker Guide, 'perhaps the leading industrial town on the continent'.

The city's meteoric rise was so impressive that many contemporaries – generally local inhabitants – felt quite giddy at the rapid rate of change, a sense of dizziness that found expression in exhibitionist gestures: 'Look at us', they would say; 'Look at our splendid achievements – the pace of our lives, our transport and the bustle of our city!' ('Bustle' was a key word in Berlin, even during the 1920s.) 'There's no one else can come near us.' Descriptions of Berlin at this time – chiefly those intended to make an impression on

Potsdamer Platz in 1896, looking eastwards towards Leipziger Straße, where building work was shortly to begin on the Wertheim department store. Leipziger Platz leads off from Potsdamer Platz through a passage formed by two gatehouses built in 1823 to designs by Karl Friedrich Schinkel. (LBS)

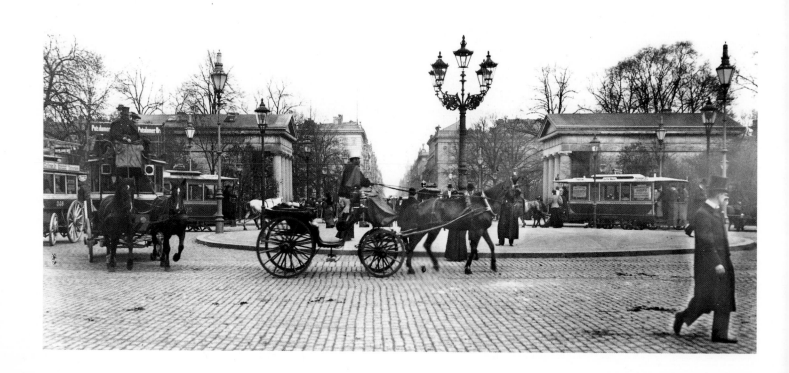

tourists from the provinces – took the form of blatant propaganda, a hymn in praise of the city's merits and exploits. Such pride is bound to strike us now as comical and offensive. And yet it was not at all uncommon, but rather a consequence of the breathtaking speed at which the rather sleepy, Biedermeier town of the 1860s had been transformed by the turn of the century into a forerunner in the field of modern experiment. The overweening arrogance and other unpleasant side effects of the developing 'New Berlin' increased aversion to the city, an aversion which was in any case gaining ground in 'the provinces'. This insidious process of alienation was to culminate at the end of the 1920s in hostile attacks on a place that was seen as the source of all the evils, real and imagined, of the modern age.

Even with its ideological bias, this hatred of Berlin had some basis in fact. If, under Frederick the Great, the city had been a slow starter, in the early years of the twentieth century, it was now regarded as an upstart, lacking in both tradition and any sense of dignity and unable to strike the right balance – a city, in short, of parvenus. (Its enemies called it 'Parvenüpolis'.) No matter what efforts it made to compete with its 'rivals', Paris and London, there was no denying the incontrovertible truth that Berlin could never exude the dignity and calm of those two cities which, steeped in their own traditions, owed their charm to centuries of cultural and urbane development, enjoying a sense of history that Berliners would never know.

Berlin has other qualities. But, unaware of these, this upstart among the world's metropolises, plagued by self-doubt and uncertainty, coveted standards set by its rivals, rather than its own. To discover its own identity in a moment of calm contemplation was a pleasure denied to Berlin. While whole new sections of the city sprang up from nothing, others were changed out of all recognition within a matter of years as houses were torn down or new storeys added, and yet others were gutted and redesigned. Friedrichstadt, once a quiet and fashionable district, became a modern business quarter with government buildings, banks and newspaper offices, the home of the city's rag trade and export business, as well as a centre for tourism, entertainment and shopping. The city, as a living organism, suffered a very real sense of

Leipziger Straße in June 1910. On the left is the Wertheim department store, built in 1896, while the Prussian Upper Chamber can be seen on the right. Completed in 1904, it is a palatial building in the Italian Renaissance style. (LBS)

dislocation: places like Potsdamer Platz, that were once a quiet corner at the very edge of the city, were now among its busiest squares, the pulsating heart of metropolitan life. Already the outlines of a second business quarter in the New West can be made out around the Emperor Wilhelm Memorial Church. Of the city's medieval origins scarcely a trace remained, and even baroque Berlin had largely disappeared, while modest middle-class buildings of the early nineteenth century were threatened with demolition. The city seemed at permanent pains to destroy all reminders of its past identity, its fixation on the present being coupled with a lack of historical awareness. Berlin was condemned to a state of eternal becoming, wrote the journalist Karl Scheffler in a penetrating description of the city published as long ago as 1910, a view which won him many local enemies.

Scheffler himself was a newcomer to the city who suffered from the fact that, even after decades in Berlin, he had still not learned to love it. The same is true of many others. In the nineteenth and early twentieth centuries the greater part of Berlin's population comprised outsiders like Scheffler. All true Berliners, so the joke went, came from Breslau or at least from Silesia. The joke was still in circulation long after the Second World War and contains a grain of truth. In 1864 barely half the city's inhabitants had been born in Berlin, a figure which fell to forty per cent by 1910. Emigrants from what were then German provinces in the east represented a sizeable minority of the population, numbering some half a million around the turn of the century, while the largest group of emigrants hailed from central Germany. Such a disparate mix of people was peculiar to Berlin, lending further weight to the city's 'American' feel.

Although there was much to support the suggestion that the only tradition in early twentieth-century Berlin was the city's lack of tradition, the Kaiser, at least, appeared to embody Prussian values, and hence to offer the best guarantee that traditions still existed. On his ascent to the throne in 1888, Wilhelm II had set great store by Prussian traditions, and, in particular, stressed his firm commitment to the army in characteristically emotive words: 'Thus we belong together – the army and I – thus were we born for each other and thus we shall stick together firmly and indissolubly.' And like his forebears the Kaiser sought, as best he could, to influence the way in which the city developed and the face it presented to the world. Yet the Berlin of the turn of the century was no longer the small but ambitious seat of royal power on which an absolute ruler could hope to impose his active will. The efforts of Wilhelm II to change the appearance of modern Berlin reached their climax in a series of public buildings of monumental frightfulness, including thirty-two statues, hewn from Carrara marble, in the Siegesallee (Victory Avenue) in the Tiergarten, each of them representing a Prussian or Brandenburg ruler since 1134, together with two of his famous contemporaries. Old houses within the palace precincts were razed to the ground to make room for an ostentatious national monument to Wilhelm I, while a vast, imposing cathedral was built near the Spree, replacing the old cathedral, which, though redesigned by Schinkel, had been found to be insufficiently grand. Its sandstone replacement, built in the High Renaissance style, destroyed the well-proportioned design of the other buildings surrounding the Lustgarten.

Whereas Prussia's absolutist monarchs had taken a personal interest in developing the city throughout the seventeenth and eighteenth centuries, their successors in the nineteenth century, to say nothing of the politicians who ran the Prussian state, had increasingly little chance to exercise any such

Julius Raschdorff's Cathedral of 1894–1905, seen from the steps of the Old Museum, c. 1930. According to Grieben's Guide to Berlin and Environs *(68th edition, 1932), 'The building creates an extremely restless impression thanks to the accumulation of Italian Baroque motifs and is highly detrimental to the overall effect of the Lustgarten, which is otherwise so wonderfully framed by the Palace façade and Old Museum'. (BPK)*

influence. While Wilhelm II was adding a few more imperial flourishes to the city's skyline, Bismarck was willing, nonetheless, to lend his support to plans to develop the Kurfürstendamm, later to become the western half of the city's most prestigious thoroughfare, a street of luxury shops, where people could saunter at leisure. It was, however, from an altogether different social sphere that the impetus came to develop Berlin and transform its structural features: the force of the modern industrial system which, in the course of the nineteenth century, had energized Berlin with the dynamism needed to enter the twentieth century.

It is one of the curious features of modern German history that the social group which shouldered the burden of this modernization process – the middle classes – should have spent the first half of the nineteenth century making repeated, if futile, attempts to play a political role (most notably, of course, in the Revolution of 1848/9), only to relinquish its claims to political rule in Germany and come to terms instead with the old-established social élite. The 'peaceful coexistence' between modern and traditional forces that came into being in this way also found expression in many aspects of the city's architecture. To give only one example, in Leipziger Straße only a few steps away from the Potsdamer Platz, two building complexes symbolized a juxtaposition of forces which, at risk of over-simplification, could be called the parties of progress and reaction. On the northerly side of the street was

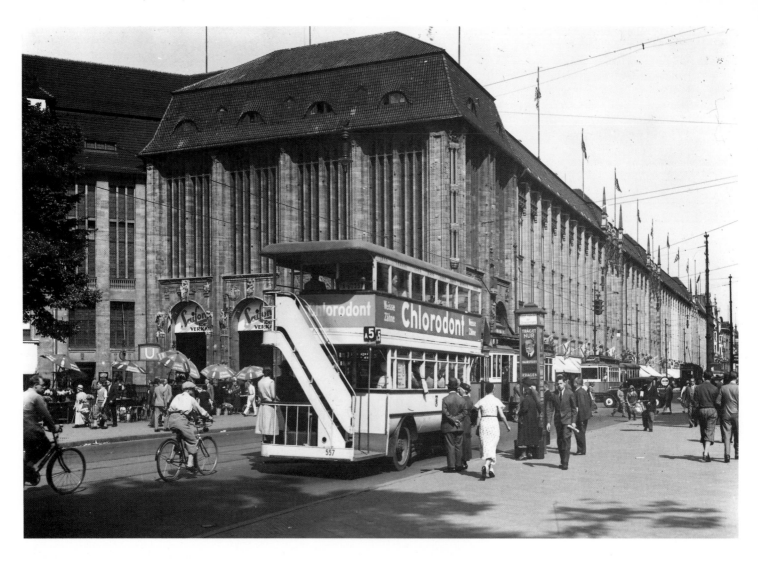

Wertheim department store, designed by the architect Alfred Messel in Leipziger Strasse, in 1932. (LBS).

the Wertheim department store, begun in 1896, built in several stages and finally completed, with the fifth phase of construction, in 1927. 'Wertheim on Leipziger Platz' was famous far beyond Berlin, not only for its architecture but for the range of goods on sale and its methods of presentation. On the opposite side of the street stood the Prussian Upper Chamber, built between 1898 and 1903 and forming part of a complex of buildings extending south as far as the Chamber of Deputies situated in the Prinz-Albrecht-Straße. Whereas Wertheim's emporium could be seen in certain respects to anticipate 1920s functionalism, the palatial Upper Chamber harked back to Renaissance Italy. If Wertheim's embodied the modern age, the Upper Chamber symbolized, politically and architecturally, Prussia's backward-looking attitudes, including its social composition. The deputies in the Prussian Landtag (state parliament) were still elected according to a three-class electoral system.

The middle classes had learned to live with their Hohenzollern rulers, but the monarchy met its match in the newly emergent workers' movement. The struggle by the social democrats to have the three-class electoral system abolished was one of the most important political issues in pre-war Berlin. At the Reichstag elections in 1912 three out of four Berliners had voted for the Social Democratic Party of Germany (SPD). The social democratic workers' movement was seen as the principal foe of all that Wilhelmine Germany stood for, in short, the Berlin of parades and exercise grounds, of court balls and military bands, of the emperor's official birthday and the day of national

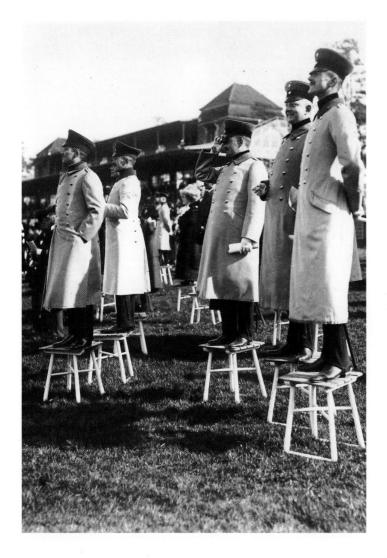

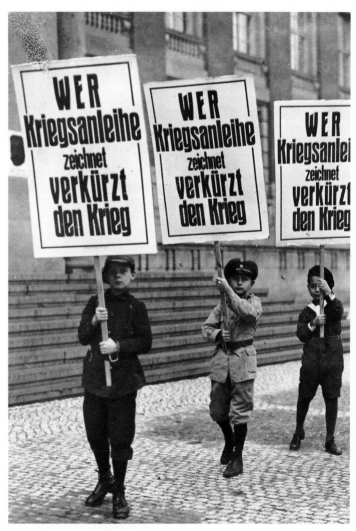

'First place in the opening race of the season at the Grunewald race course, 9 April 1912' (original caption). (BG/Gebrüder Haeckel)

Above right: Schoolchildren inviting subscriptions for war loans, 1916. The issuing of war loans was an essential way of financing the war, but it meant that at the end of the war the enormous national debt drove inflation through the roof. (LBS)

celebrations to mark the Prussian victory at Sedan, of a snooty officer corps that was conscious of its lofty social prestige and, in general terms, the grotesquely exaggerated sense of importance attached to everything military. By no means least on the list of the social democrats' objects of scorn was the Kaiser himself with his firm belief that he ruled by God's grace alone, his 'personal regiment' and absurdly amateur grasp of politics, his embarrassing vanity and need to show off, to say nothing of his love of exhibition and predilection for bombast. The 'Americanization' of modern Berlin was bound to make such a figure appear supremely anachronistic.

And yet, in those August days of 1914, a sense of harmony seemed to descend over friend and foe alike, uniting the forces of progress and reaction: traditionalists, on the one hand, and others bent on reform; workers and monocled officers; fawning courtiers and captains of industry. In making his speech the Kaiser had found the most suitable words to express the deeply emotional mood in which all the conflicts of actual life suddenly seemed unimportant. Within only a matter of months, however, the patriotic frenzy of August 1914 had largely given way to a sense of disenchantment. Hopes of a rapid military victory proved illusory, while those who, on the home front, stood to gain little out of the war – the broad mass of the population and, first and foremost, the workers – found that with each passing day their worries and deprivations were growing. Many basic provisions had to be rationed, consumer goods disappeared from the market altogether or suddenly doubled in price. The longer the war went on, the greater the shortages grew.

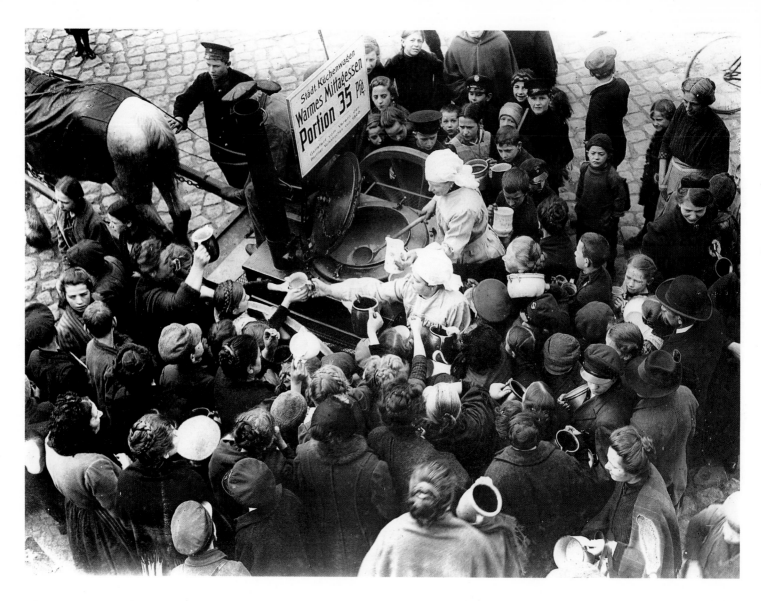

Food distribution at a mobile soup kitchen run by the city authorities, c. 1917. Public soup kitchens were introduced in 1916 to deal with rapidly deteriorating food supplies. (LBS)

The city organized soup kitchens, but these were only a stopgap measure. The 'turnip winter' of 1916/17 was graphic proof of the plight that was suffered by the poorer sections of the population. With each passing month, the numbers of those who were willing to observe the truce proclaimed on the outbreak of war grew less. The left wing of the social democrats, who had always been opposed to the war, gained increasing support and in April 1917 formed an independent party. The early months of 1917 also witnessed the first mass strikes in Berlin, while the 'January strike' of 1918 involved several hundred thousand workers, especially those employed by the city's metalworking industry.

For a while the military regained control by means of sharply repressive measures. Only slowly did the Kaiser agree to a cautious and half-hearted reform of the existing political system, a decision forced upon him by pressure from his supreme command. A cabinet reshuffle followed, bringing social democrats into the cabinet for the first time in their history. But all these concessions came too late. When Wilhelm II left Berlin on 29 October 1918 to return to GHQ in Spa, it was only a matter of days before insurrection broke out in Kiel, led by sailors from the imperial fleet. The Kaiser's minions brought the war machine to a halt. The powder keg was primed. And early on 9 November 1918 the rebellion reached the imperial capital.

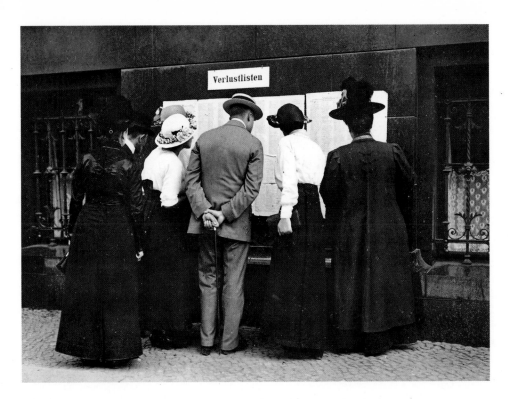

Passers-by examining a list of casualties outside the Town Hall. The displaying of lists of soldiers killed in action was suspended in 1916, since the conversations which developed on such occasions were alleged to be a threat to 'public safety and order'. (LBS)

This 'Iron Hindenburg' was erected in Königsplatz (now the Platz der Republik) between the Victory Column and the Reichstag building on 4 September 1915. Donations of one, five or one hundred marks were invited for the war effort, in return for which people were allowed to drive iron, silver or gold nails into the wooden statue. (LBS)

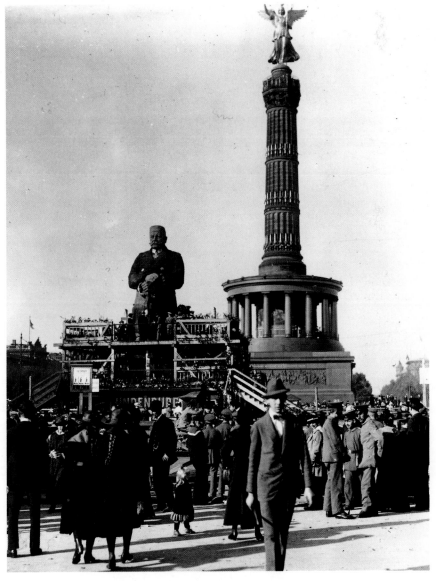

Revolution and Crisis

A T TEN O'CLOCK ON THE MORNING of 9 November 1918 news reached the Reich Chancellery in the Wilhelmstraße that a column of several thousand workers, including women and children, was making its way to the city centre from the northern parts of the capital. And not only from the north: they were also coming from Wedding and Moabit, as well as from other parts of the city, wherever there were large factories. From every direction enormous grey columns of people converged on central Berlin. By noon the inner city looked much as it had done on 1 August 1914, except that it was, so to speak, a mirror image of the earlier scene that presented itself to the startled gaze of expectant passers by. Hundreds of thousands of people were on the move again, but the mood was in stark contrast to the jingoism that had marked the onset of war.

In August 1914 it had largely been members of the middle classes that had passed along Unter den Linden, applauding the Kaiser and cheering his troops and officer corps as they made their way to the palace, whereas now it was the industrial workers who, marching alongside insurgent soldiers and mutinous marines, cursed the very same Kaiser, filling the late autumnal air with their cries of 'Long live the Revolution'. The cars and lorries which plied to and fro were no longer filled with officers but with simple soldiers and armed civilians, desperate figures waving red flags and looking as though they would stop at nothing. Whenever officers were sighted, the crowd would stop to tear away their epaulettes but left them otherwise unharmed. The revolutionary masses were not bent on attacking the representatives of the old regime. There was no sign of wanton damage or violence: the revolution was still very much a good-natured affair.

Nor, by contrast with 1914, was there any frenetic cheering or wild enthusiasm. Everywhere, contemporary observers reported, the features of the demonstrators conveyed a mood of grave solemnity. When they left their factories and foundries that morning, it was in the belief they were marching into the jaws of death. They carried placards at the front of the processions with 'Brothers, do not shoot!': words recalling those of the Kaiser himself in the speech welcoming new recruits to his army, that, in the event of internal

Previous page: Fighting around the Royal Palace over Christmas 1918 caused damage to the Kaiser Wilhelm memorial. (LBS)

The local division of Guards returned to their garrison in Berlin between 10 and 22 December 1918. As each group of soldiers reentered the city through the festively decorated Brandenburg Gate, a formal ceremony greeted those who were 'undefeated in the field'. This photograph dates from 12 December 1918. (LBS)

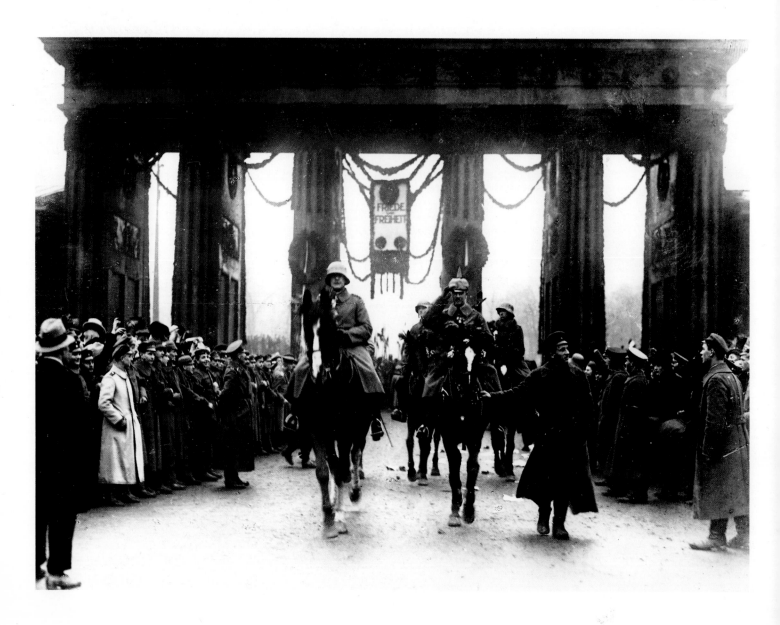

disorder, a situation might arise when 'his' soldiers would be forced to shoot not only 'their kinsmen and brothers but even their own parents'. The military character of Wilhelmine Berlin was not due merely to the military pomp of the court and large-scale parades, but also, at a more fundamental level, to the vast open spaces at the edge of the city used as exercise grounds and by fortress-like barracks which often dominated entire streets in the working-class areas of Berlin. In the years leading up to the outbreak of war, Berlin had been turned into what was perhaps the largest military centre in the world – and it was at the gates of the city barracks that the fate of this first stage of the revolution was decided during the early hours of 9 November 1918. However, the soldiers did not shoot but opened up the barracks, joining forces with the people and providing them with weapons, or slipping away as fast as they could. Among the handful of barracks which proved exceptions to this was the one which housed the Fusilier Guards in the Chausseestraße, where an officer fired into the crowd, killing three of the workers as they forced their way into the grounds. As a rule, however, it seemed as though the whole of the Reich's vast apparatus of military power had simply faded away – a development no one could have dared predict as recently as the evening before.

By around one o'clock the first special editions were already appearing on the streets, announcing the Kaiser's abdication; an hour later the Social Democrat Philipp Scheidemann, who had been permanent secretary under the old imperial government, proclaimed the new republic from one of the Reichstag windows. By a constitutional irony, the last Reich Chancellor appointed by the Kaiser, Prince Max von Baden, who had only been in office since 3 October, now appointed the Social Democrat Friedrich Ebert as his own replacement. By four o'clock the same afternoon the red flag was fluttering from the Royal Palace. Karl Liebknecht, the spokesman of the Spartacus League and well known as an embittered foe of Prussian militarist rule, proclaimed the socialist republic from the very balcony on which Wilhelm II had stood when addressing the masses on 1 August 1914. The following day the Kaiser fled into exile in Holland, remaining there until his

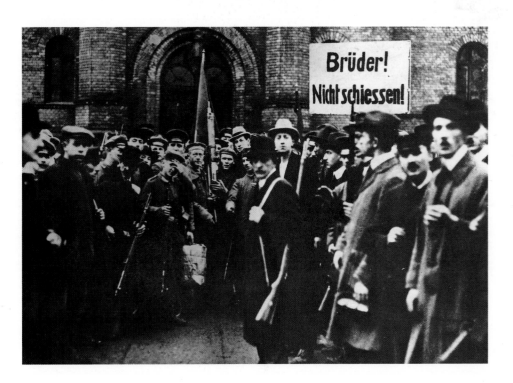

Soldiers and workers from Berlin's heavy industries fraternizing outside the barracks of the Second Uhlan Guards Regiment in Invalidenstraße on the morning of 9 November 1918. (LBS)

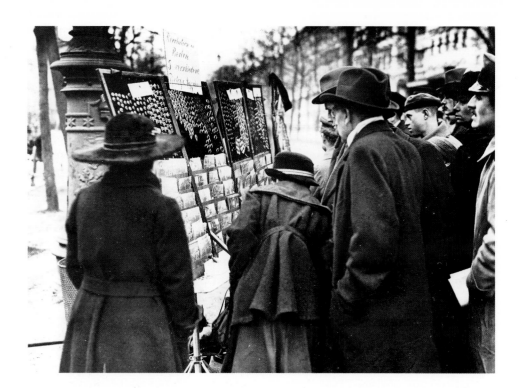

A street-trader in Unten den Linden selling badges and postcards of the Revolution, 10 November 1918. (Ullstein)

death. In Berlin, the 'Majority Socialists' (SPD) and 'Independent Socialists' (USPD) formed a Council of People's Representatives with an equal number of members from both groups. At the same time the first full meeting of the newly elected workers' and soldiers' councils appointed an 'Executive Committee' to exercise provisional power over the whole republic. Finally, on 11 November, as representatives of the German government and *entente* powers signed the armistice agreement in Compiègne, the People's Naval Division, a recently constituted body largely made up of sailors from the city's working-class districts, moved into the palace and royal stables, to the alarm and consternation of that section of the populace which had remained loyal to the imperial monarchy.

The Reich had collapsed with remarkable speed, followed in swift succession by the proclamation of the new republic and the declaration of peace, but, precisely because of the speed with which events overtook the existing political groupings, none of them was prepared for the complex situation that followed. 'The Germans knew no more about a republic than they did about the moon', was how the then editor-in-chief of the liberal *Berliner Tageblatt*, Theodor Wolff, summed it up decades later. The title of a novel published in 1930 recalled a widespread remark of the early 1920s: *The Kaiser Went, the Generals Remained*. It was certainly true that, although the Kaiser had gone, the old power structures of the Reich, including the officer corps and civil service, had largely been left untouched. A fundamental attempt at democratization was not undertaken. While the old élitist groupings and their hangers-on waited for the post-revolutionary shock waves to settle, a yawning chasm opened up between the supporters of the 'right-wing Socialist' SPD on the one hand and, on the other, the 'Independents' (USPD) and 'Spartacists' (the group around Karl Liebknecht and Rosa Luxemburg remained part of the USPD until the end of the year).

Throughout what remained of November and the whole of December 1918 the different parties wrangled not only over what should happen next but also over the aims of the revolution itself. 'All power to the workers' and soldiers' councils' and 'Summon the National Assembly as soon as possible'

were only two of the contradictory slogans of the time. For many people the arguments boiled down to simple alternatives: order or chaos, democracy or Bolshevism. The first bloody clashes occurred in early December, when soldiers shot at Spartacist demonstrators, killing sixteen. Over Christmas, troops summoned from Potsdam by the government used heavy artillery on the People's Naval Division who were occupying the palace and royal stables, an act of brutality which prompted the representatives of the USPD to quit the Council of People's Representatives at the end of the year, leaving the SPD to form a government on its own. Early in January 1919 the prefect of police, Eichhorn, a representative of the left wing of the USPD was dismissed. In the eyes of the left-wing thinkers, this meant the fall of the final bastion of the Revolution. The conflict could only grow worse.

The battles which raged between 5 and 12 January 1919, though largely confined to the city's newspaper quarter, brought the risk of civil war to Berlin. They have traditionally been described as the Spartacus Uprising, yet to do so grossly overestimates the importance and influence of the Spartacus League, which had joined together with other revolutionary groups at the beginning of the year to form the Communist Party of Germany. The Communists, particularly in Berlin, were still an extremely small group at that time, even if they gained much public attention. Far more influential was the USPD, especially its left wing (with its headquarters in Berlin), together with the 'Revolutionary Leaders', who, difficult to classify from a party-political point of view, drew their support from workers in heavy industry. Members of all these groupings barricaded themselves into the police headquarters on Alexanderplatz on 5 January 1919. The same evening they began to occupy leading newspaper offices, starting with the SPD's *Vorwärts* (*Forwards*) building in the Kreuzberger Lindenstraße. Most of those who took part in the occupation were motivated more by their violent rage at the way events were reported in the press than by any desire to gain control of the apparatus of state. Otherwise why would they have occupied newspaper offices but left the Reich Chancellery untouched?

All the occupied buildings were recaptured by government troops, starting on 8 January. In some cases, completely disproportionate means were used. It was as though the troops, still smarting from their defeat at allied hands, were keen to avenge their shame on the 'enemy within'. According to a myth that was increasingly gaining currency, the army had not been beaten in the field but had been 'stabbed in the back' at home by forces opposed to the war. On 15 January the best-known representatives of the revolutionary left, Rosa Luxemburg and Karl Liebknecht, were murdered by members of the right-wing Free Corps militia. Divisions in the workers' movement were definitively sealed by these events in Berlin in January 1919. The degree of brutality used on that occasion was to be surpassed by the violence with which an uprising two months later was brutally put down. According to official estimates, some 1200 persons were killed when units of the volunteer corps were deployed to break a general strike in working-class districts to the east of the city centre. For all its bloodless beginnings, the Revolution seemed to have turned into permanent civil war, as military drill and the brutalization learnt in war-time trenches found an outlet in running battles.

When the National Assembly was elected on 19 January, the results of the local polls in Berlin reflected those in the Reich as a whole, with only two exceptions: the Catholic centre party traditionally came off badly in Protestant Berlin, while the USPD captured 27.6 per cent of the vote, in contrast to the 7.6 per cent which it averaged in the country at large. (In the elections for the

city council at the end of February it even won more votes than the SPD.)
From a 'Red three-quarter majority' at the Reichstag elections in 1912, the
number of votes cast for the two Social Democratic parties had fallen
considerably, but the result still showed the relative strength of the left wing
of the workers' movement in Berlin. Fear of unrest and pressure from the
streets persuaded the governing powers to transfer the seat of the National
Assembly to the small provincial town of Weimar. How ironic that the first
republic in Germany should go down in history not as the Berlin Republic
but as the Weimar Republic!

The young Republic's lasting political crisis was soon compounded by
worsening economic problems. At the end of February 1919, 214,000 men
and women were registered as unemployed in Berlin. The wave of armed
battles gave way to a wave of strikes – the number of transport strikes alone
that paralysed the capital between 1919 and 1923 was huge. Curiously
enough, the workers' experience of strikes had a positive political effect,
helping to rescue the beleaguered Republic when the regrouped forces of
reaction attempted a coup on 13 March 1920. Although supported by the
6000 soldiers of the so-called 'Ehrhardt Brigade', the 'Kapp-Lüttwitz *putsch*'
was a short-lived affair, frustrated by a general strike that received almost
total support. Nevertheless, the *putsch* showed how powerful forces hostile to
the Republic had become in only eighteen months. In the field of foreign
affairs, its enemies exploited the general opposition to the Treaty of Versailles
and its repercussions for Germany, while on the domestic front they ran a
campaign of vilification against the Republic's representatives which, in the
case of the extreme right wing, went hand-in-hand with a vicious anti-
Semitism. The most prominent victim of these attacks was the Foreign
Minister, Walther Rathenau, who was assassinated by a group of right-wing
extremists on 24 June 1922. On the other hand, the huge demonstrations
held in Berlin to protest against his killing – the latest in a series of political
murders that had started in 1919 – showed to what extent large sections of
the population were ready to oppose anti-republican trends at this time.

It was shortly after Rathenau's murder that inflation – already
beginning to make itself felt as early as 1919 – became the prime political
concern at home. A consequence of the huge debts which the Reich had
incurred in the course of the war (the national debt, which had stood at 5.2
thousand million marks in 1914, had risen to 156.4 thousand million by
1918), inflation began to grow with alarming speed from the end of June
1922. The dollar exchange rate rose from 349 on 26 June, to 1460 on 16
September, and to 7500 on 11 November 1922. The municipal authorities in
Berlin were obliged to make mass redundancies, while unemployment
generally was beginning to rise again. But it was in 1923 that inflation
reached its catastrophic climax: the dollar quotation for the mark rose to
48,000 on 1 February; by June it was more than 100,000, and by the end of
July it had passed the million mark. Then suddenly the exchange rate
plummeted and the devaluing of the mark assumed surreal proportions. By
mid-October the dollar was worth 3.8 thousand million marks, on 8
November it reached 630 thousand million, hitting its all-time high on 21
November, when one dollar was worth 4,210,500,000,000 (4.2 million
million) marks. Salvation finally came at the end of November with the
currency reform and introduction of the *Rentenmark*.

'Disturbances outside the town hall caused by the unemployed,' noted
Berlin's Director of Public Prosecutions laconically in his diary on 14 October;
'food riots in the town'. And on 5 November: 'Famine riots in the streets.

Following the currency reform of November 1923 and the end of hyperinflation, Berlin's rag-and-bone men pulp the notes which were no longer legal tender, December 1923. (ABZ/Willy Römer)

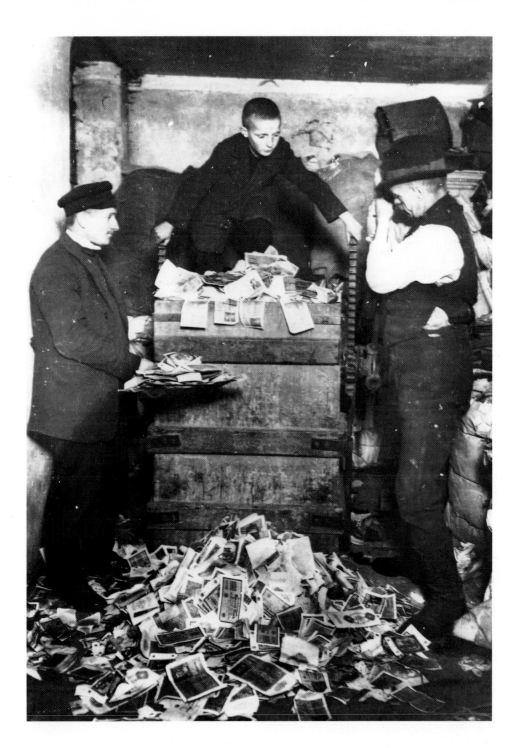

Bakeries and foodshops are stormed. Temporary bread rationing has to be reintroduced'. After years of painful shortages during the First World War, ordinary people had to put up with a further period of deprivation. It is impossible not to be shaken by contemporary accounts of the extent of the malnutrition and disease, the housing shortages and, above all, by the hardships suffered by children and the old. For large sections of the middle classes, inflation meant a fall in living standards and often total financial ruin as a result of the loss of their savings. But perhaps even worse than all the physical suffering was the sense of devastation caused by poverty and deprivation, by feelings of powerlessness and the lack of hope; for all the misery of the age was laid at the door of the Weimar Republic.

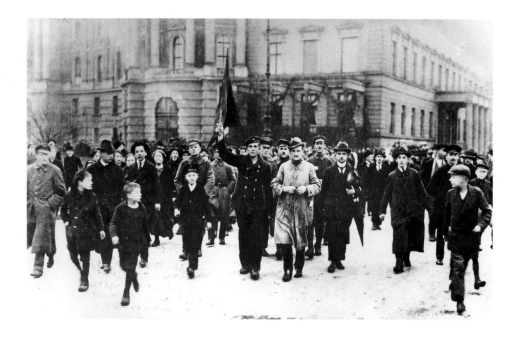

Johann Marx, a sailor from Arnstadt and a member of the Independent Socialist Party of Germany, heading a demonstration in Unter den Linden on 9 November 1918. In the background is the Palace of Kaiser Wilhelm I and the former Royal Library. (LBS/Gebrüder Haeckel)

Right: Members of the People's Naval Division, formed on 11 November 1918, in the main courtyard of the Royal Palace, mid-November 1918. (LBS)

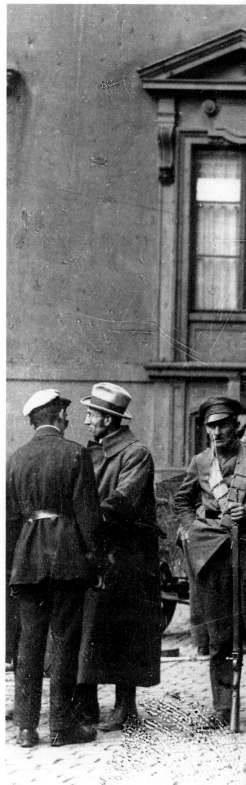

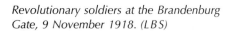
Revolutionary soldiers at the Brandenburg Gate, 9 November 1918. (LBS)

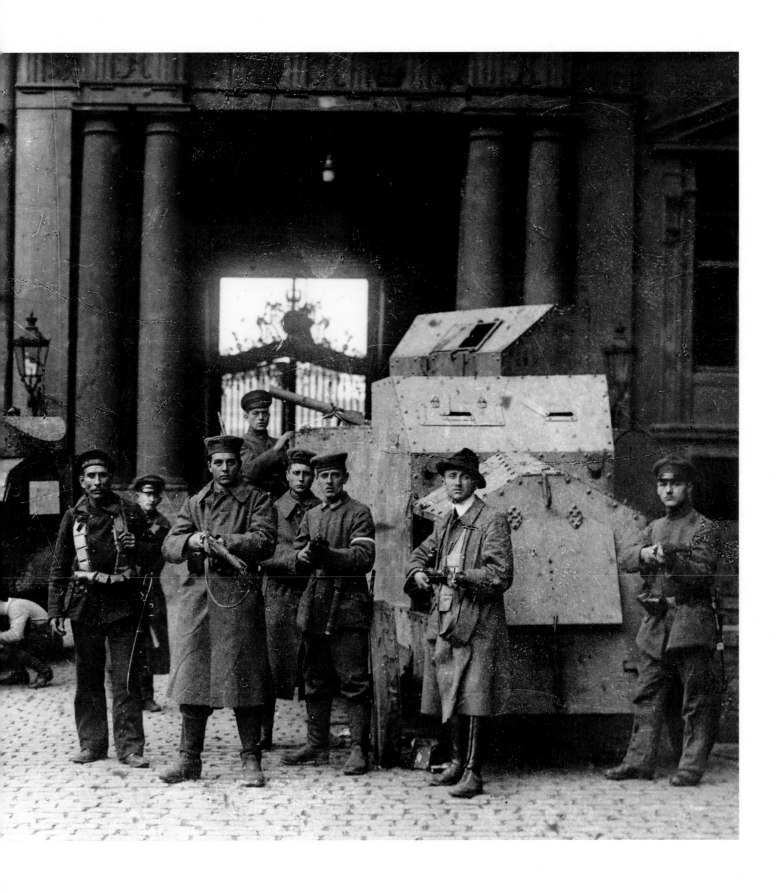

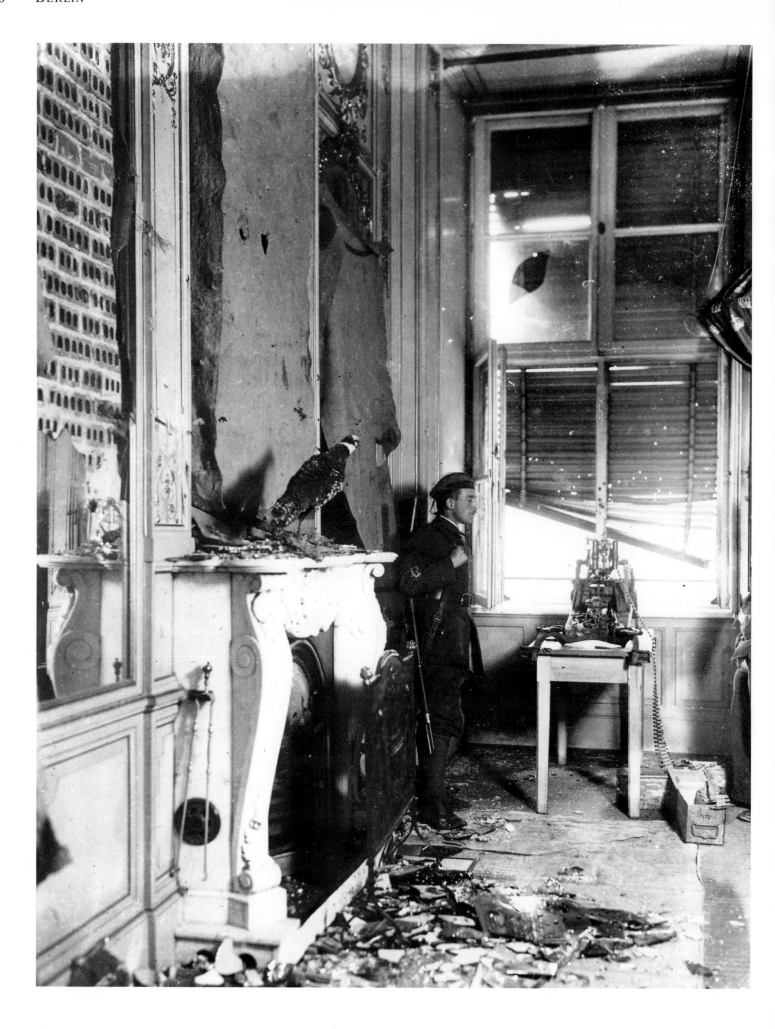

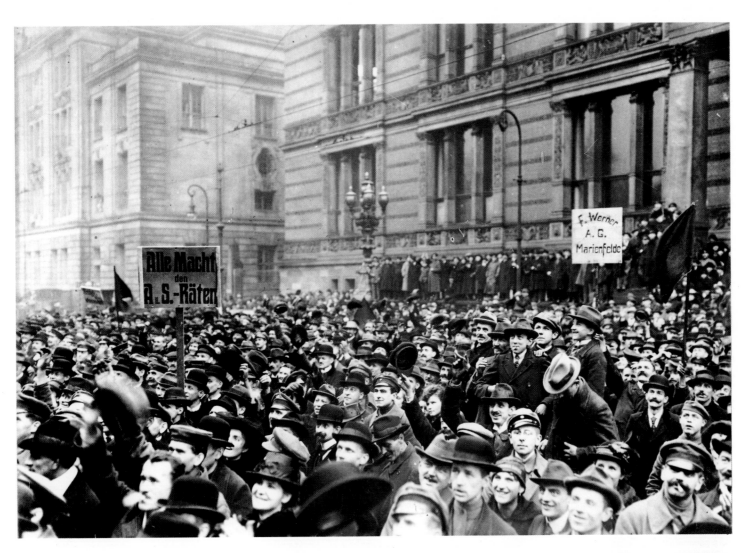

Demonstrators demanding 'All power to the Workers' and Soldiers' Councils' outside the Prussian Chamber of Deputies in Prinz-Albrecht-Straße. The first General Congress of the Workers' and Soldiers' Councils of Germany met here between 16 and 21 December 1918. In the background on the right is the Arts and Crafts Museum (now the Martin Gropius Building). (Ullstein)

Opposite: A soldier of the People's Naval Division guards his post in the Palace during the 'Christmas Battle' of 23-24 December 1918. (BPK)

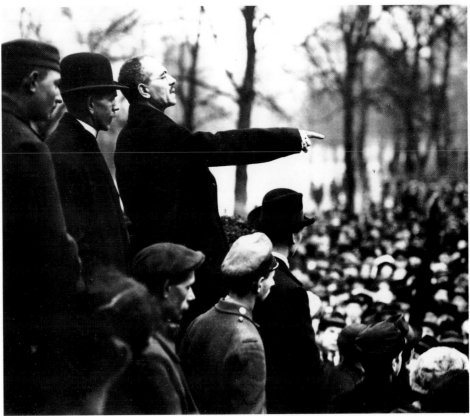

Karl Liebknecht addressing a rally in the Siegesallee in the Tiergarten on 7 December 1918. (BG/Robert Sennecke)

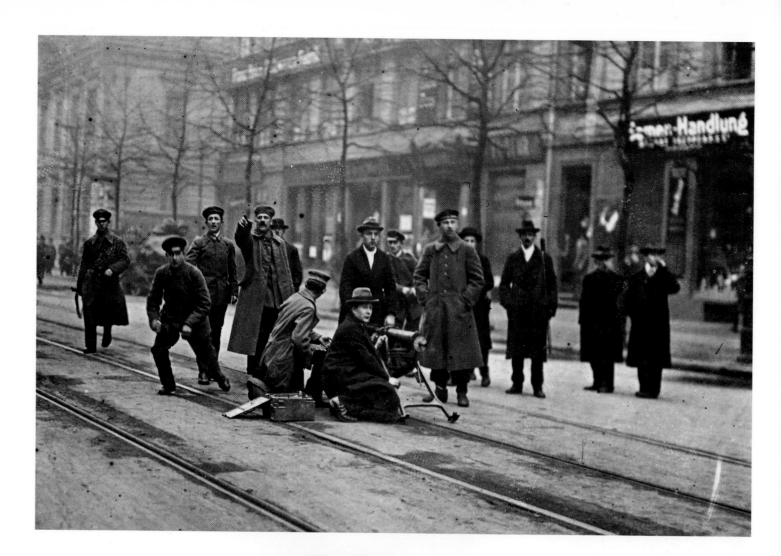

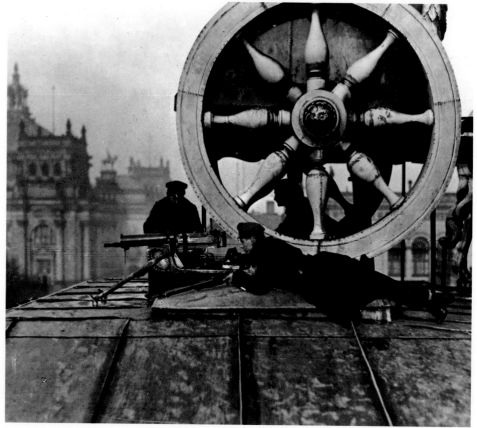

Above: Revolutionary workers and soldiers occupying the Vorwärts offices in Lindenstraße in the Kreuzberg quarter of the city at the beginning of the Spartacus Uprising, 6 January 1919. Vorwärts was the central organ of the Social Democratic Party. Its reporting and editorial features had incurred the hatred of left-wing radicals. (ABZ/Willy Römer)

Left: Government troops on the roof of the Brandenburg Gate during the Spartacus Uprising in January 1919. (LBS)

Opposite: A barricade made of bales of paper outside the offices of Scherl Verlag in Zimmerstraße in the heart of the newspaper quarter, c. 8 January 1919. (BPK)

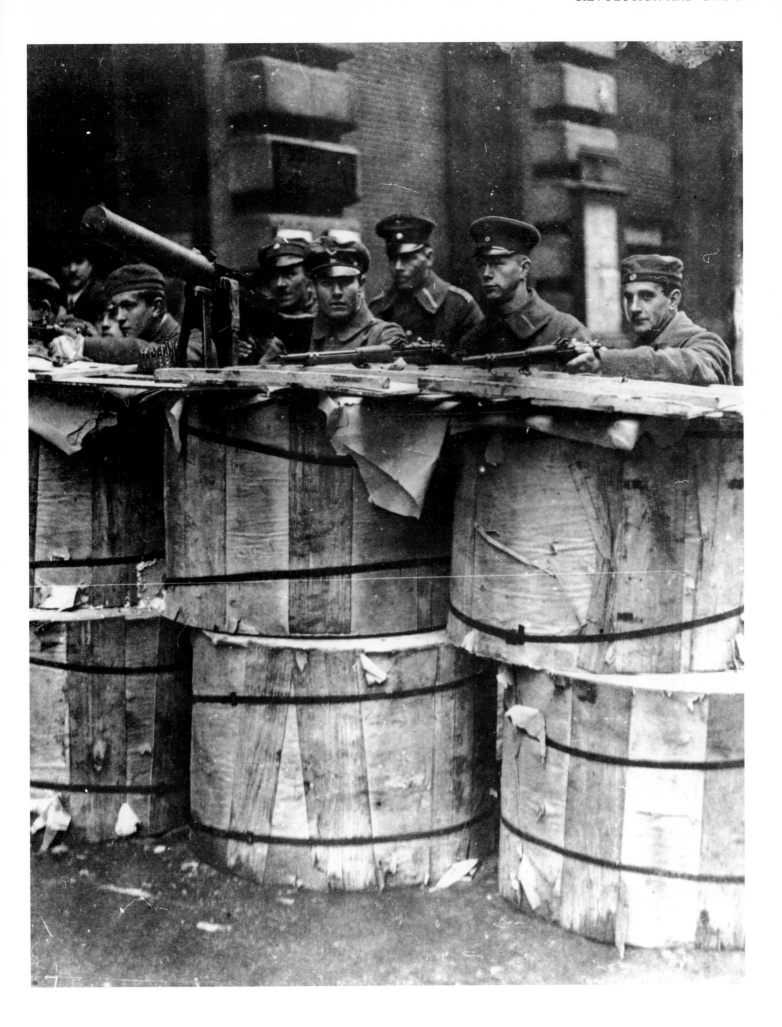

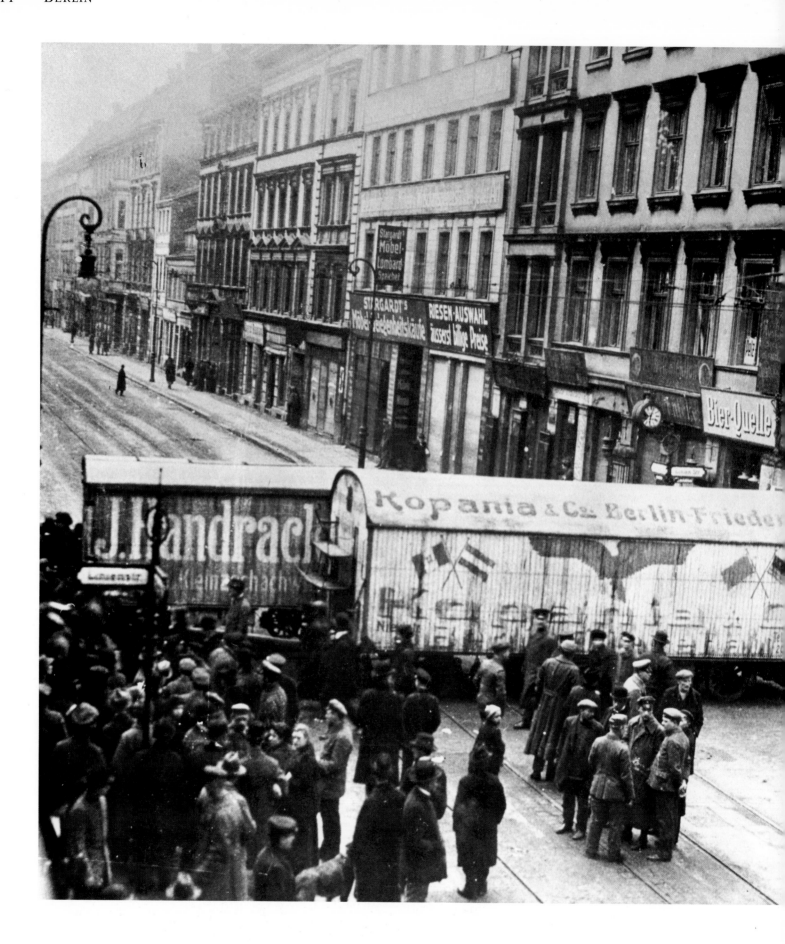

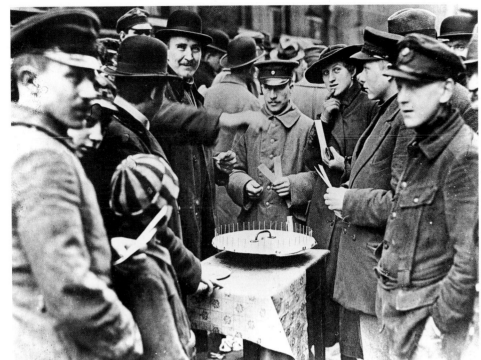

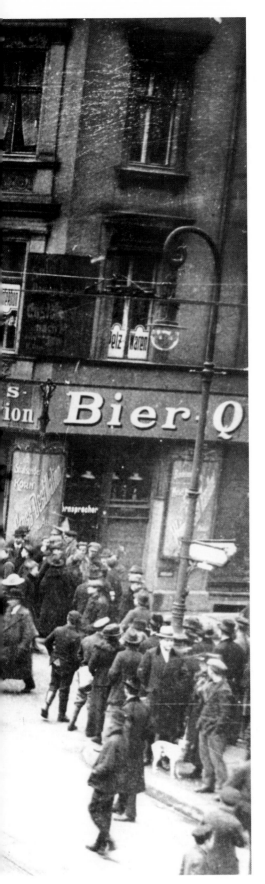

Lottery stall at a Berlin street corner, March 1919. Even during the most violent street battles, life went on as normal only a few hundred yards away. (BPK)

Left: Furniture vans being used as barricades on the corner of Prenzlauer Straße and Linienstraße during the General Strike, 7 March 1919. (BPK/Willy Römer)

Armoured vehicle with government troops on Alexanderplatz. This unit was deployed during both January and March 1919 in order to quell disturbances. (LBS)

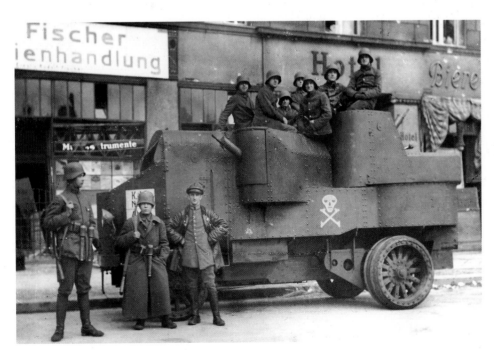

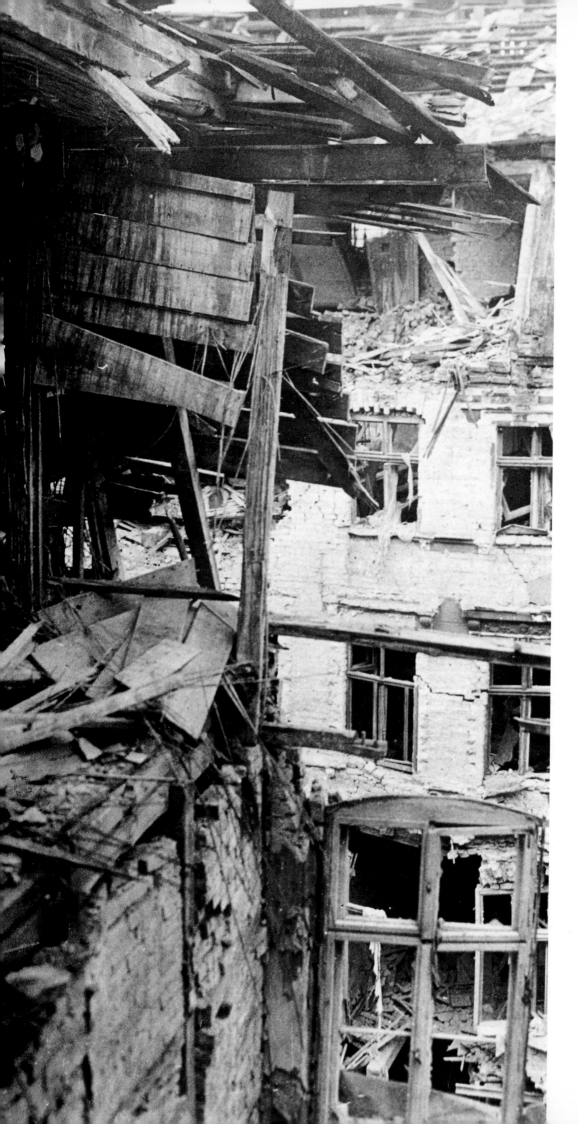

IN CONTRAST TO THE RELATIVELY well-known Spartacus Uprising of 5-12 January 1919, much less is known about the significance of the events that took place during the General Strike of 3-8 March 1919 and the days that followed, although the amount of force which the Free Corps troops used against both insurgents and innocent passers-by far exceeded anything seen before. This included heavy artillery, grenade launchers, armoured vehicles and even bombers. The Minister of Defence, Gustav Noske, issued instructions that, 'Any person who, in the battle against government troops, is found to be carrying a weapon will be shot on sight'. Apart from severe damage to property, the street fighting in the eastern part of the city resulted in more than 1200 deaths, of whom 75 were members of the armed forces.

A private house in Alte Schützenstraße (near Alexanderplatz), destroyed by heavy artillery fire, 9 March 1919. (BPK/Willy Römer)

A government soldier leading away a prisoner, c. 10 March 1919. According to eyewitness reports, the soldier shot his prisoner seconds after this photograph was taken. (LBS)

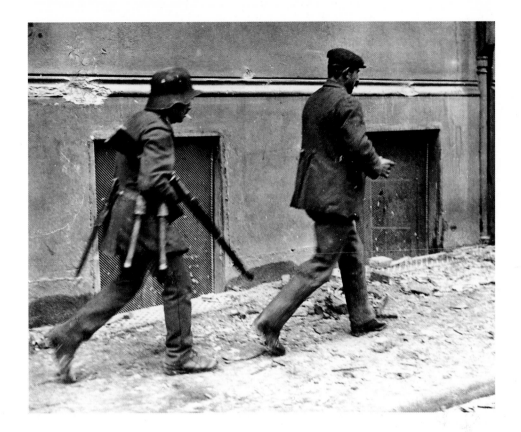

Following the end of the armed insurrection, children are seen playing in a makeshift trench in Frankfurter Allee, 11 March 1919. (LBS)

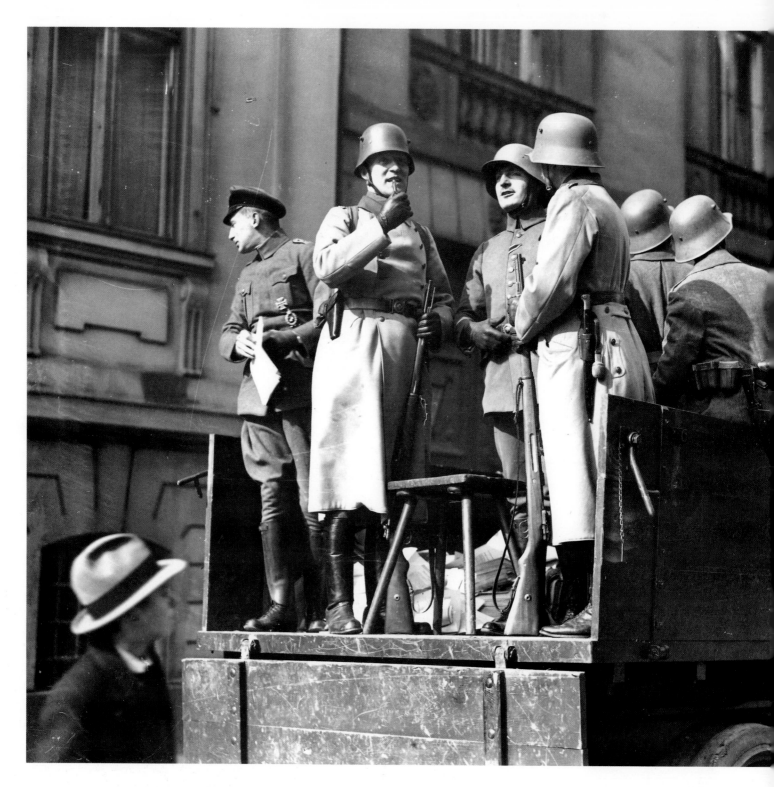

*Members of Hermann Ehrhardt's Marine
Brigade in the city's government quarter,
mid-March 1920. Under the supreme
command of General Walther Lüttwitz,
Ehrhardt's Brigade provided the military
muscle for the right-wing Kapp Putsch of
13-17 March 1920. (LBS)*

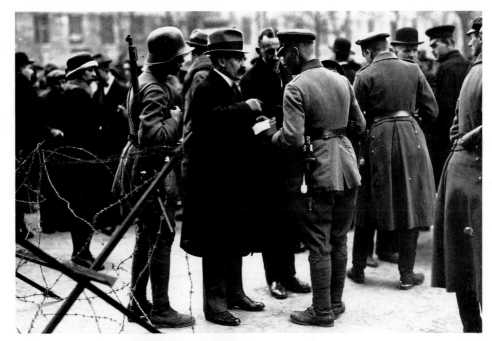

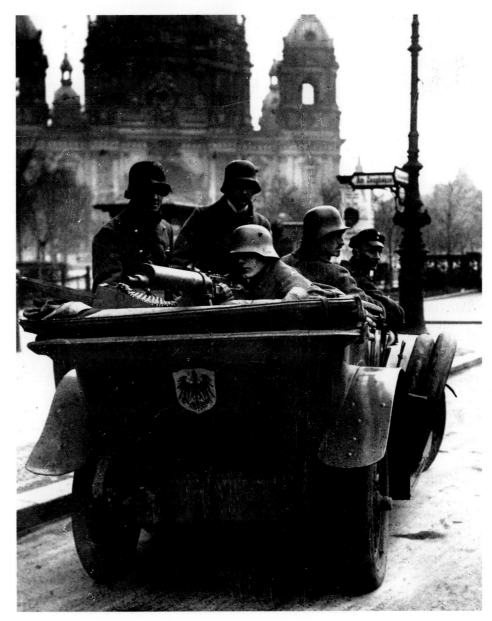

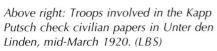

Above right: Troops involved in the Kapp Putsch check civilian papers in Unter den Linden, mid-March 1920. (LBS)

Right: Troops loyal to the Government patrol the streets around the Lustgarten during the Kapp Putsch, March 1920. (LBS)

Right: Horse-drawn omnibuses, long since taken out of service, were reintroduced during the general strike of mid-March 1920. (LBS)

Meeting of strikers at the Gleisdreieck underground station during the general strike organized against the Kapp Putsch, mid-March 1920. (BPK)

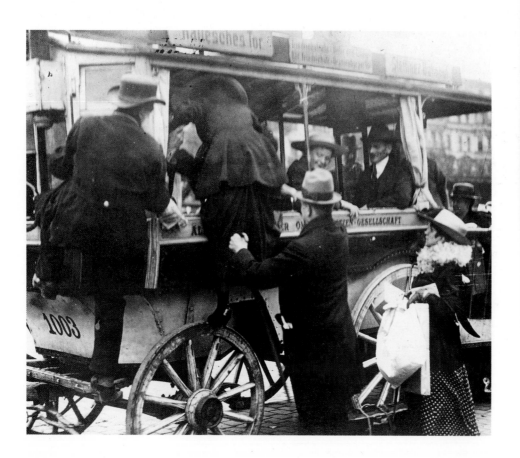

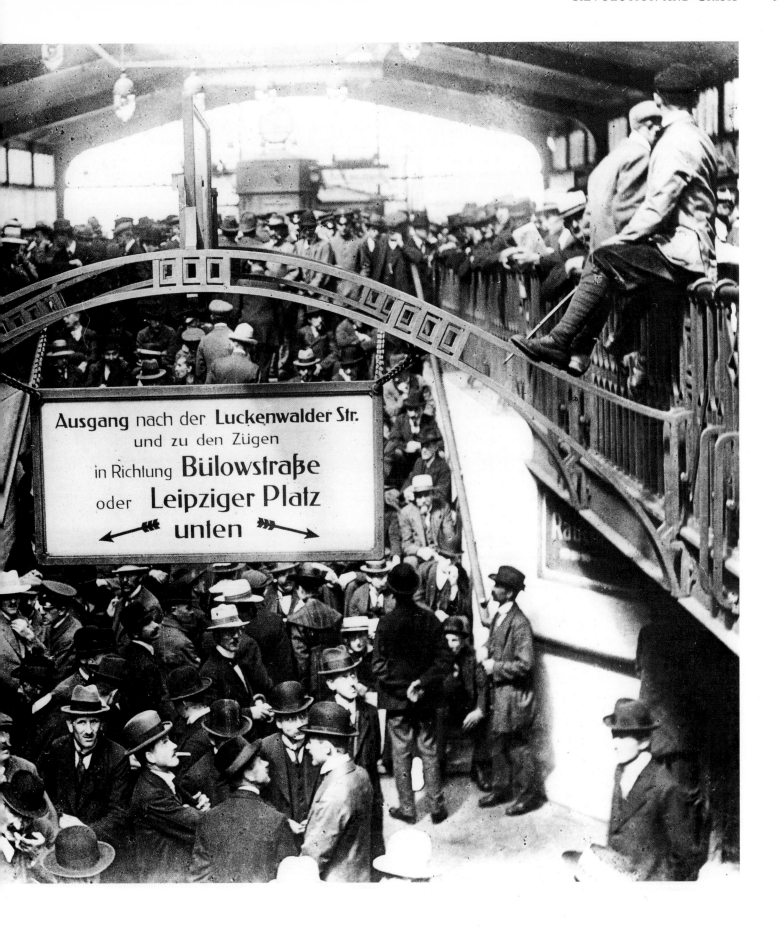

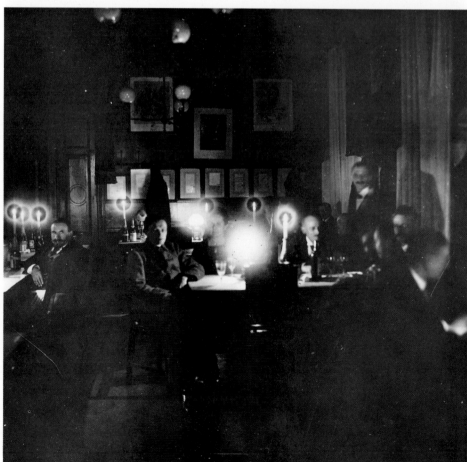

Guests having to prepare their own meals during a strike by hotel kitchen staff, 1920. (ADN)

Below left: A scene in a restaurant during a strike by workers in the electricity industry, November 1920. (ADN)

Protest demonstration by civil servants who, in view of their social situation, claimed to be 'burying their last remaining hopes', as the caption on one of their banners reads, 28 December 1920. (BPK)

SCARCELY A DAY WENT BY IN 1919 and 1920 without a strike somewhere in Berlin. Following the bitter political struggles of the early months of the year, the strikes that took place throughout the summer and autumn were aimed at bringing about an immediate improvement in social and economic conditions. The Berliners' experience of strikes also contributed to the success of the general strike against the Kapp-Lüttwitz Putsch in March 1920. Although there were repeated strikes during the years that followed, the weapon of a walkout became blunted with the rapidly rising rate of inflation, especially when, in 1923, unemployment showed another sharp increase.

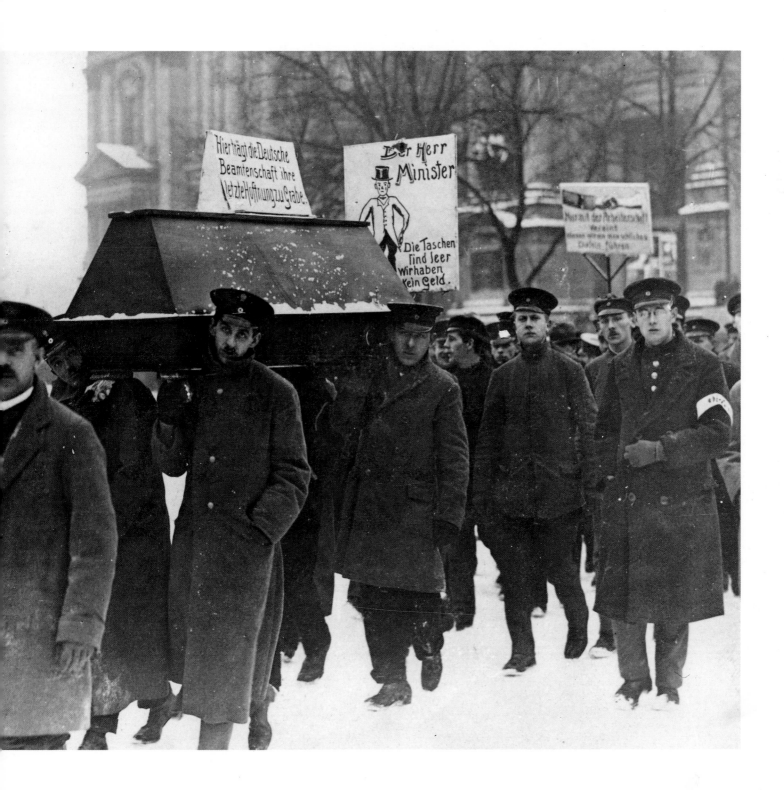

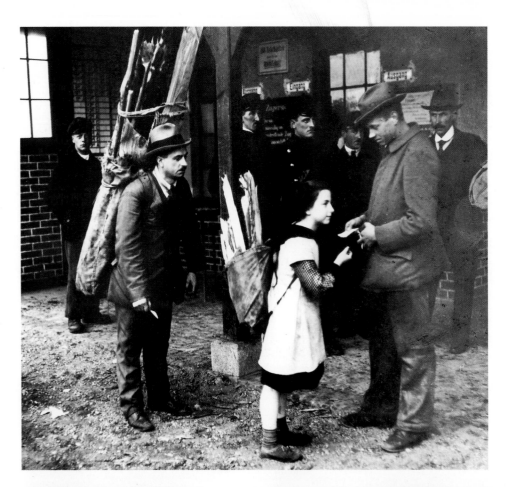

As a rule, a permit was needed to collect wood. This photograph, dating from 1920, shows permits being examined at one of the city's stations. (BPK)

'Lichte Sonntage' (Bright Sundays), was a series of event organized by the writer Franziska Mann to help middle-class women suffering during the crisis, 1923. (Ullstein)

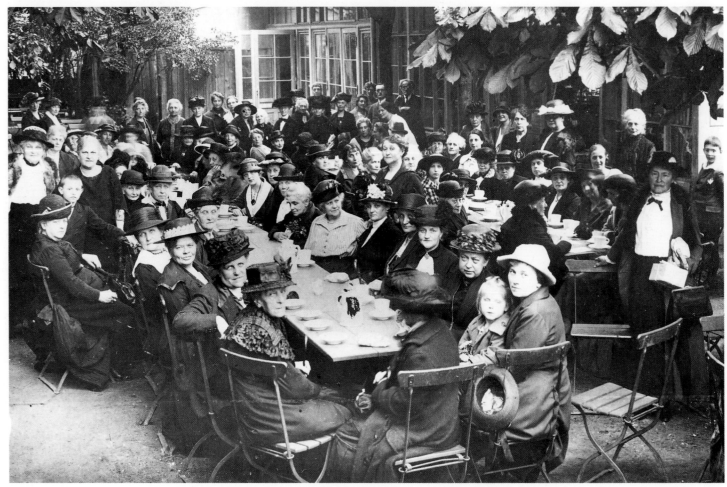

*School meal, 1921. In his 1923 pamphlet,
Social Deprivation in Berlin, the city's
mayor, Gustav Böß, noted that it was on
children that the increasing deprivation of
the post-war years was having the most
disastrous effect. So great was the level of
poverty, that the means available to deal
with it were altogether inadequate: lack of
resources meant that school meals, for
example, were available to barely half of
those in need. (BPK)*

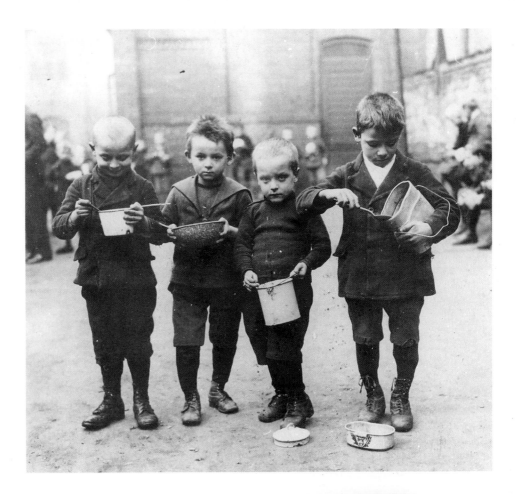

*Housewives queuing outside the Berlin
abattoir, hoping to buy substandard meat,
1923. (Ullstein)*

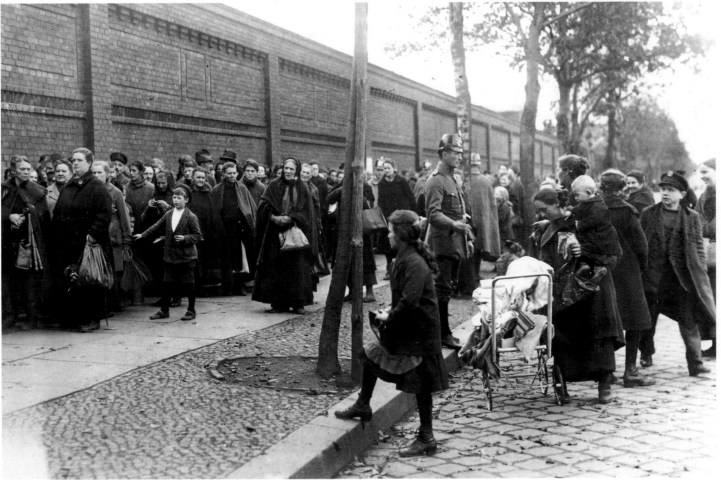

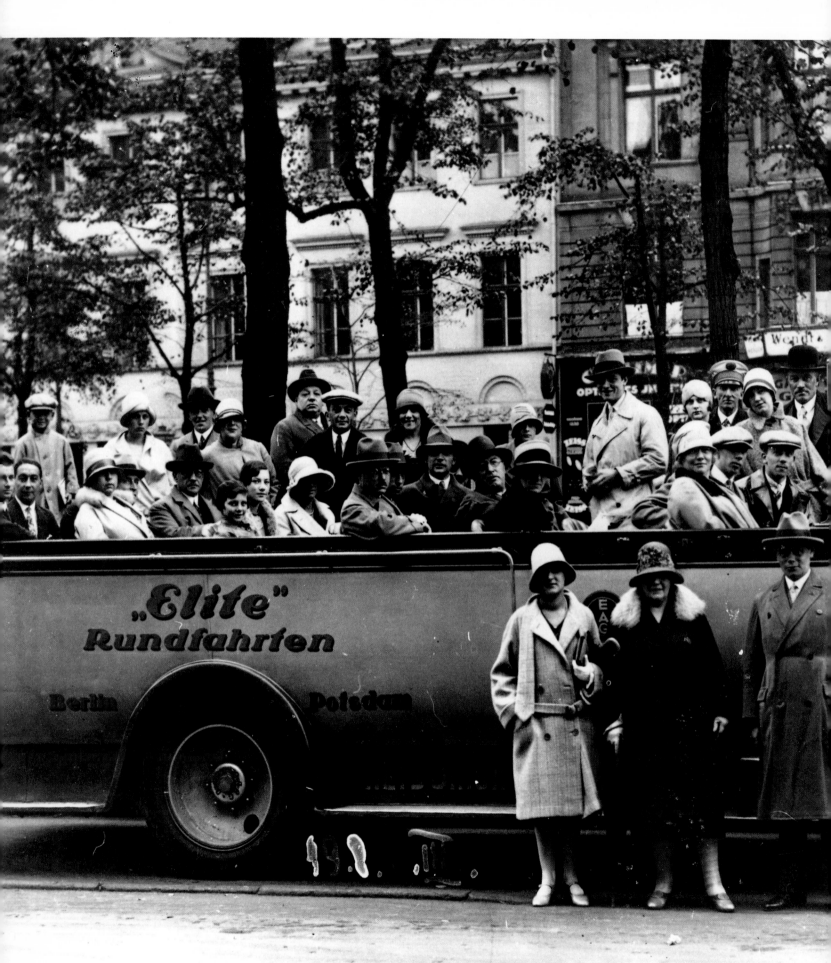

A Tour of
the City

ATTEMPTS TO MAKE BERLIN out to be a 'beautiful city' either historically or aesthetically have always failed. Berlin has its own ahistorical beauty and its own idiosyncratic quality.

ADOLF BEHNE, 1928

During the 1920s and 1930s, some half dozen firms ran daily tours of Berlin, conveying hundreds of tourists round the city in remarkably elongated charabancs, a cross between an outsize taxi and an ordinary omnibus, which, when the weather was fine, were open-topped. These tours lasted around two to three hours and included those parts of Berlin reckoned among the city's 'sights'.

As a rule they began in Unter den Linden, where three dozen or so expectant tourists would be given a potted introduction to Berlin, which might have run as follows:

> The capital of the German Reich and Prussia's principal city, Berlin is situated at the heart of the Mark of Brandenburg, straddling both banks of the navigable Spree, which flows through the city from southeast to northwest. It lies in a flat, sandy plain between 110 and 160 feet above sea level, the highest elevation being the Kreuzberg to the south of the city centre, which rises to a height of 100 feet above the level of the River Spree. A new municipality was formed on 1 October 1920 and is governed by a city council comprising 225 representatives who, since the 1918 Revolution, have been elected on the basis of universal suffrage. In turn, this council elects a governing body made up of a mayor, a deputy mayor and thirty councillors, ten of whom are unpaid. The municipality is divided into twenty administrative districts. According to the census of 1931, the population of Berlin is currently 4,288,700, making it the third largest city in the world after New York City (8 million) and Greater London (7.5 million). More than three quarters of the population are Protestant, while 11 per cent are Catholic and 4 per cent are of the Jewish faith. According to information supplied by the Office of Statistics in 1931, the city covers an area of 341 square miles. In terms of its geographical size, therefore,

Previous page: 'Elite' tours of Berlin set off from the central reservation opposite 44 Unter den Linden. In addition to the regular tours of the city (which cost four marks a person in 1932), there were also night tours, taking in 'places of entertainment', and day excursions to Potsdam, Wittenberg and the Spreewald forest. This photograph dates from 1930. (BPK)

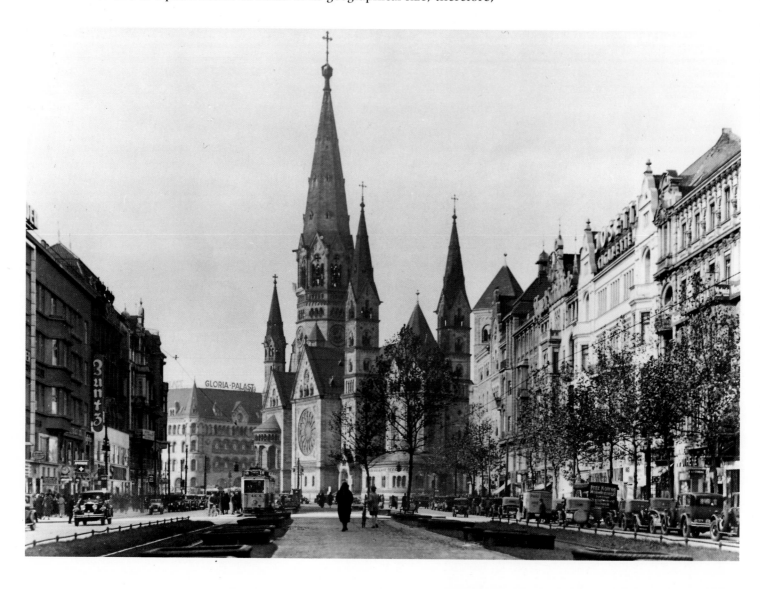

Berlin is the largest city in the world. A sprightly pedestrian, walking ten hours every day, would take five days to circumambulate the 145 miles or so of Berlin's municipal boundary.

By this date at least, visitors to Berlin must have looked on a ride in the monster limousine as welcome relief from seeing the sights on foot. As they climbed aboard, their guide might have tossed a few more statistics at them:

Only 17 per cent of the city is built up, 16 per cent being given over to agriculture, while almost 19 per cent is woodland, with the remainder divided among streets, squares, parks, cemeteries, railway sidings and areas of water. Berlin is the centre of the north German railway network and the most important railway junction in central Europe. In 1930 some 16 million people used its main-line stations. Of the 18 million tons of freight that passed through the city's goods depots in 1924, 13 million tons were imports, while exports accounted for the rest. The Spree, the Havel and adjoining canals are all navigable and provide direct links with Prague, Breslau, Danzig, Stettin, Lübeck and Hamburg. And, thanks to its excellent situation, Berlin's Tempelhof Airport is of central importance for the country's air traffic as a whole, 48,731 passengers having passed through its terminal in 1930 alone.

If the tour had gone according to plan, it would by now have reached Potsdamer Platz, where visitors to the city could see living proof of the astronomical figures with which they had been regaled. Even before they set foot in the city, most would no doubt have heard that Potsdamer Platz was Europe's busiest square, a statistic that brought a smile to the lips of the satirist Kurt Tucholsky, who, having lived in Paris since 1924, was able to draw more cosmopolitan comparisons. Indeed, the Office of Statistics had had to issue a disclaimer, admitting that, in recent years, traffic censuses had shown beyond doubt that Auguste-Viktoria-Platz by the Kaiser Wilhelm Memorial Church and even Pariser Platz at the Brandenburg Gate had overtaken Potsdamer Platz as the city's busiest squares, but by 1930 the latter had long since acquired mythical status, and myths are far too tenacious ever to be dismissed simply by quoting statistics. At all events, Potsdamer Platz epitomized modern Berlin for most of the city's tourists: it was this, after all, they had come to see. If – to repeat Karl Scheffler's remark of 1910 – Berlin was condemned to a state of eternal becoming, at least changes since 1900 had turned it into a national, and, after 1918, into an increasingly international tourist mecca. In the course of 1930 alone no fewer than one and a half million visitors registered with the police (as they were legally required to do), and of these more than a quarter of a million were foreigners. It was something of a tradition that at least some of the male visitors came to Berlin to enjoy the city's nightlife. Before World War I the area around Friedrichstraße was always their first port of call, but many visitors came for other reasons than simply indulging their pleasures in metropolitan anonymity.

Although Berlin had been the German capital since 1871, it was only at a later date that the city really developed into the focal point of the Reich, so that all kinds of interest groups, organizations and institutions made their headquarters there. In economic terms, its importance lay mainly in banking and broking – a banking quarter had already grown up around Behrenstraße well before the turn of the century. Its wholesale trade was largely devoted to foodstuffs (including tobacco), textiles, iron, chemicals, leather and grain.

The Kaiser Wilhelm Memorial Church, 1932. Not only was the traffic round the Memorial Church heavier than around the Potsdamer Platz, the square was also a genuinely international centre of modernism. The church itself, a neo-Romanesque building, was designed by Schwechten and dates from 1895. Situated in the middle of the Auguste-Viktoria-Platz, where six busy streets converged, it was partially destroyed during World War II and has been preserved in that state until the present day as a reminder of the destruction of war. (LBS)

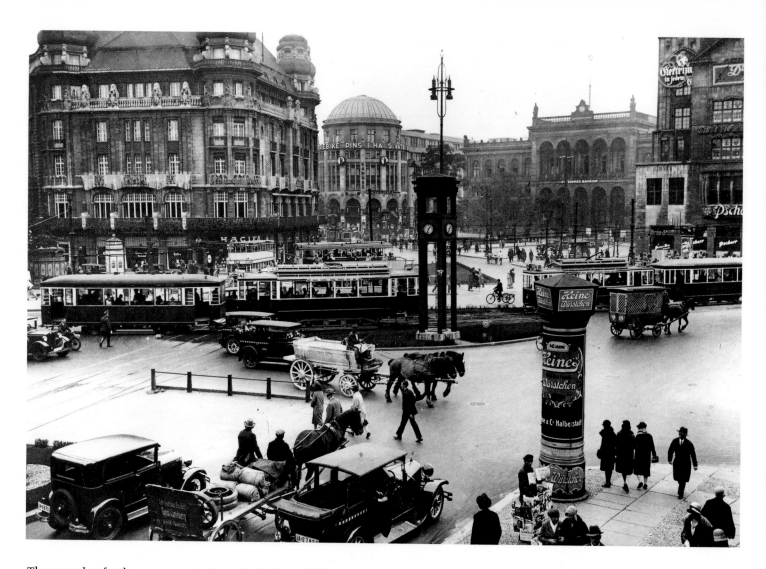

Potsdamer Platz in 1930, seen from the north. The buildings on the far side of the square are, from left to right, the Fürstenhof Hotel, the Fatherland House, Potsdam Station and the Pschorr Building. (BPK/Carl Weinrother)

Thousands of sales representatives of all these different trades would converge on the city each morning by rail. In industry, too, the city held a leading position: in 1925, for example, Berlin could boast of over 137,000 industrial concerns employing more than a million workers. Light processing industries predominated, with the electrical industry in particular enjoying an international reputation. (Until 1890 mechanical engineering had been the principal local industry.) Metal-processing, the clothing trade and printing also played major roles and, although factories had moved to the edge of the city during the nineteenth century, their headquarters still remained in the centre. The heart of the clothing industry continued to beat in Hausvogteiplatz, while the legendary newspaper quarter went on expanding around the southern part of Friedrichstraße, especially around Kochstraße, where numerous printers and publishing houses were based. Last but not least were the chemical, optical and furniture factories. As for professionals, some 30.5 per cent were white-collar workers and civil servants in 1930, but the proportion of blue-collar workers remained around 46 per cent, in spite of the gradual growth of the service sector: Berlin was nothing if not an industrial city.

The metropolis's typical characteristics had been established between 1871 and 1900. The city and surrounding countryside can be divided into four recognizably different areas. The heart of Berlin was the city centre, with its concentration of administrative and economic organizations, including those related to the service industries. The more these organizations gravitated towards the centre, the greater the exodus from the inner city. However,

those parts of the city (and there were many) concerned with tourism and the entertainments industry were never wholly deserted, even in the evening.

Encircling the inner city was the Wilhelmine residential area, where the density of housing was often extremely high and the blocks of tenement buildings were interspersed with light and semi-light industry, together with outposts of city-based firms. This was particularly true of the elegant, but on the whole no longer quiet, Wilhelmine district of the 'New West End' around the Memorial Church and along the Kurfürstendamm. In many ways this part of the town, though still comparatively new, had overtaken the 'old' city centre during the 1920s. Thirdly there was a less densely built-up outer area with numerous suburbs that had once been independent towns and villages, together with the concentration of heavy industry and outdoor areas where Berliners could go to relax. And beyond that was the surrounding countryside, which, as part of Greater Berlin, included the city's commuter belt and satellite towns, extensive lakes and beaches and large areas given over to farming and woodland.

It would tax the time and patience of any tourist to be shown all this in the time available and it seems unlikely that visiting businessmen or sightseers on the city's tourist buses expected to be taken to see the dull and often dreary working-class districts, or the factory sites and residential areas where the middle classes and government officials lived. Not even the fashionable residential suburbs and modern housing developments located at the edge of the city would be included in their itinerary. Their tours would be confined to the area around the palace, to a few remaining picturesque corners of Old Berlin, to the city centre between Alexanderplatz and Potsdamer Platz and, during the second part of the tour, to the Old West End around the Tiergarten and the New West End, which stretched as far westward as Schloß Charlottenburg and, latterly, to the exhibition centre around the Radio Tower. A visit to the eastern half of the city remained the preserve of individual tourists with a taste for the exotic.

As far as the outward appearance of Berlin was concerned, visitors probably came to the city without excessive expectations. The 1927 Baedeker Guide warned prospective visitors not to expect too much, admitting that the city lacked the charm of older cities with their artful sense of organic growth. And in 1932 Grieben's *Guide to Berlin and Environs* expressed the same idea in equally guarded terms: 'When people talk of beautiful cities, they rarely mention Berlin. [...] The city's present appearance has been little affected by passing centuries, which have elsewhere brought forth works of art with almost squanderous lavishness.' Contemporaries of Frederick the Great had numbered Berlin among the fairest cities in Europe. A century later such a view would have given rise to general mirth; industrialization and, not least, the rise of the Reich and Wilhelmine rule had destroyed a structure which had once been relatively homogeneous. At best the city invited derision and irony, at worst it met with cold contempt. The French journalist Victor Tissot, for example, came to Berlin in 1875 and concluded that the city would never be a capital in the sense that Vienna, Paris or London were capitals. Visitors to Berlin, he noted, would leave after only twenty-four hours or else they would die of boredom.

Another fifty years later such a description of Berlin would have met with frank surprise. Whatever else could be said of the city in the 1920s, it could not be described as boring. Since its precipitate transformation into a cosmopolitan capital, Berlin had evoked a strange fascination that was independent of all that one might feel of its qualities as a city. In any event,

even those who, on the whole, felt only aversion to Berlin could not resist the city's mysterious aura even as late as the 1920s. The lack of unequivocal views on the city, even after 1918, is paralleled by an apparent absence of any uniform picture in the decade that followed. After all, there could scarcely be a clearer distinction between the Berlin of the early Weimar Republic and the post-inflationary city of the second half of the 1920s and early 1930s. More and more dissenting voices were raised in these years of post-war crisis: in his 1920 novel, *Der neunte November (The Ninth of November)*, the writer Bernhard Kellermann described Berlin as the ugliest city in the world, a pile of stones that stretched as far as the eye could see. 'Naked and filthy, the ugliest of all the great coquettes lies there in public view . . .' It is no wonder, of course, that so hideous a picture was drawn at precisely this time, in the early years of the Weimar Republic. The post-war years were a time of confusion, of fighting in the streets and economic collapse but also of boundless excess, of hedonistic delights and showy exhibitionism – and not only among those groups that gained from hyperinflation – so that the city seemed, as it were, to cast off the thin veneer of modern civilization. The impression it made not only on locals but visitors, too, was altogether apocalyptic. Andrey Bely, who, like tens of thousands of fellow Russians, lived for a time in Berlin, saw it as 'an organized, systematically realized nightmare' and, as if in confirmation, a local shopkeeper hung a sign in the window of his premises in the early 1920s, urging his fellow Berliners, 'Stop and think, you are dancing with Death'.

But the years of crisis were followed by years of consolidation and stabilization, that mythical 'Golden Age'. To judge from the eulogies heaped on the city after 1924, the bedlam that Berlin had been was swept away, allowing it to develop into a living and flourishing exemplary cosmopolitan capital. By 1929 the former diplomat and writer Harold Nicolson was able to write, in eloquent terms, of 'the charm of Berlin', a charm he ascribed to its flexibility and openness. In 1931 the writer Paul Morand could still be impressed by republican Berlin, calling the city the New York of old-world Europe, while Jean Giraudoux exclaimed in delight: 'Berlin is no garden suburb, Berlin is itself a garden.' So quickly did the picture of the city change that one is tempted to ascribe this rapid transformation to the sudden improvement in the economic situation following the end of the period of hyperinflation. But to reduce the change to purely economic factors would be to oversimplify the issue. The brief period of economic growth came to an equally sudden end in 1929 with the onset of the international economic crisis, but Berlin continued for a number of years to maintain an air of modernity, open-mindedness and vitality from which the National Socialist regime was only too pleased to profit and which was soon to epitomize the Berlin of the 1920s.

The one-sided way in which the art and – in the widest sense – the culture of that decade were judged, not only by those who survived the 1920s, but also by those who were born too late to have known the 1920s at first hand, has made it almost impossible to offer a full and adequate account of the actual history of Berlin during the years of the Weimar Republic. The situation was far too complex for any partial view to be valid. A further problem that lies in the way of a proper understanding of this period stems from the fact that, as the twentieth century took its course, political and other developments on a national level grew to be more or less synonymous with the history of Berlin or overlaid it to the extent that national and local factors are no longer easy to disentangle. Thus, for example, the most important

A village smithy in Platanenstrasse in Reinickendorf one of the rural communities surrounding Berlin. (LBS)

event in the city's history, together with its consequences, has always tended to be overshadowed by the Revolution and the Kapp Putsch, by film and theatre premières, by Albert Einstein and Marlene Dietrich, by the paramilitary parades of the NSDAP and by the crash on the stock exchange.

The event in question is the 'Formation of a New Municipality of Berlin', as the law was called which was passed by the Prussian Constituent Assembly on 27 April 1920. Although the measure had the support of the Social Democratic Party, the Independent Social Democratic Party and a part of the liberal German Democratic Party, it was passed by only a small majority as a result of opposition from the centre and right-wing parties and finally came into force on 1 October 1920. After years of querulous, petty debates, to say nothing of the tenacious defence of ancient privilege, the Revolution had opened up the way for a thorough-going restructuring of the whole of the city's local government, an act of reorganization which had, it must be conceded, already been anticipated by a great deal of preliminary work in the preceding period. The 'old' city of Berlin was merged with seven independent towns (Charlottenburg, Köpenick, Lichtenberg, Neukölln, Schöneberg, Spandau and Wilmersdorf), fifty-two rural communities (from Adlershof to Zehlendorf) and twenty-seven landed estates (from Dahlem to Wuhlheide) to form the new municipality of Greater Berlin, the boundaries of which have largely remained unchanged to the present day. In addition to a single administration and the resultant increase in efficiency (although a seemingly unspectacular outcome on the reform, it had an immense effect on the whole of the Berlin region and its complicated infrastructure), the chief advantage of the merger was a fairer system of taxation and hence the possibility of socially fairer local government policies on the part of the new and unified authority. Some of the former districts like Charlottenburg that had been autonomous until 1920 and were among the richest towns in Germany, were able, thanks to their high tax revenues, to spend lavishly,

indifferent to the fact that they owed their income to the high salaries enjoyed by members of the middle classes who earned their money in what was effectively already Greater Berlin. However, areas to the east, south and north of the city, predominantly inhabited by poorer sections of the community, had far less money at their disposal, resulting in an increasing disproportion in the growth of socially differently structured communities. All these injustices and absurdities could now be swept aside in favour of a more sensible and forward-looking local government policy.

It has to be said, however, that the 'new municipality' was brought into existence at the worst possible time from the point of view of the city's finances. Indeed, the first important action of the newly created municipal authority, following the appointment of a new mayor, Gustav Böß, in 1921, was to take preventative measures to ensure that the city did not go bankrupt and that the fight against inflation was not lost even before it had started. Böß had been city treasurer since 1912 and, as such, was in the best position to meet this difficult challenge. It was also at this time that the city authorities introduced an even more important measure whose beneficial effects can still be felt today and which involved not only the implementation of a programme of measures designed to replace and improve the city's infrastructure but also the adoption of an active and forward-looking social policy. The main result of this powerful show of strength on the part of the city administration was an impressive move towards modernization, which took place against a background of strained finances and constant social deprivation. It was in 1923, when inflation was at its height, that the Western Docks were opened in Berlin: by turning the city into the second largest river port in Germany, they proved extremely important in supplying the city's needs. Also in 1923 a start was made on the central airport at Tempelhof, which was built on the site of a former parade ground.

The authorities, in the meantime, were systematically developing Berlin's position as a conference and exhibition centre, staging pioneering events such as the Great German Radio Exhibition, first held in 1924, and the agricultural exhibition, 'Grüne Woche' ('Green Weeks'), first held in 1926. The exhibition halls which were built for these occasions set new international standards, as did the Klingenberg power plant, built in 1926/7, which, as the city proudly boasted, was the largest in the whole of Europe and the most modern in the world. The Radio Tower began operations in 1926 and soon became a symbol of Berlin, indicative of its progressive position in the growth of modern media technology. In addition the city authorities took control of the rest of the local transport system, which they continued to expand and modernize, embarking on a programme of technological innovation that found a worthy counterpart in the housing programme which, supported by the city, was run by charitable housing trusts. Berlin was traditionally a city of tenants, though no less traditional was its housing shortage, the war and its critical aftermath having done little to solve existing problems. Not until the mid-1920s could new homes be built in any appreciable numbers and yet, in spite of all the enormous efforts that were made, it never proved feasible, even in times of relative economic stability, to reduce the gap between what was possible and what was needed. Only in 1930, when almost 44,000 homes were built, were the figures more or less satisfactory. By the following year, by contrast, the economic crisis had already deepened, causing a sudden slowdown in the building programme. It is noteworthy, nonetheless, that far more homes were built between 1926 and 1932 than in a similar seven-year period from 1933, when the National

The opening of the new Western Docks in 1923 by the mayor, Gustav Böß. With this new development, Berlin became the second most important river port in Germany. (Landesarchiv Berlin)

Socialists came to power. Not only was there quantity, there was also architectural quality, especially in the major housing estates which, after 1924, were largely built at the edge of the city. Mention should also be made in this context of the many sports grounds, recreational facilities and parks that were developed or newly built during the period under review. Between 1920 and 1930 the area used for sports and games in Berlin tripled in size and the city's stone-grey façade was broken up by several areas of green such as the Rehberge Gardens opened in 1929 in the working-class quarter of Wedding. If Berlin had become a modern capital by around 1930, the credit must go, at least in part, to the forward-looking policies adopted by the local authorities.

Of the many architects who helped the International Modern Style achieve a breakthrough in Berlin, not only designing major new estates, including numerous modern houses, offices, shops and factories, but also ensuring that 1920s Berlin became the uncontested centre of all the most progressive developments in contemporary architecture, there is space here to mention only Martin Wagner. Appointed head of the city's planning department in November 1926, he played a decisive role in developing the conference and exhibition centre and in building not only the lakeside resort at Wannsee but also the Lindenhof estate and the horseshoe-shaped estate at Britz. Like many of those architects whose buildings ensured that 'New Berlin' had gradually taken on its characteristic outline, he was forced to leave the country when the Nazis came to power. One of the people who drove him into exile was a man who, completely unnoticed by the press, had moved to Berlin the very month that Wagner's appointment as planning officer was being reported in banner headlines, a man who took over as leader of a political party which, here as elsewhere, was still so small as to be insignificant and who felt only hatred for all that the 'New Berlin' of the 1920s embodied. He took the title of '*Gauleiter*' (District Leader) and his name was Joseph Goebbels.

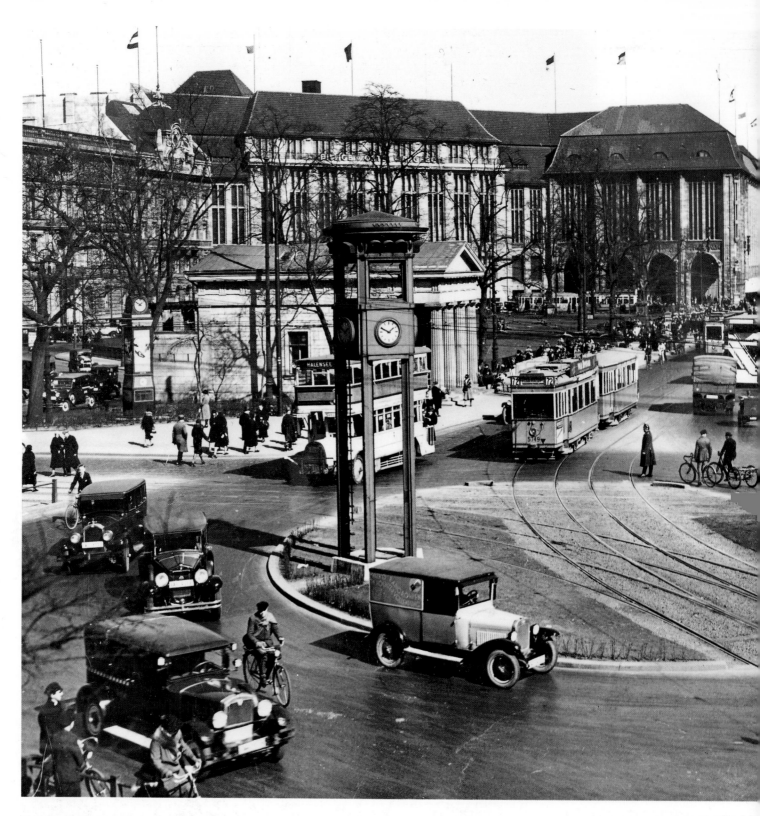

Potsdamer Platz and Leipziger Platz in
1926. The traffic tower was designed by
Jean Krämer, the chief architect of the
Berlin Tramway Company and a pupil of
Peter Behrens. It was completed in
February 1925 and quickly became a
symbol of 1920s Berlin. (BPK)

With the emergence of Friedrichstadt as the city's government quarter, Potsdamer Platz and Leipziger Platz began to play an increasingly important role as a traffic junction linking the old city centre with the old West End to the south of the Tiergarten. At a later date they came to fulfil a similar function for the new West End and for those suburbs in the southwest to which the wealthier members of the middle classes had gradually migrated from the inner city. Their position between the Tiergarten in the north and railway sidings in the east meant that traffic coming from the west and southwest was forced through the narrow defile formed by the two adjoining squares. The numerous trams and buses which crossed them, together with the luxury hotels and buildings associated with the entertainments and service industries which flanked their edges, gave them that air of urbanity which distinguished them from the city's other squares.

The northern side of Potsdamer Platz, with the Columbus Building, completed in 1932 to designs by Erich Mendelsohn, facing the Palace Hotel, which dates from 1893. Between them is Friedrich-Ebert-Straße, leading to the Brandenburg Gate. (LBS)

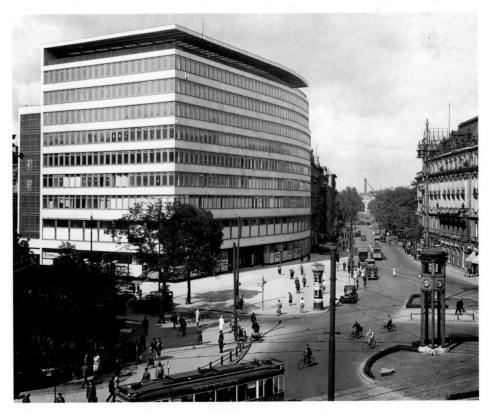

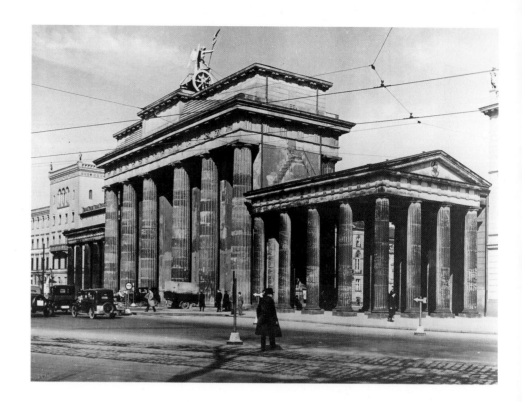

Built between 1788 and 1791 to a design by Carl Gotthard Langhans, the Brandenburg Gate has always been the city's best-known symbol. It is based on the Propylaeum in Athens and surmounted by Johann Gottfried Schadow's quadriga, added in 1794, and, as such, was the first major work by the Berlin school of architecture to be built in conscious imitation of Greek antiquity. This photograph was taken from the southwest in 1930 and shows the gate with the two open hypostyle halls added in 1868 after the city wall was demolished. (BPK)

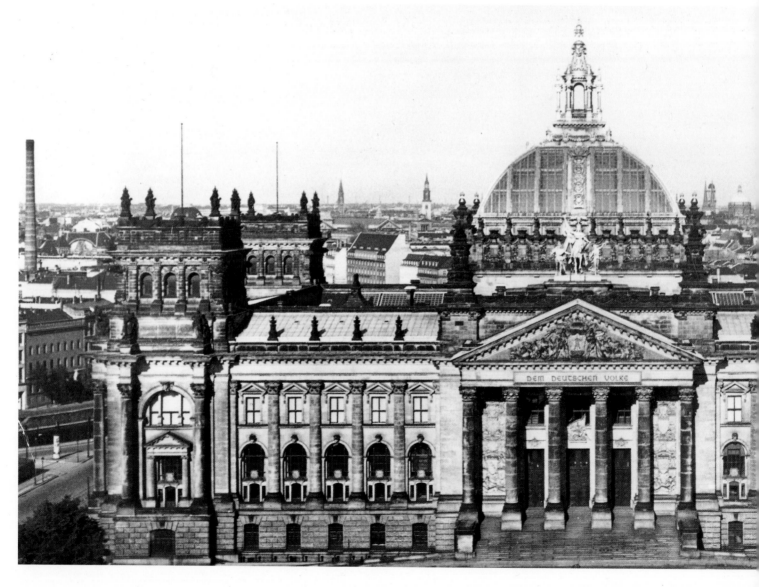

View of the Reichstag from the Victory Column, 1929. The Reichstag was designed by Paul Wallot and dates from 1884–94. The 1927 Baedeker Guide notes that it was distinguished by its 'idiosyncratic handling of the architectonic masses, its lively decoration and the functional arrangement of its floor plan'. Above the main entrance is an inscription, 'To the German Nation', which – significantly – was not added until 1916. (BPK/H. Hoeffke)

View of the Victory Column and Kroll Opera House from the East, c. 1933. The Victory Column was designed by Strack as a monument to the wars of 1864, 1866 and 1870/71, and built between 1869 and 1873. In 1938 it was removed to the 'Great Star' in the Tiergarten. The Kroll had originally been a theatre but its repertory gradually expanded to include opera, and from 1927 to July 1931 it housed the 'Staatsoper (State Opera) am Platz der Republik' under the direction of Otto Klemperer. (LBS)

Opposite: A leafy residential street in the Tiergarten district, on the corner of Alsenstrasse and Fürst-Bismarck Strasse, c. 1933. (LBS)

View of the Shell Building on the Königin-Augusta-Straße on the Landwehrkanal, 1932. Designed by Emil Fahrenkamp, the Shell Building dates from 1930/31 and is still considered one of the most successful office buildings of the International Modern Style (LBS)

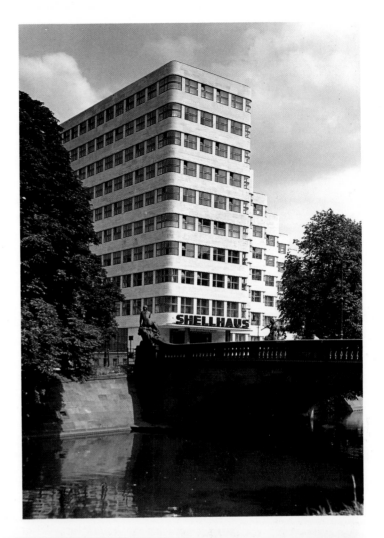

The 'Kaufhaus des Westens' known as Kadewe (Department Store of the West) in Tauentzienstrasse, c. 1925. The building of Kadewe in 1906–7 (from a design by Schaudt) marked the real beginnings of the New West End, which ran west of Nollendorfplatz and whose centre stretched from Kadewe along Tauentzienstrasse and Kurfürstendamm.

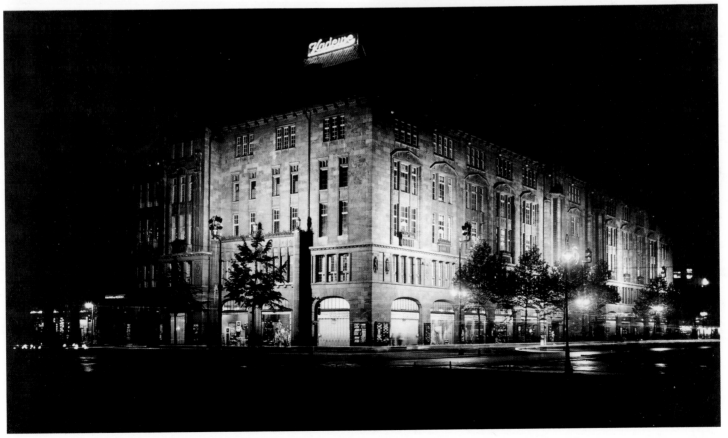

'IN RECENT YEARS KURFÜRSTENDAMM has increasingly lost its character as a purely residential street, although this is not due only to the new shops but also the impressively large number of restaurants, cafés, cinemas and theatres. The transformation is a result of different degrees of rebuilding and conversion, usually of the façade. (The Berliners have coined the term ''ground-floor architecture'' to describe these modernizations which, in many cases, affected only the ground floor of the buildings.) For the most part, the shop windows are the height of elegance itself. The most precious silks are draped over the mannequins' outstretched arms – women of flawless stature, with impeccably coiffured hair and exceptionally well-manicured hands – while passers-by admire hats which are this season's most elegant fashion but which, by next season, will already have a hint of absurdity to them. Elsewhere, magnificent limousines sparkle and flash behind vast plate-glass windows. Crowds of people surge to and fro along the street's broad pavements, especially during the afternoon and evening, while the section between the Memorial Church and Uhlandstraße is perhaps the busiest of all' (*Grieben's Guide to Berlin and Environs*, 68th edition, Berlin, 1932, p. 135)

The Uhlandeck Café on the corner of the Kurfürstendamm and Uhlandstraße (seen here c. 1930) is a typical example of the way in which the Kurfürstendamm was modernized: originally a private house dating from 1892, the premises were rebuilt inside and outside in 1929 and turned into a coffee house with Konditorei (confectioners), bar and dance floor. (BPK)

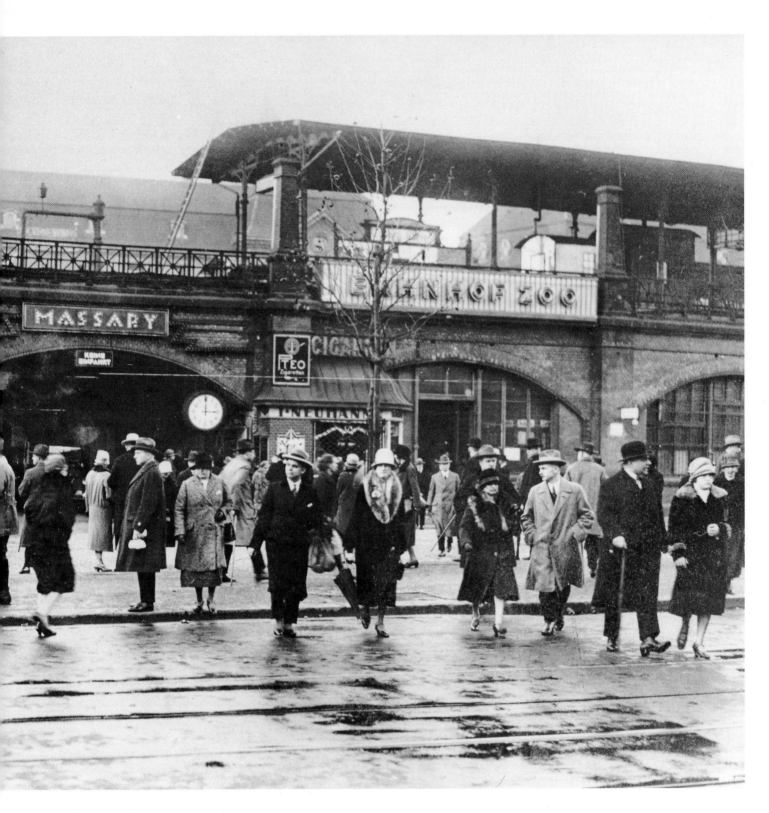

The Zoological Gardens Station (seen here in 1926) had the same significance for the new West End as the Friedrichstraße Station had for the city centre. Its clock was a favourite meeting place for Berliners. (ADN)

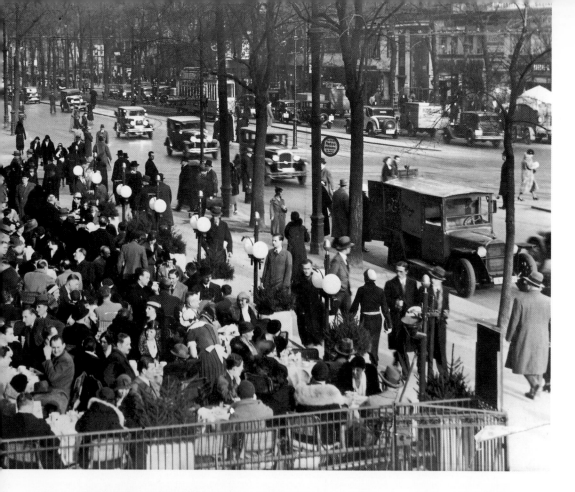

A typical pavement café on the Kurfürstendamm, c. 1930. (Ullstein)

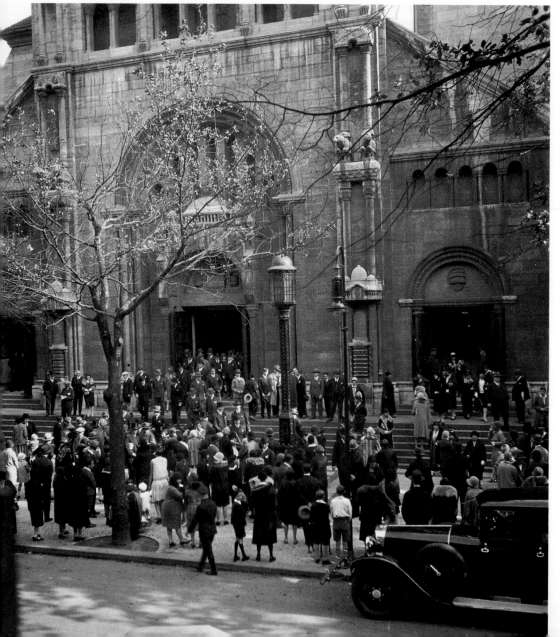

The synagogue in Fasanenstraße, following the end of a service, 1929. (BPK/Hans Casparius)

BERLIN'S NEW SYNAGOGUE opened in Oranienburger Straße in the heart of the city in 1866, but this monumental building in Fasanenstraße was the first Jewish place of worship in Berlin to be built neither in an inner courtyard nor behind some preexisting community building. The growing self-confidence of the Jewish population, especially of those in well-established social positions in the new West End, found expression in Ehrenfried Hessel's Fasanenstraße synagogue, which was consecrated in 1912. The rabbi Leo Baeck, a well-known theologist, often preached here. The building was attacked by Nazi rioters as early as 12 September 1931, when members of the local Storm Troopers organized a 'Kurfürstendamm pogrom'. It was later set on fire by a National Socialist commando during the night of 9/10 November 1938 and on that occasion was completely destroyed.

The linen firm of Grünfeld on the corner of the Kurfürstendamm and Joachimstaler Straße, c. 1930. Redesigned by Otto Firle in 1928, the building was one of the most architecturally and technologically advanced office buildings in Berlin, in contrast to which the firm's parent company in Leipziger Straße was made to seem distinctly backward – a symbol of the loss of importance suffered by the old city as compared with the new West End. (BG/Osram)

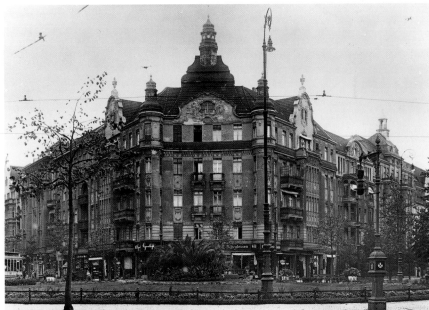

Prager Platz in the Wilmersdorf district, c. 1925. This was one of the settings of Erich Kästner's detective story for children, Emil and the Detectives. (LBS)

Kaiserplatz in the Wilmersdorf district, showing Kaiserallee (renamed Bundesallee) at its junction with Detmolder Straße, c. 1925. Prager Platz and Kaiserplatz are typical examples of the Wilhelminian architecture of this solidly middle-class district. (LBS)

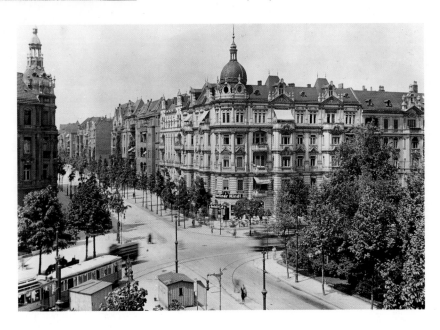

*The Cecilie Gardens in the Schöneberg
district, an early attempt to break away
from the traditional architectural style of
nineteenth-century Berlin and create
something less severe. This photograph
was taken from Sponholzstraße, c. 1925.
(LBS)*

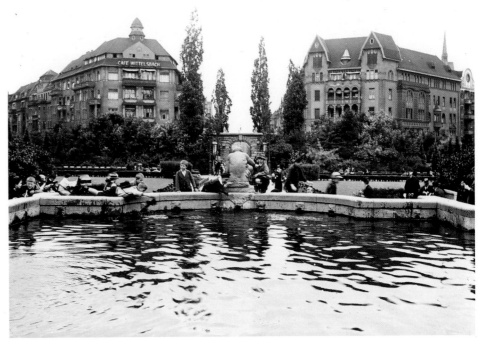

Bayerischer Platz at the heart of the Bayerisches Viertel (Bavarian Quarter), which, like Wilmersdorf, was a solid middle-class district built around the turn of the century, c. 1922. (LBS)

View of Schloßstraße and the Steglitz Town Hall, seen from the south, c. 1925. The Steglitz district had a high proportion of civil servants among its residential population. In the elections that were held here between 1930 and 1932, the Nazis' share of the vote was not only far higher than that in the rest of Berlin, it even exceeded the national average. (LBS)

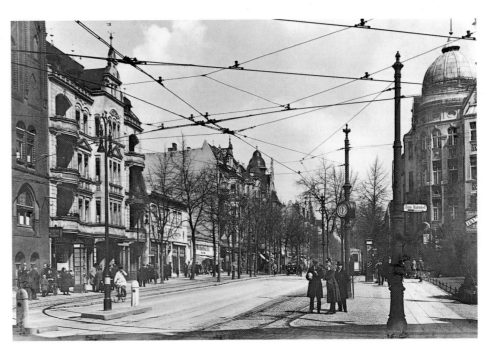

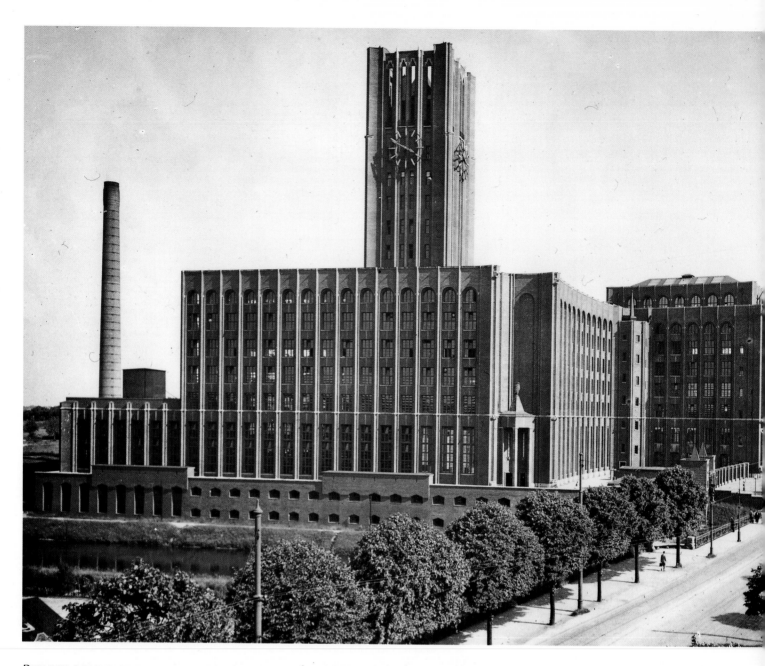

BERLIN'S ROLE IN THE AVANT-GARDE MOVEMENT after 1920 was perhaps nowhere more evident than in the field of architecture. Even before 1914 a number of Berlin-born architects such as Peter Behrens had already earned themselves an international reputation, but it was not until the 1920s that the city became the home of the International Modern movement. It is almost impossible to gain an overview of all the pioneering achievements in architecture at this time, such is the astonishing variety of their forms. In housing schemes and residential buildings, industrial sites, offices and business premises, cinemas and places of entertainment and, not least, in the municipal buildings of the city's infrastructure, countless examples of the work of Gropius, Häring, the Luckhardt brothers, Mendelsohn, Mies van der Rohe and the Taut brothers, to list only some of the most outstanding names, were to become lasting monuments to modern city architecture.

The Ullstein Printing House on the corner of Berliner Straße (now the Mariendorfer Damm) and Ullstein Straße, c. 1928. Designed by Eugen Schmohl and built in 1927, the Ullstein building was the 'cathedral' of Berlin's modern industrial buildings of the 1920s. (LBS)

Dr Sternefeld's villa in Heerstraße in the Charlottenburg district, c. 1925. Designed by Erich Mendelsohn, this was among the first flat-roofed villas in Berlin built using the new cube technique. (BPK)

Terraced houses in Schorlemer Allee in Berlin-Dahlem, c. 1930. Designed by Hans and Wassili Luckhardt and Alfons Anker, these houses, which are typical of the severe functionalism of 1920s' architecture, date from 1925. (AKG)

The Schlachtensee, the largest of a chain of lakes in the Grunewald forest, an area largely made up of pinewoods on gently undulating ground, 1926. (LBS)

A farm in Buckow, a small village at the southernmost edge of the working-class district of Neukölln, c. 1930. The village church can be seen in the background. A number of these idyllic villages survived within the city's municipal borders until well after World War II. (LBS)

Open countryside between Lübars and Schildow at the edge of Reinickendorf on the city's northern outskirts, c. 1930. (LBS)

'EVEN VISITORS WHO HAVE LITTLE TIME to spend on their way through Berlin must see the Radio Tower, a masterpiece of modern technology and the symbol of New Berlin. At 138 metres, it cannot, of course, compete with the Eiffel Tower, nor does it seek to do so. But what technological progress when compared by expert eyes with its Parisian rival! How light and efficient the present building seems by comparison! The topmost platform of the tower is reached by lift and affords a panoramic view of the surrounding area. And, as its name implies, the tower also has a more immediate purpose, namely, to support the antenna of the Berlin Radio Transmitter, which is attached to an anchor mast. At present Berlin has only this one transmitter, which operates on a wavelength of 484 metres at 4 kilowatt capacity.' (*Jeder einmal in Berlin*, Official Guide to Berlin and Environs, Berlin, c. 1928, pp. 93-4)

Designed by Hans Poelzig and built in blue-black clinker brick, the Broadcasting Centre in Masurenallee dates from 1930/31. Broadcasting was the most advanced medium of the day and was the first to be brought into line by the National Socialist regime in 1933, the date of this photograph. (BPK)

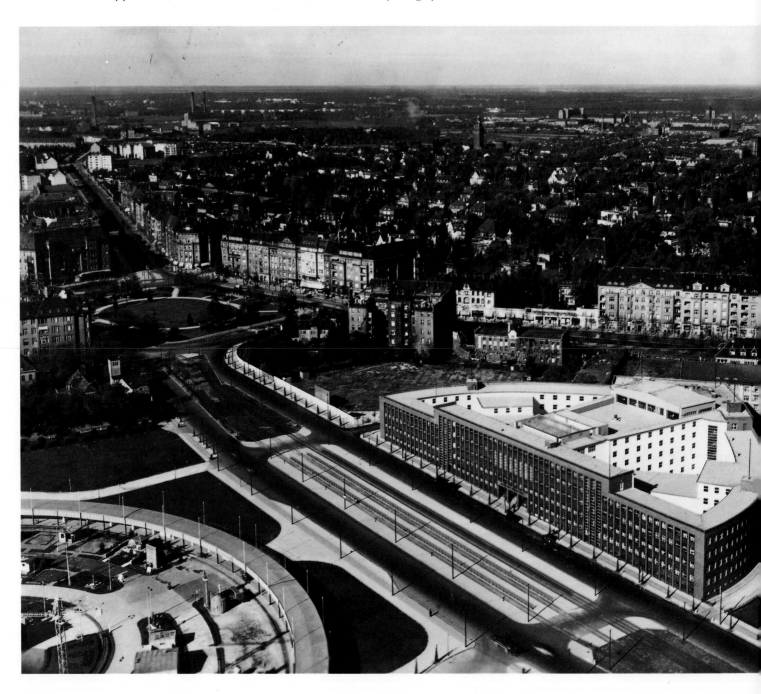

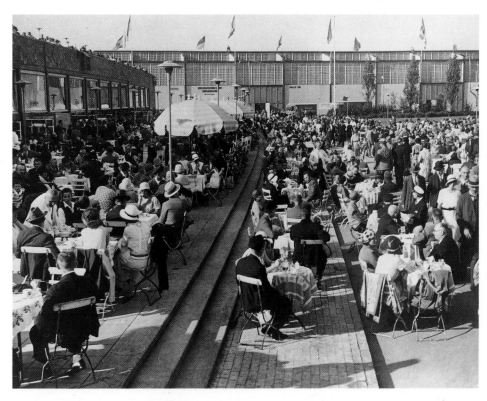

Right: The exhibition centre restaurant at the foot of the Radio Tower, c. 1927. (BPK)

The Berlin Radio Tower with broadcasting centre and open-air restaurant. Designed by Heinrich Straumer and built between 1924 and 1926, the tower became an instant favourite with the Berliners, who christened it 'Langer Lulatsch' or 'The Beanpole'. (BPK)

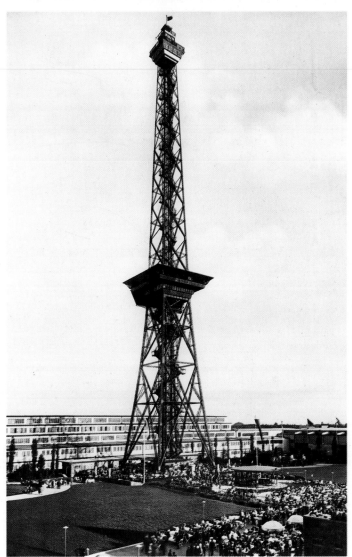

BERLIN'S POSITION AS A CENTRE FOR NATIONAL and international exhibitions and trade fairs was systematically built up from 1923 onwards. The main development was the exhibition centre on Masurenallee. By the early 1930s this site included the two earlier halls used for motor shows and a vast rectangle of six halls with the Radio Tower at their centre, amounting to 56,000 square metres, with a further 200,000 square metres of open space. Berlin's recipe for success was due in particular to its strategy of introducing specialized exhibitions and fairs such as the Radio Exhibition, the Agricultural Show and the Berlin Furniture Exhibition.

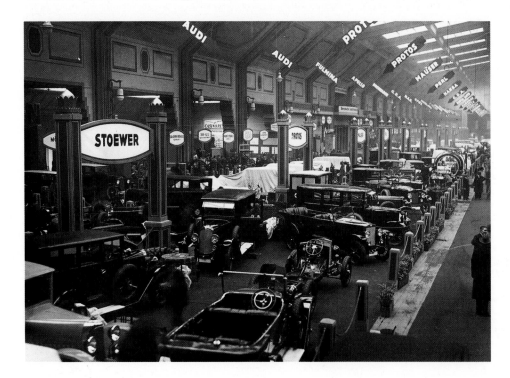

The 1925 Motor Show in Exhibition Hall 1. (LBS)

Opposite: An exhibition of women's fashions held in 1927 in the Broadcasting Studio on the Kaiserdamm, which was designed by Heinrich Straumer to house the 1924 Radio Exhibition. (AKG)

Below: The first two exhibition halls in the Königin-Elisabeth-Straße, c. 1930. The one on the right was built in 1914, while the one on the left dates from 1924. Both were used for motor shows. (LBS)

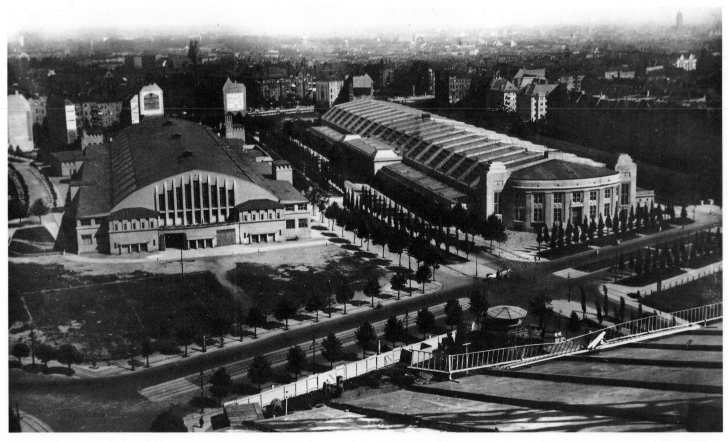

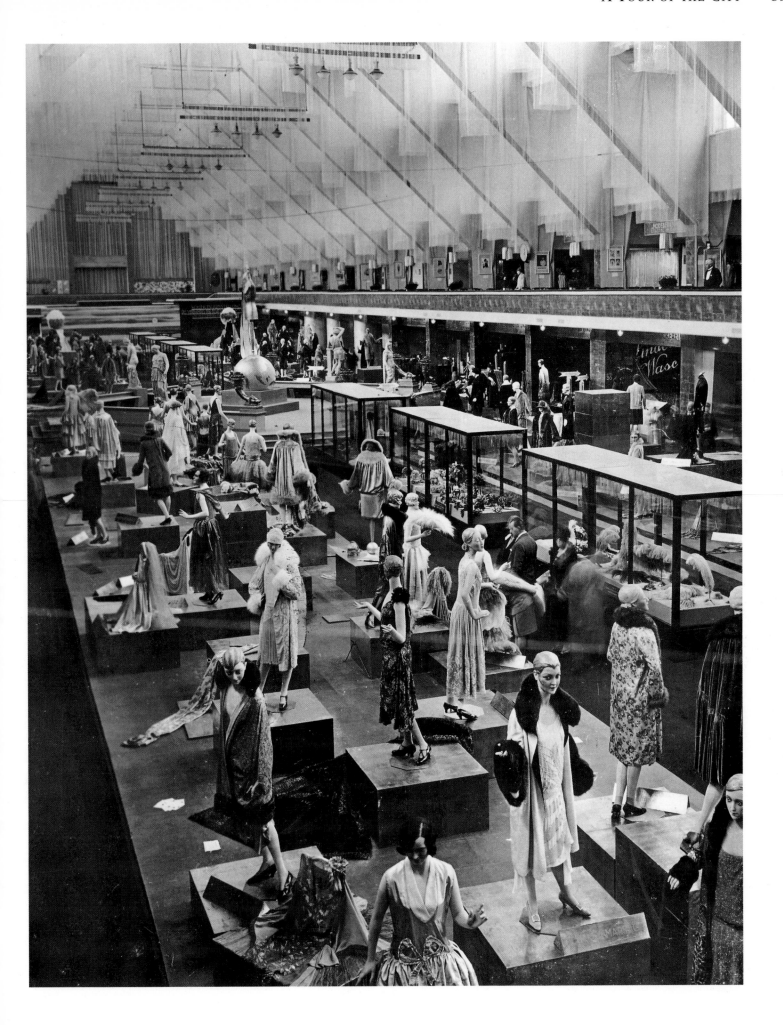

Below: The tower of the Borsig Works in Tegel, c. 1930. Designed by Eugen Schmohl and built in 1927, this multistorey administrative block is a late example of neo-Gothic Expressionism. (BPK)

Below right: An example of modern, if more conventional architecture in Elstaler Straße, part of a residential estate in the Spandau district, 1927. (LBS)

A view of the large-scale housing development at Siemensstadt, built between 1929 and 1931. The estate was a joint venture, designed by the architects Bartning, Forbat, Gropius, Häring, Henning and Scharoun, with engineering work by Mengeringhausen. It was built as a strict north-south ribbon development to ensure that the houses received the maximum amount of sun. (BPK)

Left: The corner of Potsdamer Straße and Ritterstraße in Spandau, 1921. As is clear from the photograph, a small-town atmosphere, far removed from the hectic pace of metropolitan life, was not confined to the outer edges of the city. (LBS)

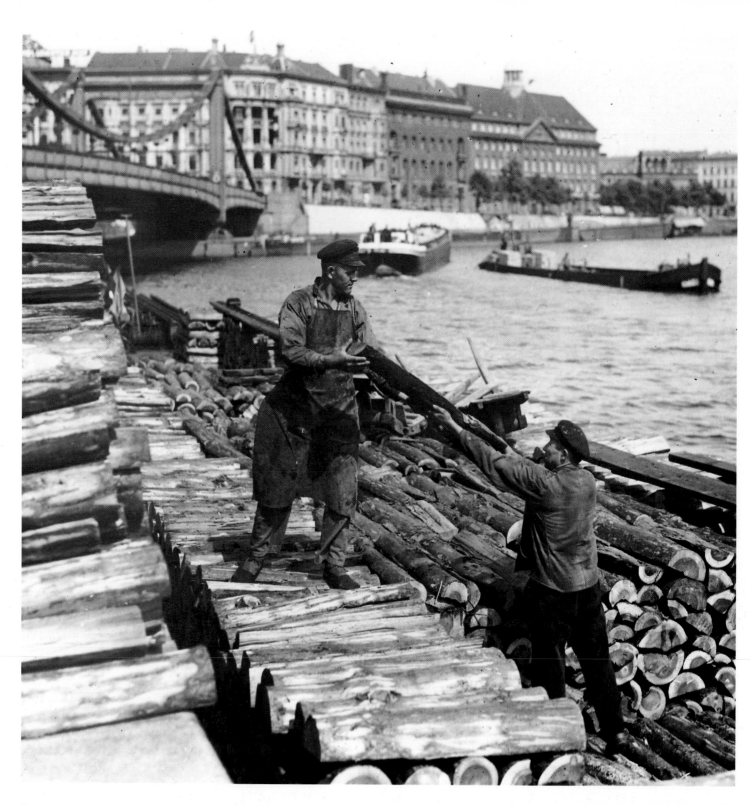

BERLIN HAD ALWAYS BEEN A HARBOUR TOWN, but by the mid-1920s, with the construction of huge docks, and especially of the Eastern and Western Docks, it had become the country's second largest river port after Duisburg. In addition to the docks, Berlin's waterways also had loading areas for transferring goods. The bulk of the goods traffic was traditionally made up of coal (almost 3 million tons in 1928), followed by soil, gravel, lime, clay, etc. (2.5 million tons) and stones and stoneware (1.6 million tons). From an architectural point of view, however, the Berliners rarely knew what to do with their river and canal banks: although the river and canals were much used, they were never integrated into the townscape.

Unloading a ship's cargo at Friedrich-Karl-Ufer on the Spree below Humboldt Dock, c. 1930. (LBS)

Opposite above: A dredger on the Landwehr Canal, c. 1922. The bridge in the background is the Herkulesbrücke, leading to Lützowplatz in the Tiergarten district. (AKG)

Opposite: The Friedrichsgracht between Inselbrücke and Roßstraßenbrücke in the centre of Berlin, c. 1920. (LBS)

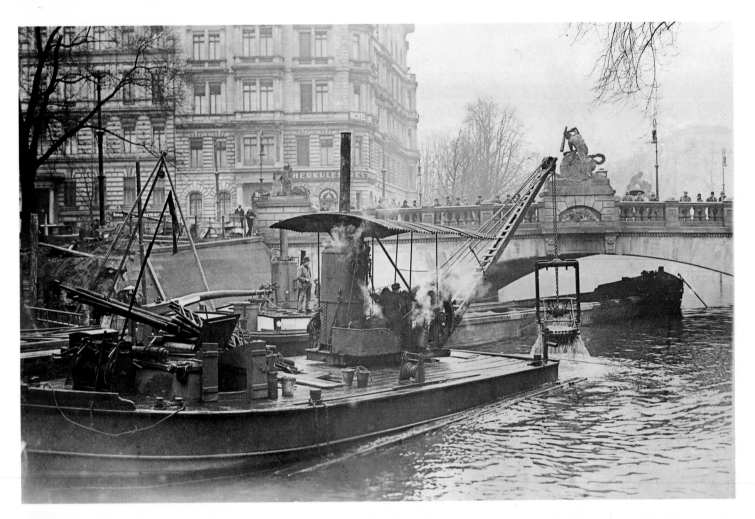

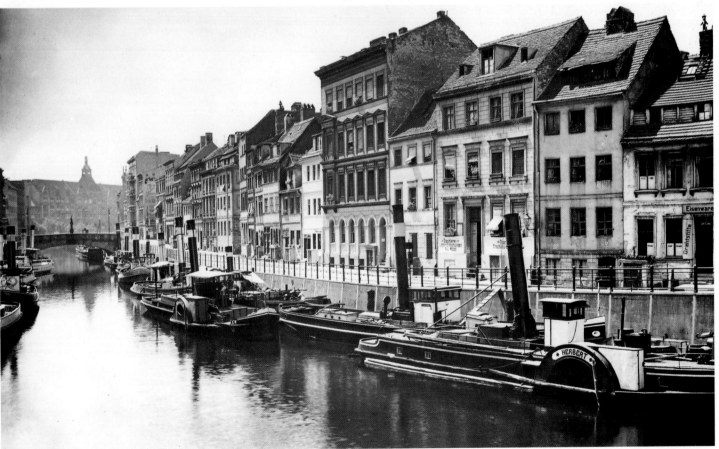

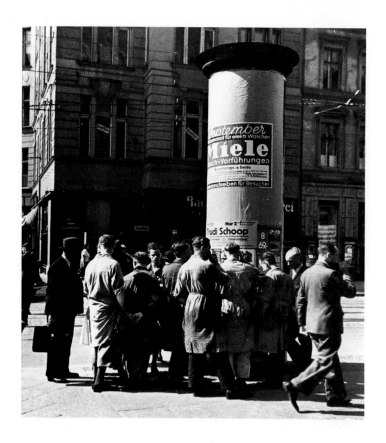

Osram employees reading a notice on an advertising column in the Wedding district, 1932. These columns are known in Germany as Litfaß columns after their inventor, Ernst Litfaß, who owned a printing works and who introduced these columns for posters and notices in July 1855. The photographer here was Friedrich Seidenstücker (1882–1966), one of the finest chroniclers of everyday life in Berlin during the final years of the Weimar Republic. (BPK/Friedrich Seidenstücker)

Opposite: Am Tempelhofer Berg, a street in the Kreuzberg district which, at the time of this photograph (c. 1925) had not yet been made up. (BPK/Friedrich Seidenstücker)

A typical roofscape looking over the workers' districts of the city, 1930 (BG/Fritz Brill)

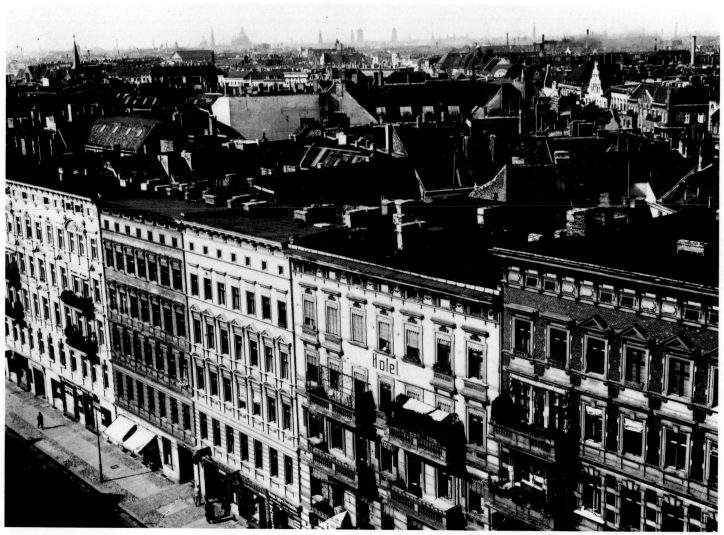

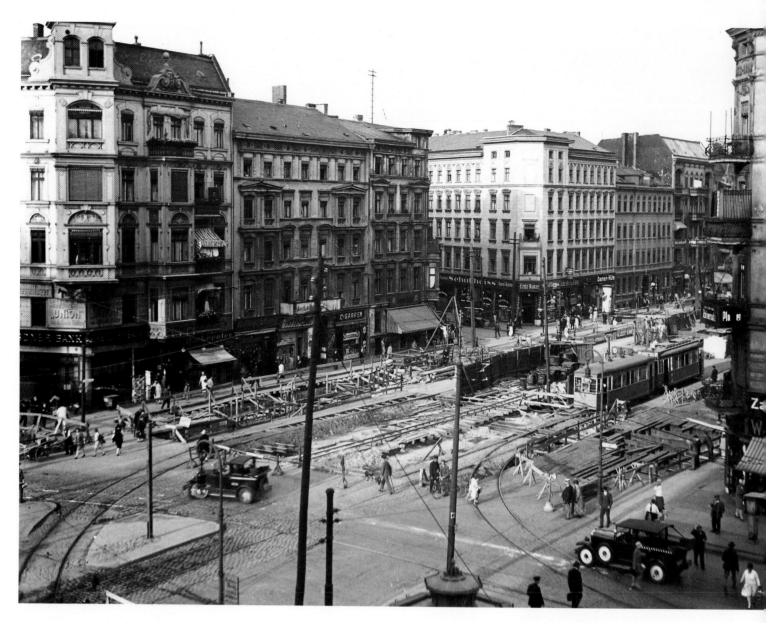

Construction site for the underground station at Friedrichsfelde-Alexanderplatz on the corner of Frankfurter Allee and Warschauer Straße, 1929. (LBS)

Opposite above: The 'Carl Legien' residential estate in the Prenzlauer Berg district, c. 1932. Designed by Bruno Taut and Franz Hillinger, it was built by the Gehag Housing Association in 1929/30. (LBS)

Opposite: The Rummelsburg power station, built in 1924–6 and later renamed the Klingenberg power station after its architect. In its day it was the most modern power station in Europe, with a capacity of 240,000 kilowatts and what, for the time, was state-of-the-art technology, with preheated air and coaldust firing. This photograph dates from c. 1930. (LBS)

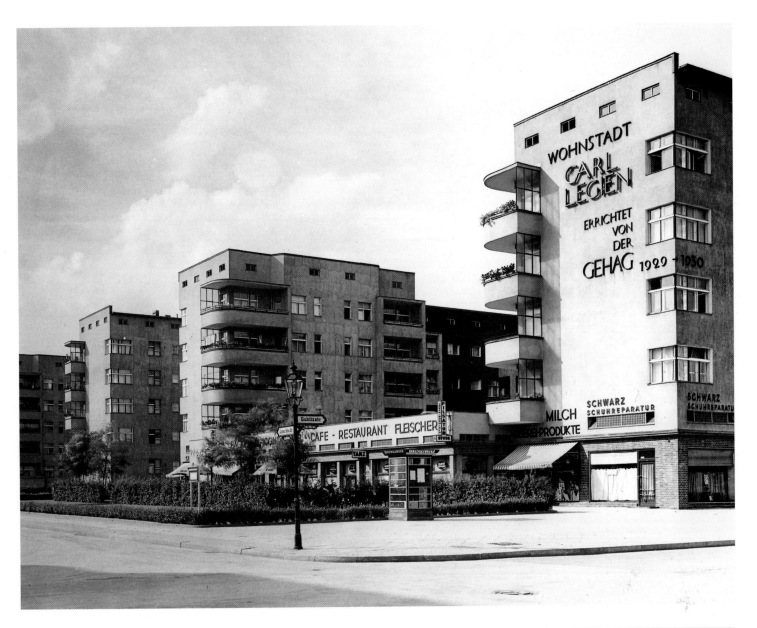

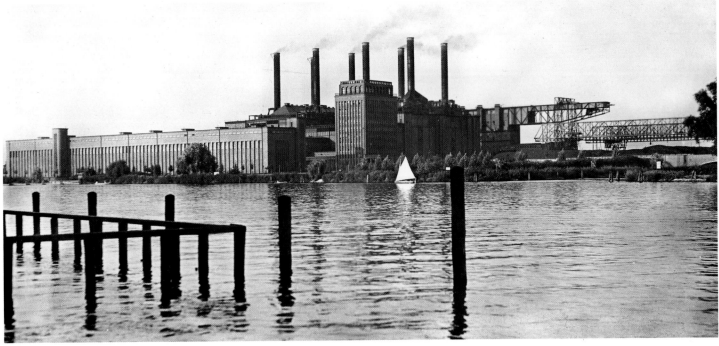

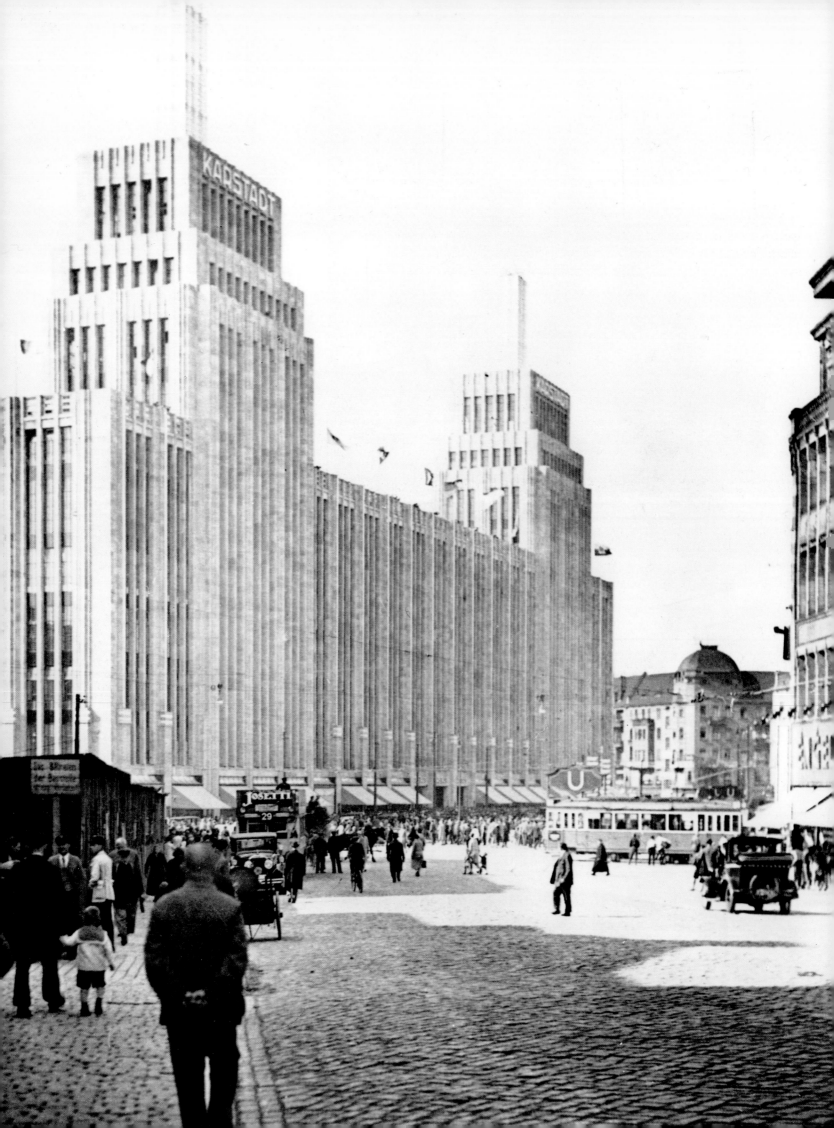

'WE HAVE ACHIEVED THE AMERICAN DREAM'; so ran a commentary in a contemporary architectural handbook on the biggest new department store in interwar Berlin. This vast building (340,000 cubic metres) was completed in just 15 months and opened its doors on 21 June 1929. The main structure with its seven storeys was 32 metres high, the towers added a further 4 storeys, reaching a height of 57 metres. Although this was comparatively modest against a US skyscraper, the architect Philipp Schaefer, who designed the building's reinforced concrete skeleton, could refer to the futuristic designs for Berlin skyscrapers of the early 1920s. The direct link into the underground station of Hermannplatz and the roof garden were particular attractions of the store. It was completely destroyed in World War II.

Opposite: The Karstadt department store on Hermannplatz in Neukölln, c. 1931. (BPK)

A hoarding on the side of a house, advertising beer. The roughcast fire-proof walls of Berlin's tenement blocks and factories were well calculated to catch the eye, not least of the thousands of commuters who travelled past them every day on the city's suburban trains. (BPK/Friedrich Seidenstücker)

THE LARGE RESIDENTIAL ESTATE AT BRITZ was generally known as the Horseshoe Settlement because the heart of the estate was laid out in the shape of a vast horseshoe round a large depression, with an artificial lake at its centre. The estate was built in seven separate stages between 1925 and 1933. For the first six stages the architect was Bruno Taut, who was assisted on the first stage of all by Martin Wagner. A total of 2317 houses were built, of which 679 were individual family houses; the rest were apartments. From a conceptual point of view, estates of this size were something completely new, intended, as they were, to achieve a new social

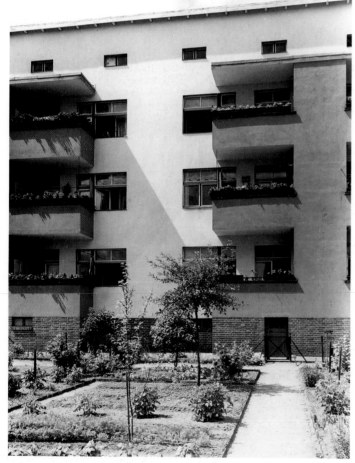

arrangement. In Taut's words, 'All the needs of the inhabitants' were to be 'organically structured' in the estate; its size, he argued, was necessary 'in order to regulate the relationships between community and individual'. For all the progress which these huge estates represented in terms of the city's housing shortage, the rents which were charged were beyond the means of ordinary working-class people.

The corner of Landsberger Straße and Kurze Straße in the immediate vicinity of Alexanderplatz, 1929. (LBS)

Alexanderplatz, in the city centre, at the time of its reconstruction, c. 1931. On the left is the former Königstadt Theatre, with the Wertheim department store and Red Town Hall behind it; on the right of the picture is Peter Behren's Berolina multistorey office block of 1930/31. (LBS)

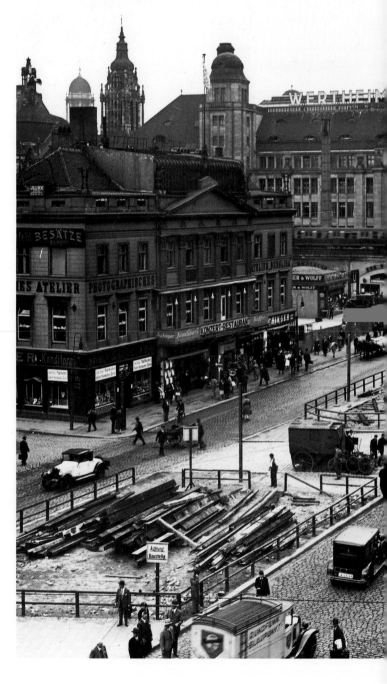

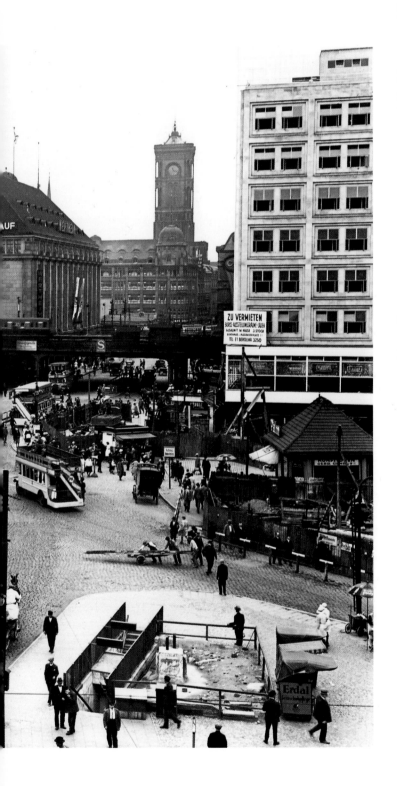

A view of Fischerstraße in the city centre, leading down to the Spree, with the Town Hall in the distance, 1928. Travel guides of the time spoke of the 'picturesque corners' of Fischerstraße and adjoining streets, all of which formed part of the oldest residential quarter of the city, the area of Alt-Kölln around the Kölln fish market. (LBS)

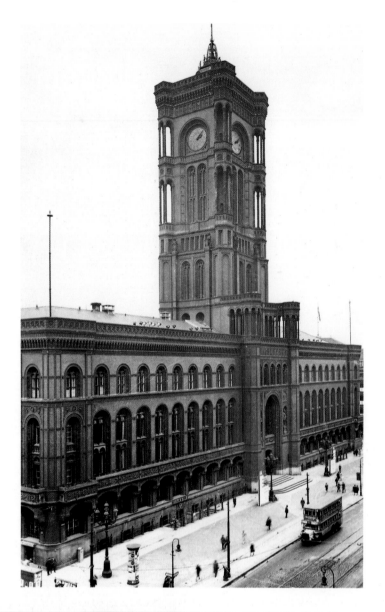

A tour round the oldest part of the city stops at the Jungfernbrücke, one of nine swingbridges on the branch of the Spree flowing through Alt-Kölln, the southwest part of the former twin towns from which Berlin was formed. (BPK)

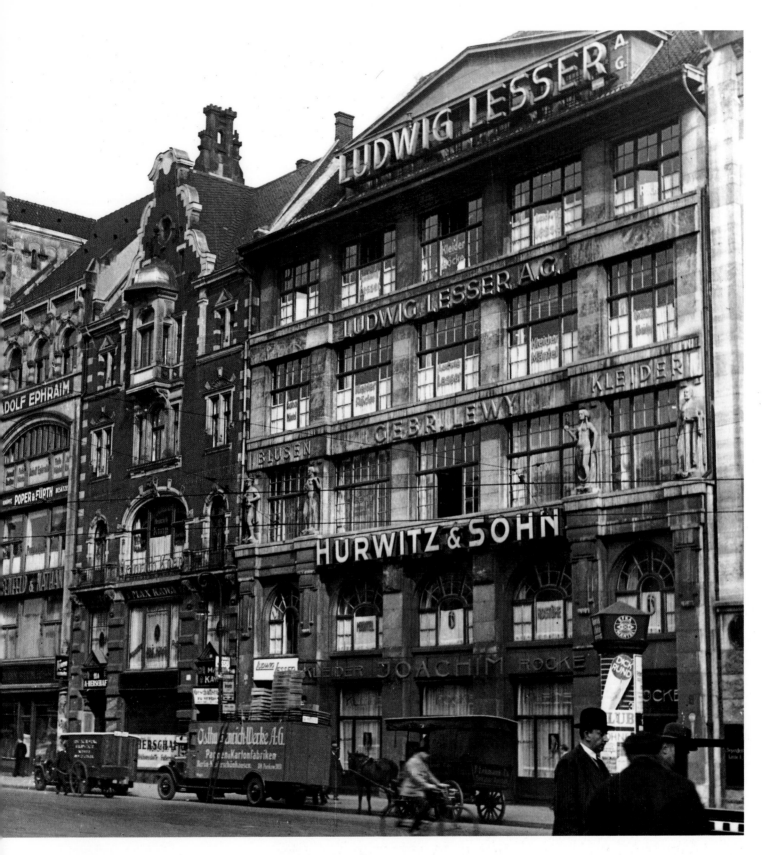

Hausvogtei Platz, in the east of Friedrichstadt near Leipziger Strasse, was the centre of the Berlin fashion trade, c. 1930. (LBS)

Opposite above: The 'Red' Town Hall in Konigstrasse, viewed from Hohen Steinweg, so called because of the terracotta decoration on the building designed by F. A. Wiesemann, 1861–69, c. 1930. (LBS)

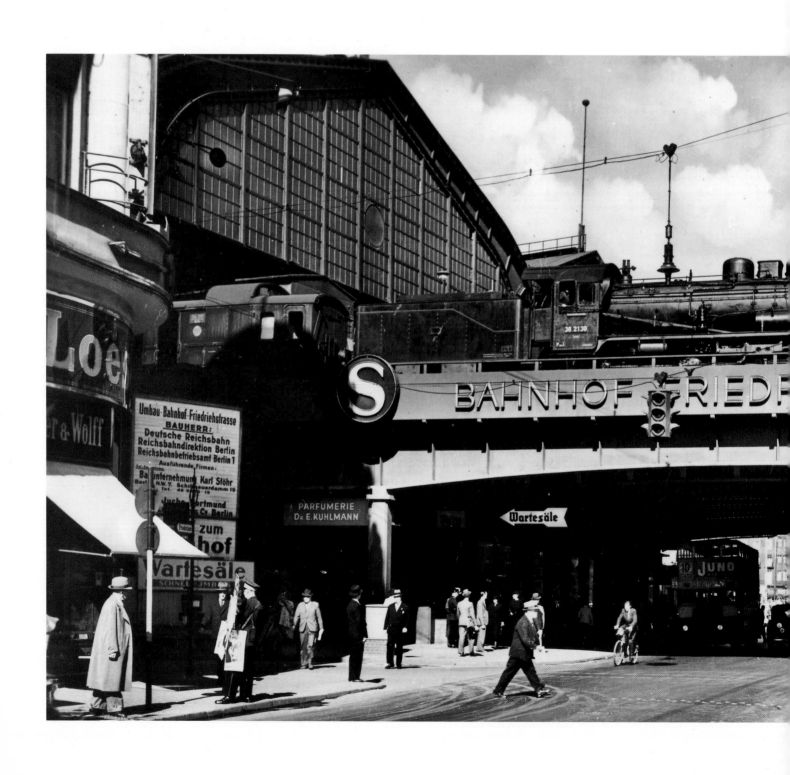

The junction of Unter den Linden Friedrichstraße, looking eastwards towards the Red Town Hall, c. 1926. In the centre of the picture is the departure-point for the 'Elite' tours of the city. (BPK)

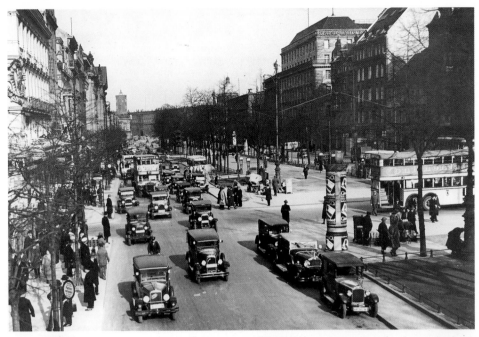

Friedrichstraße Station, the city centre's principal station and, in its day, the most modern mainline station in Berlin, c. 1930. (BPK)

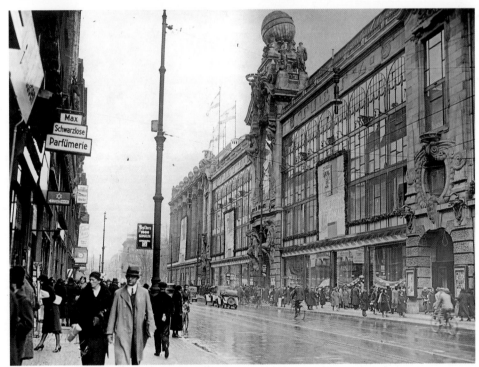

The main façade of the Hermann Tietz department store in Leipziger Straße on the corner of Dönhoffplatz, seen from the west, c. 1928. The original building dates from 1899/1900 and was designed by Lachmann & Zauber, with the frontages by Bernhard Sehring. An extension was added in 1912 to designs by Cremer & Wolffenstein. The store – which was 'Aryanized' as 'Hertie' by the National Socialists (and still trading so today) – was the antithesis of Wertheim's on the Leipziger Platz. (AKG)

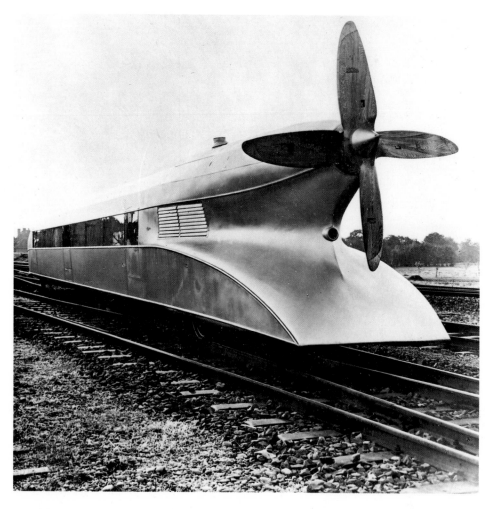

The 'Rail Zeppelin', a form of transport which caught the contemporary imagination, drawing crowds of curious onlookers to the railway track at Spandau where Franz Kruckenberg's invention clocked up a speed of 143 miles an hour on 21 June 1931. (LBS)

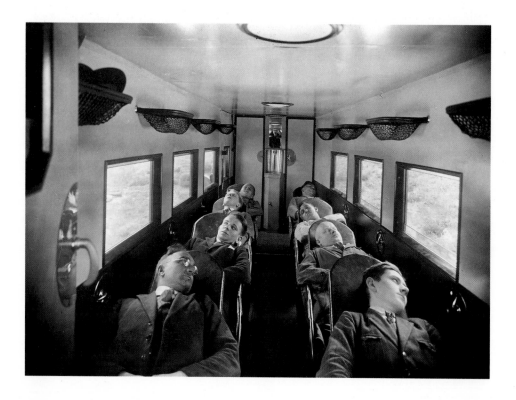

Interior shot of an Albatross L 73, or 'Flying Sleeper', which, in the mid-1920s, was among the most up-to-date aircraft in service. The photograph was taken in 1927 at Staaken Airport on the western edge of Berlin. (LBS)

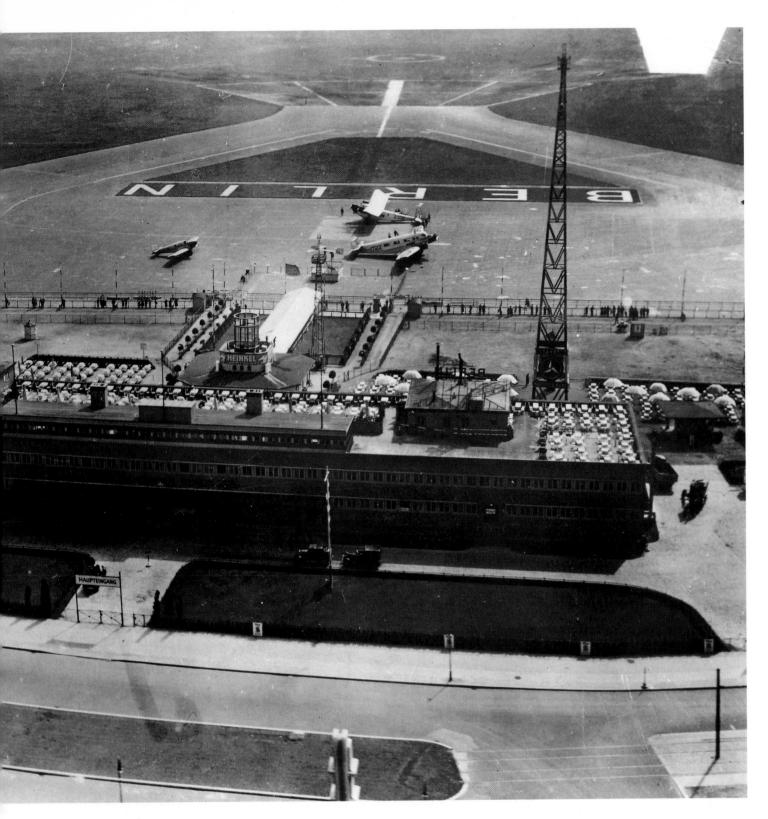

Berlin's central airport on the eastern
section of the Tempelhof Fields, a huge
area of open land formerly used by the
Berlin garrison as an exercise and parade
ground. The arrival lounge was build in
1926–8; this photograph dates from c.
1930. (LBS)

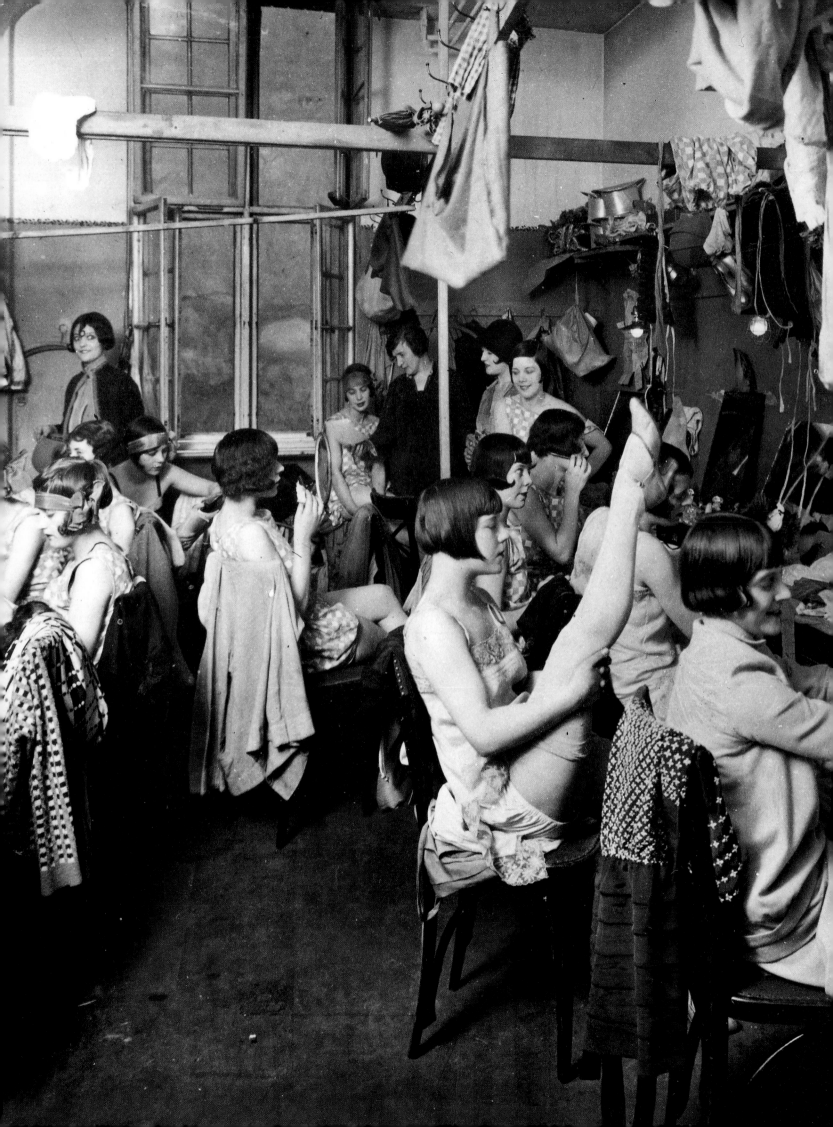

Art and Culture

WHAT IS TRUE OF THE CITY AS A WHOLE is also true for the arts and culture, whether high- or lowbrow; the 'Golden Twenties' did not appear out of the blue. The great blossoming of culture experienced in Berlin in the 1920s was the result of at least the previous ten years, which laid the foundations for the subsequent incredible burst of artistic creativity and experimentation, in all its forms. As far as fine arts were concerned, the decade up to 1920 was as important as the ten years afterwards. Berlin had begun only very late on to develop as an artistic centre in its own right – until the turn of the century it had seemed 'provincial' compared with Munich.

Previous page: The Tiller Girls in their dressing-room at the Scala, a nightclub in Lutherstraße in the Schöneberg quarter, 1927. (BPK)

Max Liebermann, founder of the Berlin Secession and President of the Academy of Arts, sitting in front of a self-portrait in his studio, c. 1930. (BPK/Fritz Eschen)

If Berlin was now in the forefront of the modernist aesthetic, it was thanks to artists such as Max Liebermann, Lovis Corinth and Käthe Kollwitz, and to the organizational talents of the Berlin Secessionist Movement, founded in 1898. But it was not until the years leading up to the outbreak of war that Berlin began to compete with Munich's claims to be seen as Germany's leading artistic centre. In 1910, for example, the artists of Die Brücke, Erich Heckel, Ernst Ludwig Kirchner and Karl Schmidt-Rottluff, moved from Dresden to Berlin, where the city's new-found vitality inspired some of their greatest works. Also in 1910 Herwarth Walden launched his weekly arts magazine, *Der Sturm*, and two years later opened a gallery of the same name, inviting Cubists and Futurists alike to exhibit their work in the city. Together with Franz Pfemfert's journal *Die Aktion*, first published in 1911, Walden helped Expressionist art and literature to achieve their decisive breakthrough. In the main, it was this generation of artists, together with their various groupings, which left its mark on the city's art scene and affected its development, during the years that followed, into the second wave of Expressionism; the Dadaist revolt; the Constructivist experiment, and, finally, the decade of stylistic heterogeneity, which, for want of a better term, was described at the time as 'post-Expressionism' and later as 'Neue Sachlichkeit' ('New Objectivity'), a somewhat curious catch-all phrase that embraces highly

disparate trends and different modes of expression, from Magical Realism to Social Realism, from Christian Schad to Beckmann and Otto Dix.

Quite apart from the wealth of constantly changing works on offer in the city's countless galleries, most of which were located in the Old or New West End, art lovers with an interest in contemporary art in 1927 – to take a year at random – could visit the Spring Exhibition at the Prussian Academy of Arts in the April and May of that year, where new work by George Grosz and Karl Hofer, Kokoschka and Liebermann was on show. From May to September there followed the Great Berlin Art Exhibition, held in the Regional Exhibition Centre in Moabit. Under one roof was gathered work by a disparate group of artists, from the Berlin Secession, many of whose successes dated back to the early years of the century, to the recently founded *Abstrakten*, and from the *Novembergruppe*, which took its name from the 1918 Revolution, to the rather more traditional Society of Women Artists of Berlin. More than a thousand paintings, engravings and sculptures were exhibited here, ranging in style from conventional academicism to works by the well-established school of classical Modernism and experimental pieces by young artists who, as yet, were largely unknown. There were also various special exhibitions, including the first retrospective in western Europe of works by Kasimir Malevich, and an exhibition of architectural projects designed by *Der Ring*, a group of local architects concerned with the city's urban development programme. Among the architects represented were Ludwig Hilberseimer and Hans Poelzig. Scarcely had the Great Berlin Exhibition closed its doors when another exhibition opened in the very same building. This 'Jury-Free Exhibition', as it was called, comprised no fewer than 1,345 individual exhibits, including fifteen 'camera-less photographs' by the Bauhaus artist László Moholy-Nagy, canvases by the 'proletarian' artist and pupil of Zille, Otto Nagel, and works by Ernest Neuschul, one of the New Objectivists. Hundreds of other works of art were on show at no fewer than four additional exhibitions: 'Poster Art of Soviet Russia'; 'Garden Art'; 'The Collector's House' and 'Religious Art'. The *salon d'automne* was held at the Prussian Academy of Arts in November/December and, with it, the season came to an end. Here, too, there were several hundred works on display by artists of every generation, although most of them – Baluschek and Grossberg, Jaeckel and Kubin, Orlik and Pechstein, Sintenis and Slevogt – were already well known.

In addition to the city's many galleries and museums there were scores of public and private schools and colleges where the next generation of artists could study and train. The 'applied' arts, too, received their due, with training in various arts and crafts, together with commercial art and photography, both of which were gaining in importance in journalism and advertising. As far as photography was concerned, Berlin could look back on a tradition stretching back as far as 1839 and the beginnings of the new medium. During the nineteenth century, Berlin had not only developed into a centre of commercial and art photography, it had also played its part in developing new photographic processes and techniques, from negative papers to lenses. It was a lead that Berlin maintained by developing other reproduction processes, one consequence of which was that, by the turn of the century, the most up-to-date and newsworthy magazines were being published in the city, foremost among which was the *Berliner Illustrirte Zeitung*, whose circulation passed the million mark in 1914. In order to remain competitive, the leading dailies were forced to publish illustrated supplements at least on a weekly basis, resulting in a new profession of photo-journalism. Throughout the

1920s, Berlin was undisputed leader in the field not only of photo-journalism but also of art photography. A quite literally new way of looking at people and things evolved, as the invention of the lightweight camera encouraged a further move towards modernization in the overlapping areas of the visual arts, journalism and films. By 1930 Berlin was a veritable El Dorado for the modern wave in photography: Erich Salomon had already made a name for himself with his photo-journalistic reports and John Heartfield was already famous for his political photomontages. Other photo-journalists, too, such as Alfred Eisenstaedt, Felix H. Man, Robert Capa and Martin Munkacsi, all of whom were soon to be internationally famous, were now emerging as major talents. Everything was here in abundance – a surfeit of themes, photographers, workshops and studios, agencies and, above all, a ready market. In addition to the illustrated periodicals and magazines, which continued to grow in popularity, there were also political journals such as the Social Democratic *Volk und Zeit*, the republican and democratic *Illustrierte Reichsbanner-Zeitung* and the Communist-orientated *Arbeiter-Illustrierte-Zeitung*. The demand for photographs grew and grew across the journalistic spectrum, as more and more events and objects, both animate and inanimate, were deemed worthy of being photographed.

But publishing and journalism were also important in other areas. Never before had the city had so many publishing houses producing books and magazines whose pages were filled with reports and polemical writings on art and literature, theatre and films, and cultural matters in general. Almost every leading literary publisher, and certainly many of those that

Frau Firle and Count Albrecht Montgelas examining Magnus Zeller's oil painting, Page Assembly of *B.Z. am Mittag* at Ullstein, *at the 1928 Berlin Secession Ball. (Ullstein)*

belonged to the avant-garde, had their headquarters in Berlin. But however important books and magazines may have been for the city's cultural scene, their broader impact was often overshadowed by the arts pages of the daily newspapers. For decades, theatre criticism had played a leading role here and none of the city's editors-in-chief was such a household name as Berlin's most famous theatre critic, Alfred Kerr of the *Berliner Tageblatt*, who was very much a public institution in his day. By the 1920s, however, it was no longer the theatre reviews alone that provided the chief attraction of the arts pages in Berlin: other topics, too, had been granted equal coverage, with the visual arts, music and fashion, architecture and urban development, literature and the humanities, radio and, above all, the cinema, now filling column inches as equally valid art forms. During the 1920s many leading writers wrote for the city's newspapers over a longer or shorter period, or worked as correspondents for provincial German papers, filing reports on life in Berlin: Alfred Döblin, Joseph Roth and Erich Kästner were only a few of the literary figures of the day who combined journalism with writing. And journalists, too, could turn in work of artistic merit, as is clear from the foreign reports of Egon Erwin Kisch and the essays of Siegfried Kracauer.

Surprisingly enough, it was not the papers with the largest circulation which, as a rule, brought out the liveliest and most ambitious supplements, but smaller newspapers, such as the liberal *Berliner Börsen-Courier* and *8-Uhr-Abendblatt*. These outsiders also took advantage of the fact that what one contemporary called the vast 'Berlin intelligentsia market' could always field experienced journalists, while new talents were regularly emerging to bring a breath of fresh air and experimentation to many an editor's office. In his study of Berlin as a centre of the newspaper industry, the historian Peter de Mendelssohn has noted that, 'by the end of 1928, when the city reached the high point of its economic, intellectual and cultural development, Berlin was a newspaper city in the truest sense of the word'. In 1928 alone no fewer than 2633 newspapers and periodicals – more than a quarter of the total for the whole of the rest of Germany – were published in the city. Even if one discounts the numerous local papers, whose circulation was limited to individual districts and suburbs, the number of daily papers that were published in Berlin – often with both a morning and an evening edition – was still impressive enough, with some sixty or so appearing in 1931 in print runs of between a few thousand and the 560,000 copies of the largest of them all, the *Berliner Morgenpost*, published by Ullstein Verlag. Without this mass of newspapers and their plethora of supplements, to say nothing of the many literary, cultural and political magazines, from the legendary *Literarische Welt* to the equally legendary *Querschnitt*, from the *Kunstblatt* to the *Filmkurier*, the city's cultural scene could never have evolved so multifaceted an aspect nor achieved the sort of dimensions that it had reached by the time of the Nazis' accession to power. In 1933 most of the city's cultural and political papers were promptly banned and burned, and its journalists driven into exile, where many of Germany's émigré journalists and magazine editors became involved in setting up and successfully running projects such as *Life* and *Picture Post*, to name only two examples of the later influence of Weimar Culture on the rest of the world.

When the Reich collapsed and was replaced by the Weimar Republic, art and literature had still been dominated by the Expressionist movement. But within years – and certainly by the onset of economic stabilization in 1924 – Expressionism seemed to have played itself out as a movement,

abandoning the field to New Objectivity. In its later manifestations, Expressionist literature produced no more than a handful of minor derivative works: lyric poets failed to note that the 'O Man!' cliché had had its day, while prose writers clung in desperation to an Expressionist aesthetic that had lost all claim to authenticity. Texts such as those appearing in *Die Aktion* early in 1919 in response to the murder of Karl Liebknecht and Rosa Luxemburg would have been unthinkable had they been published in its pages even two years later. At much the same time the formal language of Expressionist painters and graphic artists was now beginning to pall, a change of heart which has prompted later writers to view the Expressionist movement as the artistic expression of the crisis of Wilhelmine Germany and the revolutionary phase of 1918/19. Although this is only half the truth, it is by no means as wayward an explanation as the attempt by various dogmatic Marxists of the 1930s to denounce the Expressionist movement as the ideological and cultural 'forerunner of Fascism', simply because a handful of former Expressionist writers – lyric poets in the main – later joined the Nazi party or, in the case of Gottfried Benn, toyed for a time with National Socialism.

If, by the early 1920s, Expressionist paintings were just as *passé* and just as great a source of irritation as the Expressionist poetry of the period, there is no denying that, as a movement, Expressionism was still far from being played out in other areas of culture; indeed, in certain genres Expressionist elements enjoyed something of a revival in the early 1930s. The German cinema, at least during the first half of the 1920s, owed much of its impact, not only on contemporary audiences but also on later generations, to a style of acting which can only be characterized as Expressionistic, while film techniques and set design betrayed a similar influence. In their content, too, many films made at this time – at least those offering more than mere entertainment – use motifs from Expressionist art and poetry, adapting them to the new medium. That this is true not only of Robert Wiene's *The Cabinet of Dr Caligari* (1919) is clear when one thinks of the films being made during this period by Ernst Lubitsch, which range from *Madame Dubarry* (1919; *Passion*) to the typically spectacular *Das Weib des Pharao* (*The Loves of Pharaoh*), shot in 1922 and, as such, the last of Lubitsch's films to be made in Berlin before he left the country to follow up his successful career in the States. (Lubitsch was the first but by no means the last director to be lured away to Hollywood, where the German film scene of the 1920s was followed with close professional interest.)

The Cabinet of Dr Caligari remains the classic example of Expressionist cinema. Whenever French critics spoke of the *école allemande*, they had in mind German Expressionist films, a cinematic style succinctly summed up as *Caligarisme*. Nor was it mere chance that the three young artists who painted the impressive designs directly onto two-dimensional canvases (in contrast to techniques used in film-making hitherto), were close to Herwarth Walden and his circle of *Sturm*-based artists. No wonder, either, that one thinks of Expressionist poems when reading Rudolf Kurtz's contemporary account of the settings of the film: 'Winding streets appear to fall on one another . . . trees are fantastically soaring structures, leafless, eerie, chilling in their fragmentation of the composition of each shot . . . Sharp-angled stairways groan beneath the user's weight, unseen forces animate the doorways, which are really hollow, avaricious openings.' The *Demonic Screen* was the title of a later account of the German cinema of the early 1920s, an apt description of films that aimed to depict the depths of the human soul or, as Siegfried Kracauer claimed in his study of the subject, *From Caligari to Hitler*, to lay bare

The classic Expressionist film, The Cabinet of Dr Caligari, *directed by Robert Wiene. Seen here are Werner Krauss as Dr Caligari, Conrad Veidt as Cesare, Friedrich Fehér (standing) as Francis and Rudolf Lettinger (bending) as the doctor. (BPK)*

the workings of the German psyche. Be that as it may, the film historian Ulrich Gregor is no doubt right to claim that in developing sophisticated techniques with which to enhance the composition of the image, the cinema also moved, if only temporarily, away from the real world. There is, after all, only one small step dividing the Expressionist cinema from such a classic horror film as F. W. Murnau's *Nosferatu: Eine Symphonie des Grauens* of 1922. The interplay of light and shade, the subtleties of composition which are typical of all the major German films of this period are the result not least of the technical conditions under which they were made: they were shot, almost without exception, in film studios using artificial sets, so that not only the set designers but also the lighting technicians and cameramen were actively involved in the composition of each shot.

In contrast to the visual arts, there was no sudden break in the German cinema of the mid-1920s between Expressionism and post-Expressionism. That the transition was gradual is clear from the work of Fritz Lang, beginning in 1922 with *Dr Mabuse, the Gambler* (a film thematically linked to *Caligari*), continuing with his two-part epic *Die Nibelungen* (*Siegfried's Death,*

1923, and *Kriemhild's Revenge*, 1924), in which he explores the kitschy and deeply reactionary nature of the 'German soul', before dealing – in name, at least, and certainly in a highly questionable manner – with the social conflicts of his day in the Utopian vision of *Metropolis*, an ambitious and overbombastic project dating from 1926. Both here and in the later *M* (1931) it is clear that Lang came to films from architecture and that Expressionist elements left their mark on his work over a period of many years.

The gradual 'objectification' of the German cinema was due, in all likelihood, to the huge impression made on German cinema audiences by Sergei Eisenstein's *Battleship Potemkin*, released in Germany in 1926. By the end of the 1920s there was no ignoring a certain socio-critical realism in many of the more discriminating films that were being made at this time, a trend that reached its high point in Brecht's and Slatan Dudow's *Kuhle Wampe* (1931), set in Berlin at the time of mass unemployment. But the most famous of all the films from these years was Josef von Sternberg's classic, *The Blue Angel*, made in 1930 and starring Marlene Dietrich and Emil Jannings in the principal roles. Indeed, it is on the acting talents of its leading performers that the film's reputation largely rests and especially on that of Marlene Dietrich. Nevertheless, it also succeeds in drawing audiences into its action through a combination of scenery, sophisticated camerawork, Expressionistic elements imaginatively and skilfully inserted into the visual framework, and its atmospheric and emotional appeal. Even if the film departs completely from its source in Heinrich Mann's satirical novel *Professor Unrat*, it remains essentially realistic in its underlying conception.

Film production in Germany was synonymous with film production in Berlin at least until 1933: the city had established a virtual monopoly in both making and distributing films. And Berlin audiences were firmly in the grip of the cinema. Starting out from the humble beginnings, an industry had evolved that presented its products in elegant palaces designed by some of the country's leading architects. Even at the height of the economic crisis, the number of cinemas in Berlin rose from 391 to 396 (the total seating was almost 200,000), although the number of cinemagoers fell from 55.6 to 51.9 million between 1931 and 1932.

If the city's theatres could not compete with such impressive statistics, it was simply because there were 'only' thirty-six theatres in Berlin in 1931, with a total seating capacity of some 43,000 seats. Yet the theatre played at least as important a role as the cinema in the culture of the 1920s. It is difficult now to imagine the degree of excitement and interest roused by the theatre in Berlin during the years in question. It is said that on first nights, restaurants and cafés were deserted – and not only the legendary haunt of theatrical people, the Romanisches Café. Productions of the classics were discussed with the same degree of passion as the latest political gossip: in December 1919, for example, Fritz Kortner described Leopold Jessner's production of Schiller's *Wilhelm Tell* as 'revolutionary and anti-nationalist'. Jessner was intendant and, from 1928–30, general intendant of all the city's state-owned theatres, reigning over an empire which prompted Alfred Kerr to describe his years in office as the 'Periclean age' of German theatre. Together with Max Reinhardt and Erwin Piscator he deserves to be numbered among the giants of the German theatre. From 1905 to 1920 and again from 1924 to 1933, Reinhardt was director of the Deutsches Theater, which he tended to use for spectacular stagings involving elaborate scenery, purveying a style which Brecht was later to criticize as 'culinary theatre'. Piscator, by contrast, pioneered 'political' and experimental theatre, striving to influence social

The Universum Cinema on the corner of Lehniner Platz and Kurfürstendamm in the Wilmersdorf district, c. 1931 (BPK). The Universum Cinema was part of a block of buildings designed by Erich Mendelsohn and dating from 1928 to 1931. In addition to the cinema, the complex housed a shopping arcade, a block of flats, a row of houses looking out over Cicerostraße and the 'KadeKo' (Kabarett der Komiker or Comics' Cabaret) building, which itself included a restaurant and shops. The block was a classic example of the International Modern style. The Universum Cinema seated almost 1800 patrons and its walls were mahogany-panelled up to the height of the balcony railing.

reality with his revolutionary productions. With the exception of the commercial theatre, which, like its silver-screen counterpart, the light-entertainment film, occupied the majority of the city's stages, the theatre of the 1920s still had a social function, contemporary in the literal sense of the word. Such was the Weimar Republic's political weakness, that this 'Theatre of the Republic' served as a kind of substitute, acting both as a safety valve and as a surface on which to project a host of contemporary images. It was also related to the cinema – with which it had many other links – by virtue of the fact that it had started life in 1919 as a form of Expressionist theatre (one thinks, above all, of the plays of Ernst Toller), a role which it never entirely lost. Only on one occasion – Brecht's *Dreigroschenoper* (*Threepenny Opera*) of 1928 – did literary ambition combine with financial success to produce a commercial synthesis. Generally, however, discerning writers considered entertainment value a sign of inferior quality.

Wilhelmine Germany stood for emotional superficiality, anti-intellectualism and anti-sensuality. Only if we interpret Expressionism as a revolt – not in the narrow political sense but in a wider and more general sense – against this social system and as a rejection of its code of values can we explain much of the liberating and inspirational effect which it continued to have on so many different aspects of twentieth-century culture, from architecture to modern dance, long after it ceased to influence art and literature. Even the field of pure entertainment proved not to be immune, when, in 1919/20, Max Pechstein and Rudolf Belling provided Expressionist sculptures for Luna Park in Berlin, Europe's largest amusement park, though attempts such as these to influence the masses remained no more than

The actors Friedrich Kayssler, Paul Wegener and Friedrich Kühne rehearsing Kleist's Prinz Friedrich von Homburg *in a production by Max Reinhardt (right), 1932. (Ullstein)*

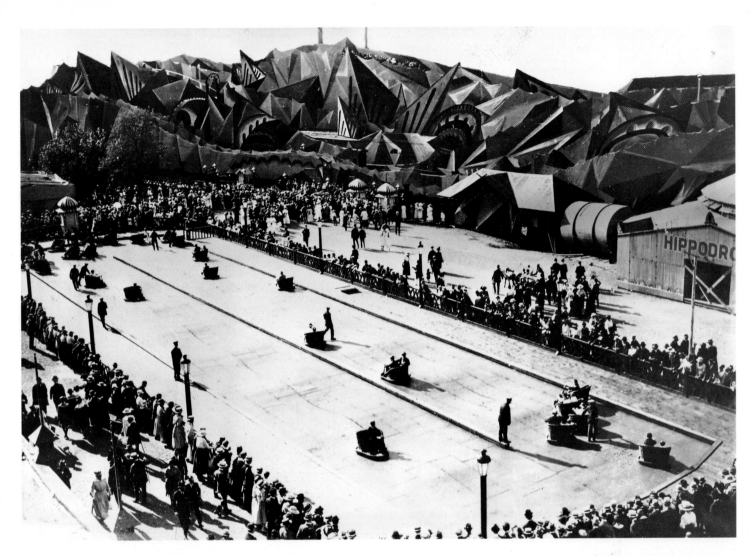

View of Luna Park, the popular leisure complex, with Expressionist sculptures by Max Pechstein and Rudolf Belling, in 1923. (LBS)

isolated episodes. In much the same way, the showy and spectacular revues of impresarios such as James Klein used Expressionist stylistic means only as long as the public demanded them. But the organizers of revues and operettas, of vaudeville and cabaret acts had rather more interest in earning money than changing the world. However much the *Lebensgefühl* (spirit) of the 1920s may have been embodied, at least in part, by the Tiller Girls and the Comedian Harmonists, by Claire Waldorff and Fritzi Massary, by the Scala and the Wintergarten, they were still dependent in no small way on public taste, still subject to fashion and to the *Zeitgeist*'s every whim. If the products of the entertainments industry are more 'ephemeral' than those of the 'serious' arts, they nonetheless reveal a certain truth about a country's inner state, not least when that industry undergoes a radical change of direction. When, in the early 1930s, increasing numbers of films extolling Prussian military might began to emerge from the UFA studios, and *The White Horse Inn* (1930) proclaimed the gospel of a new and better world, it was clear – as we know today – that these were the first faint signals announcing an imminent turning-point in world history.

METROPOLIS is today Fritz Lang's best-known film, but at the time it was his most financially disastrous. The fantastical architecture (Eugen Schufftan), the deliberately anti-naturalistic style of the actors (Alfred Abel, Heinrich George, Brigitte Helm) and the disturbing, surreal plot (screenplay by Lang's wife, Thea von Harben) did not suit the tastes of 1920s cinema audiences. Nevertheless, *Metropolis* counts today as one of the greatest films of the silent era.

Scene from Metropolis, *1926. (BPK)*

Fritz Lang (with monocle) on the Metropolis *set in the UFA Studios, 1925/6. (BG)*

'The Great Machine', a still from Fritz Lang's Metropolis, *1926. (Ullstein)*

Lilian Harvey and Harald Liedtke in Anatol Litvak's 1931 film Nie wieder Liebe (Never Again Love). A number of scenes in the film, which is set on the French Riviera, were shot in the indoor swimming-pool in the Luna Park at Halensee. The early UFA sound films had made Lilian Harvey an international star. (BPK)

A scene from Gerhard Lamprecht's 1931 film, Emil and the Detectives, based on Erich Kästner's book of the same title. Both film and book are set in and around Kaiserallee (now Bundesallee) in the Wilmersdorf quarter in the heart of Berlin's West End. (BPK)

Opposite: Pola Negri as Madame Dubarry in Ernst Lubitsch's film of the same title, 1919. Thanks to Lubitsch's direction, Negri became a major star of the silent German cinema from 1917 onwards. Lubitsch had learned to direct crowd scenes while working with Max Reinhardt. Among his other films were Anne Boleyn (1921) and The Loves of the Pharaoh (1922). He moved to Hollywood in 1923. (BPK)

The auditorium of the Titania Palace, seen from the stage, 1928. (LBS)

The actress Carola Neher (left), the scriptwriter Karl Vollmoeller (co-author of the script for The Blue Angel*) and an unidentified woman at the 1929 Film Ball. (BPK/Erich Salomon)*

The Capitol Cinema on Auguste-Viktoria-Platz in October 1931, during the run of Robert Z. Leonard's Susan Lenox: Her Fall and Rise, *starring Greta Garbo. Designed by Hans Poelzig, the Capitol was one of several modern cinema buildings round the Kaiser Wilhelm Memorial Church. (BPK)*

DESIGNED BY SCHOFFLER, Schloenbach and Jacobi, the Titania Palace cinema boasted a lighting system that was one of the earliest examples of the modern architectural use of light. With its parabolic and irregular curved surfaces, the interior of the building spoke an architectural language totally different from that of its Cubist exterior. Even the proscenium arch was formed from several parabolic curves, which framed the display pipes of the cinema's organ. The auditorium was bathed in a multicoloured flood of indirect light, an effect enhanced by the bronze and reddish-brown ceiling, a silvery coloured dome, lacquered walls, mahogany panelling and the claret-coloured velvet upholstery of the seats.

ACCORDING TO CINEMA HISTORIAN JERZY TOEPLITZ, *The Blue Angel* may be seen as an example of the fruitful marriage of the commercial cinema and its more prestigious counterpart. The film owed its phenomenal success to Josef von Sternberg's direction, to Emil Janning's acting and to the fact that the screenplay was based on Heinrich Mann's novel *Professor Unrat*. Among other great names involved in the project were Friedrich Hollaender (music), Carl Zuckmayer and Karl Vollmoeller (screenplay), Hans Albers and Kurt Gerron in supporting roles and, not least, the producer, Erich Pommer. 'In the course of editing,' Jerzy Toeplitz concluded, 'it emerged that the film maker had another ace up his sleeve – arguably the greatest of all – in the form of Marlene Dietrich.'

Scene from The Blue Angel, *with Marlene Dietrich. (BPK)*

Marlene Dietrich with Hans Albers and Emil Jannings in a scene from Josef von Sternberg's 1930 film, The Blue Angel. *(Ullstein)*

Lilian Harvey in Chaste Susanna, *1926. (BPK)*

The White Mouse Cabaret in Jägerstraße in the centre of Berlin, 1926. Among the artistes who appeared here was the legendary dancer, Valeska Gert. Jägerstraße was famous for its bars, ranging from sophisticated dance bars to popular dives and cellar casinos. Among the best known were the White Mouse, Indra, Maxim's and Vienna-Berlin. (BPK/Herbert Hoffman)

*The Scala Girls at the entrance to the
Variety Theatre in Lutherstraße in the
Schöneberg quarter, 1929. (BPK/Herbert
Hoffmann)*

Tableau vivant *in a James Klein review at
the Apollo Theatre in Friedrichstraße, c.
1919. Seen here is the goddess of peace
from the Brandenburg Gate, portrayed
astride her chariot with an all-star
supporting cast. (BPK)*

The Comedian Harmonists, with the film actress, Gitta Alpar, 1932. Front row: Asparuch Leschnikoff and Erwin Bootz; middle row: Roman J. Cycowski, Gitta Alpar and Erich Abraham-Collin; back row: Robert Biberti and Harry Frommermann. (BPK)

Claire Waldoff and Harry Lamberts-Paulsen at the Zille Ball in the Großes Schauspielhaus (Grand Theatre), 1925. Claire Waldoff had made a name for herself with songs such as 'He's called Hermann', while Lamberts-Paulsen was acclaimed in his day as a 'genius of the cabaret'. His most frequent appearances were at the White Mouse Cabaret. (Ullstein)

THE COMEDIAN HARMONISTS were Germany's most famous vocal ensemble. Initially, they took their lead from the Revellers, a group of American jazz vocalists, and were even marketed by their record company as 'The German Revellers', but they soon developed their own inimitable and still popular style. Their best known numbers are 'A friend, a good friend', 'Veronica, spring is here', 'Weekend and sunshine', 'My little green cactus' and 'I've ordered a flowerpot for you'.

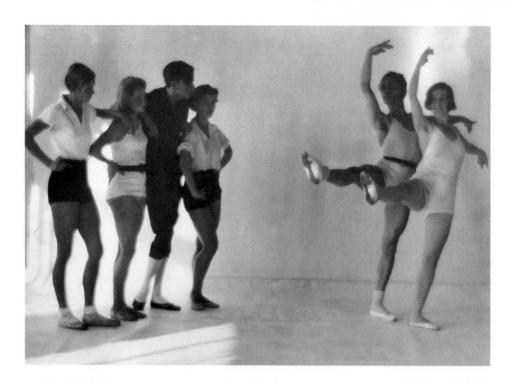

At the Gsovsky School of Ballet in Fasanenstraße in Wilmersdorf, 1932. (Ullstein/Martin Munkacsi)

Opposite: Mary Wigman in Visions, 1928. Mary Wigman was the best-known representative of the Ausdruckstanz or modern ('expressive') dance movement. During the years that followed, there were a number of dance schools in Berlin continuing the Wigman tradition, including those of Vera Skoronel and Berthe Trümpy. (Ullstein)

A dance group at the Palucca School, run by Gret Palucca (b.1902) (BPK/S. Enkelmann)

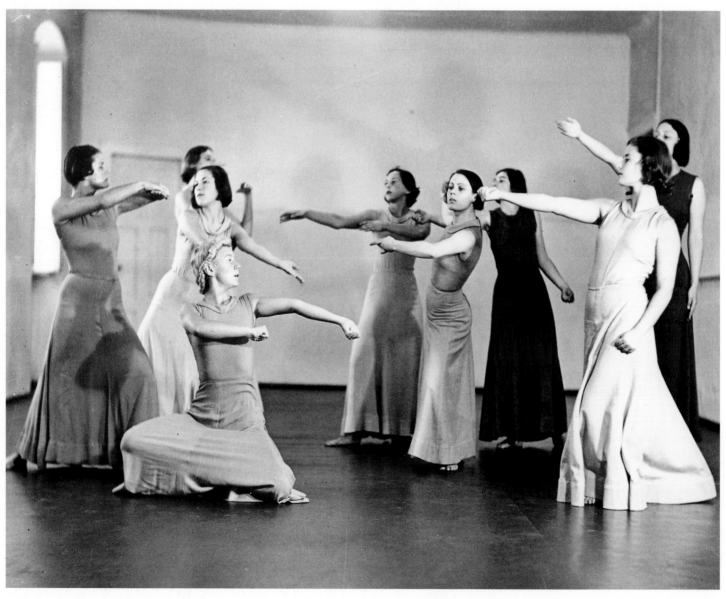

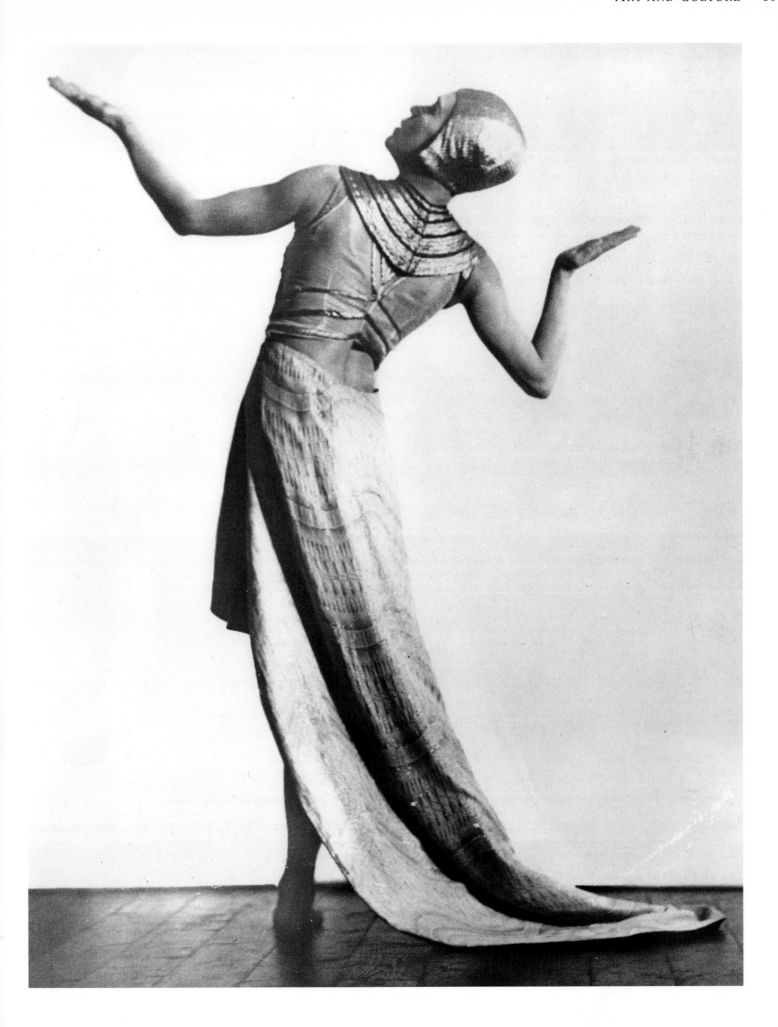

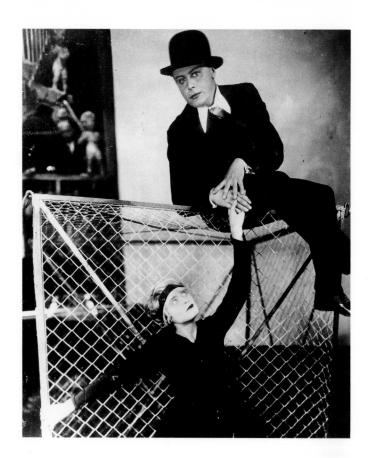

FIRST PERFORMED IN 1928 in a production by Erich Engel, *The Threepenny Opera* marked Brecht's breakthrough as a popular playwright, although the rehearsals were almost constantly disrupted by arguments between the various participants, including the composer Kurt Weill, the designer Caspar Neher and the conductor Theo Mackeben. More than once the whole production was called into question. Brecht had an outstanding cast at his disposal, with Harald Paulsen as Mackie Messer, Erich Ponto as Peachum, Rosa Valetti as Mrs Peachum, Carola Neher as Polly, Lotte Lenya as Pirate Jenny and Kurt Gerron as Tiger Brown. Brecht's writing became more political in the years that followed *The Threepenny Opera*. *Kuhle Wampe*, for example, deals with the social conflicts of the day as seen through the eyes of members of a working-class family who are evicted from their home and forced to move to a camp site for the unemployed on the edge of Berlin.

A scene from the first performance of Brecht's The Threepenny Opera *at the Theater am Schiffbauerdamm, 31 August 1928. (BPK/Willy Saeger)*

Bertolt Brecht (seated), Hanns Eisler (left) and Slatan Dudow during work on Kuhle Wampe or To Whom Does the World Belong?, *1931/2. (Ullstein)*

Kurt Weill, the composer of The Threepenny Opera, *with his wife Lotte Lenya, who played the role of Pirate Jenny, 1928. (BPK)*

Scene from Brecht's Man is Man *at the Staatliches Schauspielhaus (State Theatre) am Gendarmenmarkt, 1931. (AKG)*

A scene from the first performance of Carl Zuckmayer's Der fröhliche Weinberg (The Happy Vineyard), produced by Reinhard Bruck at the Theater am Schiffbauerdamm in 1925. 'Storms of applause from the stalls to the gallery, [. . .] a fabulous success,' noted the theatre critic, Herbert Ihring, in his review. (Ullstein)

A scene from Ernst Toller's Hinkemann, starring Helene Weigel and Heinrich George and first performed at the Volksbühne am Bülowplatz, 1924. Critics complained that the play marked a return to the social drama of Naturalism dressed up in Expressionist clothing. (BPK)

Opposite: Eduard von Winterstein and Gustav von Wangenheim in Romeo and Juliet in Max Reinhardt's production at the Berliner Theater in Charlottenstraße, 1928. (AKG)

Elisabeth Bergner as Saint Joan in Bernard Shaw's play of the same name, seen here in Max Reinhardt's production at the Deutsches Theater in Schumannstraße, 1924. It was as Saint Joan that Elisabeth Bergner began her rise to fame as one of Berlin's most popular actresses. (BPK/Herbert Hoffmann)

Opposite: Renée Sintenis, a sculptor who became famous in Berlin in the 1920s, was best known for her delicate animal sculptures, c. 1928. (BG/Steffi Brandl)

Fritzi Massary, the idolized operetta star of the 1920s, c. 1925. (BPK) Neither cabaret nor music hall could field a star performer able to compete with Fritzi Massary. Reactions to the première of Madame Pompadour were typical: 'Our delight, enthusiasm and utter enchantment are due entirely to the genius of Fritzi Massary. She brings to all her roles a sense of style which extends beyond the level of operetta plots' (Berliner Tageblatt); 'Fritzi Massary remains a miracle. . . . The way in which she always find fresh nuances by a flick of her head or hand or by a movement of her body, shedding new light on even the oldest and most hackneyed lines, shows what is so unique and incomparable about her' (Berliner Börsen-Courier).

Marlene Dietrich sitting for the sculptor, Ernesto de Fiori, in 1931. (Ullstein)

The organizers of the First Russian Art Exhibition, 1922. From left: David Sterenberg, D. Marianov, Nathan Altmann, Naum Gabo and Friedrich Lutz, director of the Berlin branch of the Van Diemen Gallery, where the exhibition was held. Works by abstract artists made up around a third of the exhibition, which provided the West with its first opportunity to get to know the whole range of Russian avant-garde art. Naum Gabo's Constructed Torso can be seen in the foreground, while the works in the background are canvases by Sterenberg and a sculpture by Alexander Archipenko. (ABZ/Willy Römer)

The official opening of the First International Dada Fair in Dr Burchard's Bookshop on Lützow-Ufer in the Tiergarten district, 30 June 1920. From left to right: (standing) Raoul Hausmann, Otto Burchard, Johannes Baader, Wieland and Margarete Herzfelde, George Grosz and John Heartfield; (sitting) Hannah Höch and Otto Schmalhausen. The exhibition was the high point of Dada's activities in Berlin (it disintegrated soon afterwards) and roused much public interest. (BPK)

Käthe Kollwitz, perhaps the most well-known of all the graphic artists and sculptors working in Berlin during the first third of the twentieth century and well known for her strong social convictions, c. 1930. (BPK)

Opposite: George Grosz in his studio, with a self-portrait, 1924. Grosz made a name for himself in the early 1920s, notably with his collections of socio-critical drawings, God With Us, The Face of the Ruling Class, Ecce homo and Invoice Follows. (BPK)

Heinrich Zille, best remembered for his scenes from everyday life among the poorest sections of the population, before 1926. (BG/Hugo Erfurth)

Plenary session of the Poetry Section of the Prussian Academy of Arts at its inaugural meeting, 25 November 1926. The four in the centre are, from left to right, Thomas Mann, Hermann Stehr, Max von Schillings and Max Liebermann. (BPK)

'Group photograph following the Prialbstra party, 11 March 1921' (original caption). 'Prialbstra' was the abbreviation of 'Prinz-Albrecht-Straße' and was the alternative name of the School of Applied Arts, in the Prinz-Albrecht-Straße. Parties at the school were famous for their high spirits and imaginative decorations. This photograph was taken on the main staircase of the building in which the last Artists' Ball was held at the end of February 1933. In May the Gestapo took over the school as its central command. (BG/Martha Astfalck-Vietz)

The entrance to the High School of Fine Arts in Hardenbergstraße, designed by architects Kayser and Grossheim (1898–1902). This photograph was taken around 1930. (BPK)

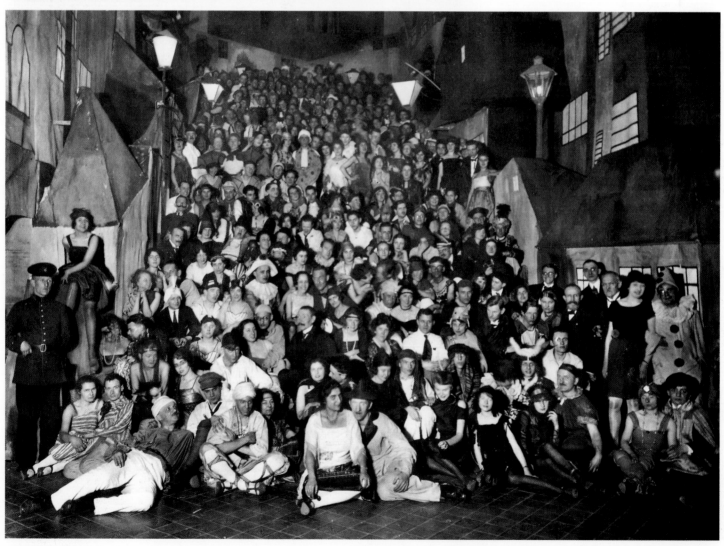

The courtroom during the blasphemy trial of George Grosz and his publisher, Wieland Herzfelde (both of whom can be seen in the dock in the background), 3 December 1930. (BPK) Grosz already had two convictions to his credit (including a sentence in 1921 for 'insulting the German army' with lithographs from his portfolio God With Us) when, in 1928, he was accused of blasphemy for the drawing Christ with Gas Mask from his Background series of works for Piscator. He was fined 2000 marks but acquitted on appeal. However, in February 1930, the case was referred back to the Berlin District Court for retrial. Grosz was finally aquitted on 4 December.

Carl von Ossietzky saying goodbye to his friends (including the dramatist, Ernst Toller, with whom he is shaking hands), outside the gates of Tegel prison, 10 May 1932. Ossietzky had been sentenced to a term of imprisonment for treason since, as editor of Die Weltbühne, he was held responsible for an article which had revealed that the German army was illegally rearming. (BPK)

The writer Anna Seghers, before 1930. In 1928 Anna Seghers received the Kleist Prize for her short story, Der Aufstand der Fischer von St. Barbara *(The Uprising of the Fishermen of St. Barbara). (BG/Lotte Jacobi)*

The writer Alfred Döblin who, until 1933, continued to work as a general practitioner in addition to his writing (his novel Berlin Alexanderplatz *appeared in 1929). This photograph shows him in his surgery in Schönhauser Allee in Prenzlauer Berg, c. 1931. He only treated National Health patients. (LBS)*

*A concert given by the Berlin
Philharmonic under Wilhelm Furtwängler
at the Old Philharmonic Hall in
Bernburger Straße in the Kreuzberg district,
c. 1930. (AKG)*

The composer Richard Strauss, c. 1930. (BG/Erich Salomon)

The composer Igor Stravinsky (left) and the conductor Otto Klemperer, 1928. From November 1927 until its closure in the summer of 1931 Klemperer was musical director of the Staatsoper am Platz der Republik (generally known as the Kroll Opera), where he came to international prominence chiefly through his performances of works by contemporary composers such as Hindemith, Schoenberg and Stravinsky. (BPK)

Some of the guests at the 1926 Berlin Secession Ball, including the actress Olga Chekhova (third from left) and the publisher Ernst Rowohlt (fourth from left). (Ullstein)

The actresses Camilla Spira (left) and Grete Mosheim (right), together with the wife of the painter Wolf Röhricht at the 1926 Berlin Secession Ball. (Ullstein)

A fancy-dress party at the Reimann School during the 1930 Carnival. The Reimann School was a private institution best known for its courses in fashion design and illustration. It specialized in dance, variety, film and theatre costumes. Highlights of the annual calendar were the fancy-dress and masked balls, which gave free rein to the students' lurid (or lurex) imagination. (Ullstein)

BERLIN'S INDUBITABLE IMPORTANCE for 1920s fashion was due not least to the fact that, of some 600 German manufacturers of off-the-peg clothing, almost 500 were located in Berlin. No other city in the whole of Europe could compete with such a concentration of ready-to-wear clothing manufacturers. During the early 1920s dresses were calf-length, but from 1924 to 1928 women's fashions were dominated by the *garçonne* look, the principal features of which were a knee-length shift and bobbed hair. By the end of the 1920s skirts were becoming longer again and by 1930 they were mid-calf length, as both dresses and women's clothes in general became less austere, more close-fitting and more 'feminine'.

Opposite and above: Ladies' Day at the Berlin Races, 1930. The three elegant numbers seen opposite are by Becker, a couturier's in Tiergartenstraße who specialized in women's clothes and fashionable coats. (Ullstein)

Men's and women's sportswear, c. 1928. (BG/Ernst Schneider)

Meeting between science and politics at a reception given by Reich Chancellor Brüning in honour of the British Prime Minister Ramsay MacDonald. Left to right: Max Planck, Ramsay MacDonald, Albert Einstein, Finance Minister Hermann Dietrich, Privy Counsellor Schmitz (of IG Farben) and Foreign Minister Julius Curtius, August 1931. (BPK/Erich Salomon)

A banquet in honour of the historian Hans Delbrück on the occasion of his eightieth birthday, 1928. From left to right: Ernst Jäckh, President of the School of Political Science, Hjalmar Schacht, President of the Reichsbank, Otto Gessler, Minister of Defence, and Carl Petersen, Mayor of Hamburg. (BPK/Erich Salomon)

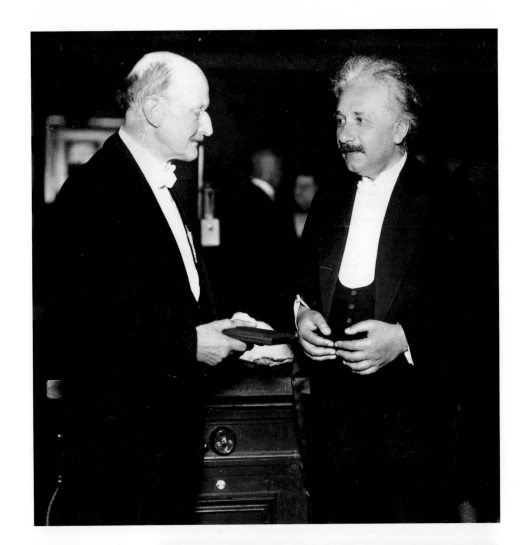

Nobel Prize winners face-to-face. Max Planck (left) presents the Max Planck Medal to Albert Einstein, 28 June 1929. Planck was a professor in Berlin until his retirement in 1928, while Einstein ran the city's Kaiser Wilhelm Institute for Physics from 1914 until 1933. (Ullstein)

Below left: Carl Friedrich von Siemens (1872–1941). The Siemens industrial empire, based on the Siemens dynamo, rose to international power under Carl Friedrich, son of the founder. (BPK)

Below right: Louis Ullstein, head of the publishing empire (1863–1933). (BPK)

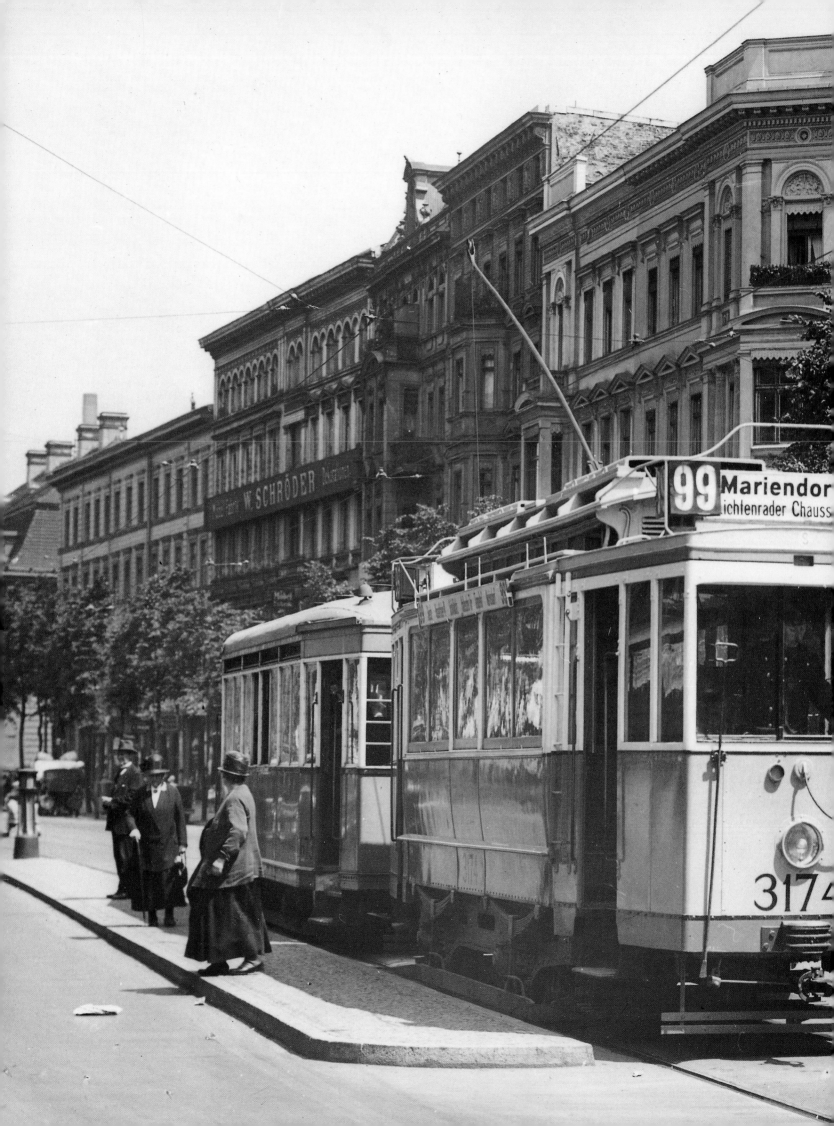

Everyday Life

IT IS NOT AT ALL EASY TO visit or live in a city that is always on the move, always in the process of becoming something else and never content to stay as it is.

<div align="right">FRANZ HESSEL</div>

Almost half a century after his arrival at Anhalt Station, one cold winter's morning in 1920, the poet and playwright Carl Zuckmayer could still recall his earliest enthusiastic memories of Berlin: 'The wet streets were full of people hurrying to their offices, their collars turned up against the rain. They were pushing, jostling and shouting at each other. "Hey, look where you're going! Otherwise you can go and book yourself a passage at Grieneisen's!" The charm of this cheery greeting became clear to me only when I saw the name of Grieneisen on advertising hoardings, accompanied by a coffin. They were the biggest firm of undertakers in Berlin. But I loved it all, the noise in the streets, the shoving at tram stops . . . it was the big city, and its effect on me was sensational and refreshing.'

Previous page: No. 99 street tram stopping in Lindenstrasse, in the Kreuzberg district, c. 1925 (LBS)

The hustle and bustle of Berlin and its traffic proved daunting to many visitors, 1929. (ADN)

Everyone who travelled to Berlin at this time would generally arrive, like Zuckmayer, by rail. Even as late as 1931 almost nine million rail travellers passed through the city's mainline stations, in contrast with only a few tens of thousands of air passengers. Most of these long-distance journeys ended at the city's five major termini, where trains arrived from every corner of the globe. Of these mainline stations – Anhalt, Potsdam, Lehrt, Stettin and Görlitz – it was the first two that inspired so many descriptions and tales from the pens of those who arrived in Berlin before and after 1918. Many stayed, while others were forced to take their involuntary leave of the city as early as 1933.

Even those arriving in Berlin for the very first time knew, generally, what to expect: first and foremost was the city's legendary pace of life, a hectic, restless round which seemed a natural part of metropolitan existence. Many saw a causal connection between the Berliners' pace of life and the local air, which was said to be uncommonly bracing, so that life went faster almost of its own accord and people never grew tired in spite of all their exertions. The rest of Germany, to say nothing of other nations, had fixed and firmly entrenched ideas about the city's inhabitants: the latter, it was believed, worked harder and longer hours but, for some unaccountable reason, they still found time to spend their days and, above all, their nights at cafés, restaurants, pubs and other more or less serious venues. As for their characteristics, Goethe's opinion of the Berliners had become ingrained in people's minds as a result of constant repetition over the century: 'I have noticed in everything and everyone that so forward a type of person lives there that delicacy does not get you very far, rather you must be firm with them and also somewhat rude in order to keep your head above water.' During the first third of the twentieth century, it was said that Berlin's population showed scant respect; that they were noisy and brash; that they tended to act in arrogant ways and were graspingly aggressive, but that, in their heart of hearts, they were really very goodnatured. They found fault with each and everyone, and had a curious sense of humour and a way of speaking which, conjoined with the qualities mentioned above, was described as *Berliner Schnauze* (literally, 'Berlin mouth'). In other words, they were a race apart, in whom kindness was counterbalanced by less agreeable traits.

Before embarking on a round-the-world voyage, the airship Count Zeppelin *flies a 'lap of honour' around the city. Here the people stop and stare as it passes over Wilhelmplatz, 1929. (LBS)*

All in all, the Berliners' view of themselves was little different from that of the city's visitors and guests, due to the fact that although they tended to look down on those they saw as outsiders they had nevertheless preserved a fair degree of self-criticism. Certain things, however, were accepted truths: Berliners were industrious and hard-working, quick on the uptake ('bright' was the Berliners' word for it) and always on the ball. As Franz Lederer put it in 1930: 'The rhythm of this city is its work, purposeful, high-grade work. Only those with genuine achievements can win prestige in Berlin and gain a position of importance here. There is no standing still, no chance to rest on one's laurels.' Half a century earlier, Fred Hildenbrandt, the arts editor of the *Berliner Tageblatt*, had written: 'It is said that in no other city in the length and breadth of the Reich do people work as doggedly and as fanatically as in Berlin. Everyone coming here from the provinces notices this and is taken aback at the pace of this vast, untiring labour. You have to work in Berlin,

whether you want to or not, and even those who really have no need to do so are drawn along by the pace of this will to work.' Five years earlier, Kurt Tucholsky had adopted a tone of distant irony when writing in *Die Weltbühne*: 'The Berliner has no time ... He always has something planned, he picks up the 'phone and makes an appointment, arrives at the said appointment out of breath and rather late – and is rushed off his feet. It is not so much work that is done in this city as sheer hard labour.' Unfortunately, Tucholsky went on, the Berliners had forgotten the actual reason for being placed on this planet: 'Even in Heaven – assuming he gets to Heaven – the Berliner would still have "something on" at four o'clock.' And Tucholsky, a native Berliner, knew of other less pleasant qualities among his fellow citizens: 'The Berliner has no conversation. Sometimes you see two people talking, but it is not a proper conversation. They are merely mouthing monologues at one another. Berliners do not know how to listen. They simply wait impatiently for the other person to finish speaking, at which point they break in. . . . The Berliners are total strangers to each other. Unless they have been introduced, they snarl at each other in the street and on the tram, so little have they in common. They do not want to know about each other and keep themselves to themselves. Berlin combines the drawbacks of an American city with those of a German provincial town. Its advantages are listed in Baedeker.' The latter, however, remains politely silent on the subject of the qualities of the city's population.

Apart from their love of work, it was the city's transport system of which Berliners were most proud. The highly efficient Office of Statistics published a weighty compendium every year, listing exactly how many people had died in the course of the previous year and what were the causes of death; how many head of cattle and sheep had been taken to the city's slaughterhouse; how many homes had been built; and how many people were being supported by local welfare payments. (This invaluable vein of information was also mined by Alfred Döblin in his novel *Berlin Alexanderplatz*

Hermannplatz underground station in Neukölln, giving direct access to the Karstadt department store, June 1929. Like many others in Berlin, Hermannplatz station was designed by Alfred Grenander and built between 1923 and 1926. (LBS)

(1929) and was further tapped by this author in the course of his researches.) On the question of public transport, the volume was as exhaustively comprehensive as on every other subject. In 1931 the city's tramways covered almost 140 million passenger-kilometres, while its buses covered almost 37 million and the overhead and underground railways almost 60 million. The figures fell considerably in 1932, but there was less work this year than there had been in 1931, and the principle that 'transport creates work, work creates transport' was evidently also true in reverse. Be that as it may, there were evidently very good reasons for describing the events that unfolded every day of the week (holidays included) at 248 different stations throughout the city as a gigantic never-ending mass migration. (Of these stations, 163 were either in the inner city, on the city's ring road or in the suburbs, 20 were main-line stations and 65 were overhead or underground stations.) In the course of a single year some 1.5 thousand million passengers – almost the whole of the world's population at that time – used the city's public transport system.

It is scarcely surprising that Berlin's writers, especially those lyric poets of the 1920s who prided themselves on their closeness to everyday reality (it was here that the term *Gebrauchslyrik*, 'practical poetry', was coined) were fascinated by the theme of city transport. Walter Mehring, a writer of satirical *chansons* and cabarets and co-founder of Berlin Dada, wrote a series of *Simultangedichte* (simultaneous poems) in 1920, in which he sang of the 'Hectic Electric [tramway company of] GREATER Berlin, rhyming 'underground' with 'merry-go-round', and, in a poem significantly titled 'Home is Berlin', treated the city as a living person who keeps on calling out the words: 'No time! No time! No time!'

Erich Kästner was a New Objectivist, a 'practical poet' *par excellence*. He had barely been living in Berlin for two years when he turned to deriding visitors from the provinces who stood around, confused and speechless, on Potsdamer Platz, not knowing which way to turn:

> The tramways rattle. The car tyres scream . . .
> The underground rumbles. The houses gleam.
> It's not what they're used to. Why should they risk it?
> In terms of its noise Berlin takes the biscuit.

The terrified provincials huddled on Potsdamer Platz 'until run down by a passing car'. In the same anthology of Berlin writing (*Hier schreibt Berlin*), we also read of buses 'crawling' through the night and of trams 'squealing over the points'. Leon Feuchtwanger can be found here recalling a journey he made in carriage Number 419 of the Berlin Overhead and Underground Railway shortly after the city's shops and offices had closed ('This shipment of people'), while Alfred Döblin imagines the trams and buses passing over the Alexanderplatz: 'Rumble, rumble, the trams go by.'

Statistics have also survived, of course, detailing traffic counts taken at important points in the inner city, from which it emerges, for example, that between eight in the morning and eight in the evening on 14 August 1928 more vehicles passed through Auguste-Viktoria-Platz (by the Kaiser Wilhelm Memorial Church) than had used Potsdamer Platz a few days earlier, on 28 July. When broken down, the figures also reveal the 'social' and qualitative composition of the traffic: of the 38,998 vehicles which passed the Kaiser Wilhelm Memorial Church, some 73 per cent were registered as motor vehicles, whereas at Potsdamer Platz (where the overall total was 33,037) the equivalent figure was 56.5 per cent. The latter square, by contrast, had a

much higher proportion of trams (10.2 per cent) and bicycles (26.4 per cent) than the square in the more fashionable West End, where the figures were 4.2 and 15.9 per cent respectively. Not only do these figure refute the myth that Potsdamer Platz was the 'busiest square on the continent', they also show that those of us who did not live through the 1920s must strain our imagination when we speak of the urban traffic of that time, when cars did not yet have a monopoly and when horse-drawn vehicles and handcarts still made up a not insignificant proportion of the traffic. Nonetheless, these older forms of transport were already being supplanted in public and private life by a process of mechanization and motorization that could hardly be ignored. Horse-drawn carriages were slowly disappearing from the city's streets. At the beginning of 1923 the ratio between horse-drawn carriages and cars (or 'petrol-driven carriages' as they were known at the time) was still finely balanced at 2.151 : 2.142, whereas by the end of 1932 there were only 74 horse-drawn carriages left in the city, against 7,924 petrol-driven motor cars. And the final hour of the last remaining horse-drawn vehicles was about to strike, as the dray horses used by brewers and milkmen were finally put out to grass.

Another symbol of modern life, the radio, had caught on with spectacular speed since the first programme had been transmitted from a studio at Vox House in Potsdamer Straße on 29 October 1923. The catchword of the age was 'rationalization', a word repeated on every occasion, both inside and outside the office. The result was that by 1930 much was already regarded as old-fashioned that had been the height of fashion ten years earlier, a change of perception nowhere more keenly felt than in the 'old' city centre in Friedrichstadt. The centre's gradual move to the west robbed it of

The latest office technology – addressing machines – is demonstrated at a trade fair in 1929. (Ullstein)

The 'Big Fight' in the Sports Stadium on Potsdamer Straße: Hans Breitensträter (right), Berlin's most popular boxer, photographed after his third-round knock-out of the Irish heavyweight champion, Paul Murray, 10 February 1921. (BPK)

much of the fascination that it had had in the years before World War I. Even the nightclubs along Friedrichstraße were accused by the 1931 *Guide to Alternative Berlin* of offering attractions which had 'only a certain museum-like appeal', whereas Tauentzienstraße and Kurfürstendamm, stretching for several kilometres between Wittenbergplatz and Halensee, were 'entirely modern and of the present day'.

A reduction in working hours made it possible for large sections of the working population to enjoy the weekend (often referred to by the English word) by relaxing away from home. There were still the good old fairgrounds in working-class quarters, but the vast entertainments complex of Luna Park on the Halensee held a far greater appeal. Crowds of Berliners flocked to major sporting events as never before. Boxing increased in popularity within a matter of years, and a golden age began for the six-day cycle race held at the city's indoor sports arena. This insane event drew not only blue- and white-collar workers but also high society and prominent figures from the city's cultural scene, who would call in at the arena, after attending the theatre, for a couple of hours of amusement. Like so many other aspects of metropolitan life, the six-day race inspired the muse to literary endeavour. Alfred Kerr, for example, devoted a poem to the subject, including the following lines:

> Six days and six nights they pedal away
> In a bi- or tricyclical sort of a way.
> If they start to nod off in this circular race,
> Their partners are waiting to take up their place.

In the case of the six-day race at the Sports Stadium it was the fascination of technology that provided the unifying force for an audience made up of rich and poor alike. Football, by contrast, was still regarded largely as a 'proletarian' sport, while tennis and, of course, golf were reserved for a relatively insignificant section of the upper échelons of society.

As well as the open-air swimming pools, where people thronged in their thousands, Berlin had its own 'seaside' at the lakes surrounding the city. Founded in 1907, the lakeside resort at Wannsee achieved its phenomenal popularity only after the beach had been artificially extended in 1929/30 and the surrounding area subjected to a fundamental modernization programme. The lakeside lives of the city's population are a chapter in themselves. For many Berliners, as well as for visitors to the region, the natural beauty of those parts of the city on its western and south-eastern edges – the lakes around the River Havel and the reaches of the upper Spree – exerted a great appeal. The mass migration that took place every weekday as Berliners went to work became a mass exodus every weekend as they fled from the city, escaping into the countryside, to open-air swimming pools, lakeside resorts and woodland restaurants, bars and cafés. But even here the social differences were readily apparent. A local guidebook from 1932 makes no bones of the matter: 'Since the inhabitants of the western parts of the city generally head westwards when going on outings, while those who inhabit the easternmost parts of Berlin prefer the reaches of the upper Spree, the hostelries on the Havel, at Wannsee and in Potsdam are rather more elegant than those in the east.'

The terrace café at the most popular lakeside resort at Wannsee, 1932. (BPK/Arthur Koster)

Every weekend Berliners flocked en masse *to their garden houses in the green environs of the city, 1931. (LBS)*

The villas of the wealthy bourgeoisie found their counterpart in the garden houses and allotments of the lower and middle classes, who took up allotment gardening in their thousands. By 1932 there were no fewer than 102,299 such allotments in Berlin. Those who had not leased a weekend retreat for themselves could at least gratify their love of nature by filling the balconies of their rented flats with carefully tended flowerpots. The 1927 Baedeker painted a highly idyllic picture of the city with its countless tracts of green: 'The external aspect of Berlin is almost without exception pleasing to the eye. Even in the old town, dark alleyways are very much the exception.' But such a generalization ignores the housing shortages and the squalor in which so many of the city's children lived, a squalor all too plain to those who peered behind the façades of the blocks of rented accommodation. The vast expanses of grey were just as much a part of Berlin at this time as the many flashes of colour which the city had to offer: only when taken together do they produce a picture of the city as a whole.

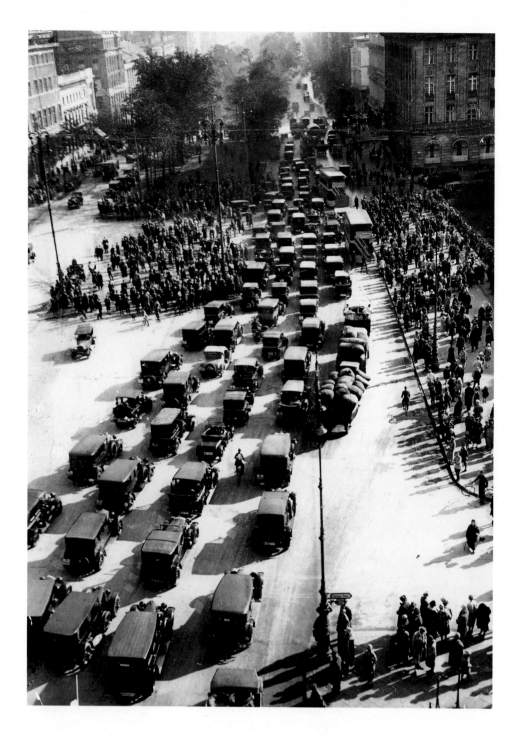

Traffic in Unter den Linden, viewed from the Brandenburg Gate – on the right is the famous Hotel Adlon, 1930. (Ullstein)

Right: An underground train between the overhead station at Danziger Straße (visible in the distance) and Senefelder Platz, 1931. This old underground line (No. 1) had been operational since 1913 and led from Nordring Station, via the stations at Alexanderplatz, Spittelmarkt, Potsdamer Platz, Nollendorfplatz and Zoologischer Garten, to Wilhelmplatz (now Richard-Wagner-Platz) in Charlottenburg. (LBS)

Below right: A No. 1 bus on the Auguste-Viktoria-Platz (now the Breitscheidplatz), c. 1930. The No. 1 bus route ran from the Arsenal in Unter den Linden to Halensee Station at the western end of the Kurfürstendamm, linking the old city centre to the New West End.

Statistics prove that Potsdamer Platz, shown here, was not actually the busiest square in Berlin, but this had no effect on popular mythology. The hoardings covering construction work on the Columbus House provide a perfect opportunity for advertising. (LBS)

THE CITY'S CIRCLE LINE was built in 1867–77 and was complemented by the suburban railway of 1874–82. Between them they handled most of Berlin's commuter and holiday traffic, involving a rail network which, in the mid-1920s, covered 53 kilometres. To this should be added the 54-kilometre network of overhead and underground railways, built in 1897–1902 and repeatedly extended after 1907. The trains ran on overhead lines between Warschauer Brücke and Nollendorfplatz and between Danziger Straße and Nordring, while the remainder of the track – with the exception of a section of cutting between Breitenbachplatz and Thielplatz (Dahlem) – was underground. Some seventy tramlines and twenty 'motorbus' routes completed the local transport network. For decades the separate services were in the hands of a variety of firms and it was not until 1 January 1929 that buses, trams, overhead railway and underground were combined, economically and organizationally, as the Berlin Transport Joint-Stock Company.

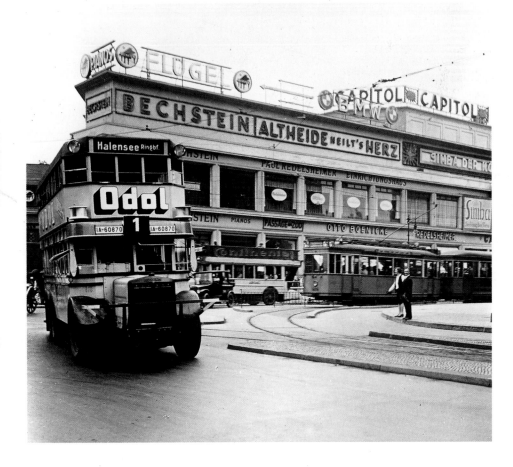

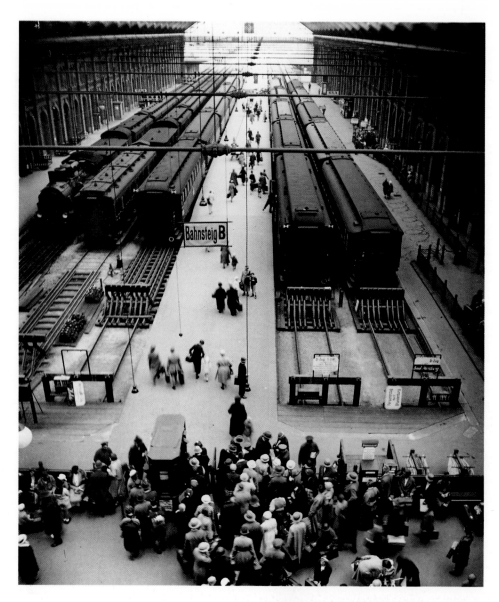

Opposite: A driver of a horse-drawn cab, one of a dying profession, 1928. (BPK/Friedrich Seidenstücker)

A crowd of people around the ticket barrier at the mainline Potsdamer Station on Potsdamer Platz, 1932. (BPK/Friedrich Seidenstücker)

Passengers on the suburban railway, 1927. The suburban and circle lines handled around a quarter of Berlin's local passenger traffic at this date. (BPK/Friedrich Seidenstücker)

Newspaper deliverymen and their bicycles in the yard of a Berlin publishers, c. 1930. (BPK/Friedrich Seidenstücker)

Below right: Three-phase generator ESD 375/21500 at the General Electric Company works in Prüffeld, 1929. (BPK)

Engineers at the Borsig Works assembling one of the first three express locomotives of the new 03 type, summer 1930. (BPK)

Inside one of the factory buildings at Siemens, 1928. (BPK)

The Rummelsburg power station which, by the time of this photograph (1930), had become officially known as the Klingenberg power station, after its architect. (Ullstein/Emil-Otto Hoppé)

THE 1907 CENSUS revealed that there were 8.5 million working women in Germany. By 1925 there were 11.5 million, of whom almost 1.5 million were employed in trade and industry. The image and prototype of the 'New Woman', propagated chiefly in Berlin, had more or less become a fact of life by the late 1920s, at least on a superficial level. In real social terms, however, women never achieved actual emancipation, and the picture of the New Woman remained largely a cliché put about by advertising and the media. The differing rates of pay contributed in no small way to this state of affairs, in that the hourly rate for male unskilled workers in the Berlin metal industry was 0.84 marks in October 1929, while their female equivalents were paid 0.59 marks. In the textile wholesale trade a male clerk was paid a starting salary of 125 marks a month, while his female colleague received only 106.50 marks.

Office rationalization programme at the regional post office in Berlin, where dictation by telephone was introduced in 1931. (Ullstein)

A female operative on a telephone assembly line, c. 1930. (LBS)

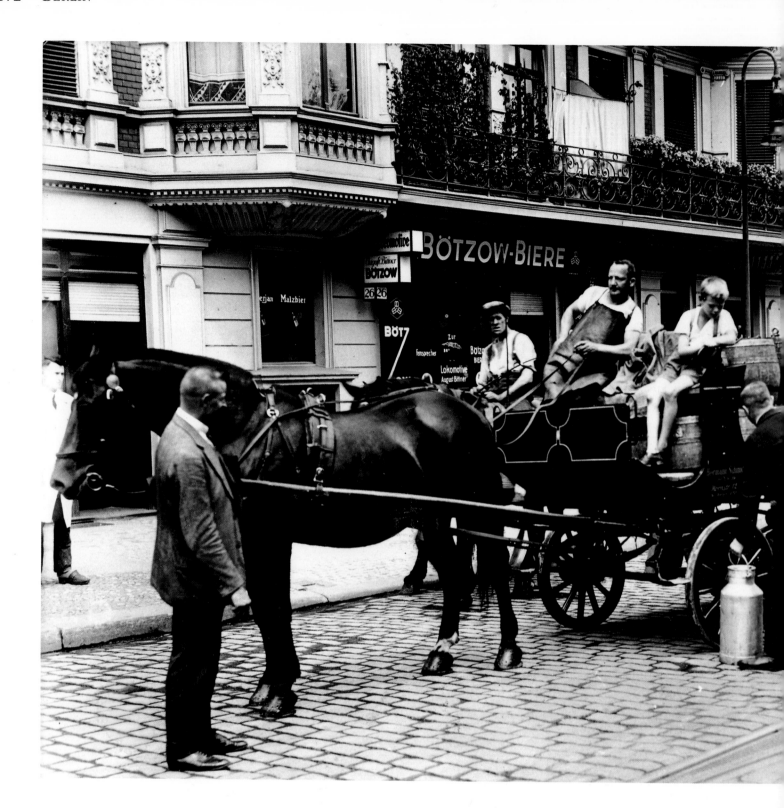

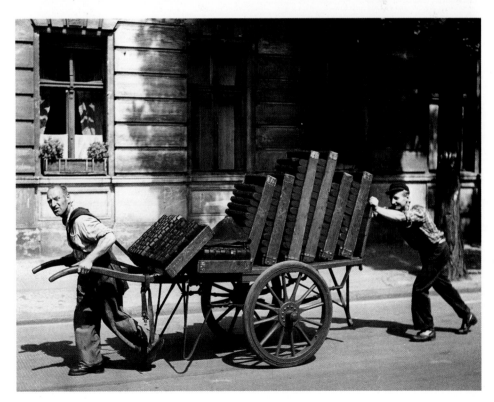

A horse and cart used to deliver not only beer but milk, 1927. (Ullstein)

Above right: A construction worker pouring tar into the cracks between the cobbles, c. 1930. (BPK/Friedrich Seidenstücker)

A coal delivery cart, c. 1930. The majority of Berlin's homes were heated by means of tiled stoves fired by briquettes. (BPK/Friedrich Seidenstücker)

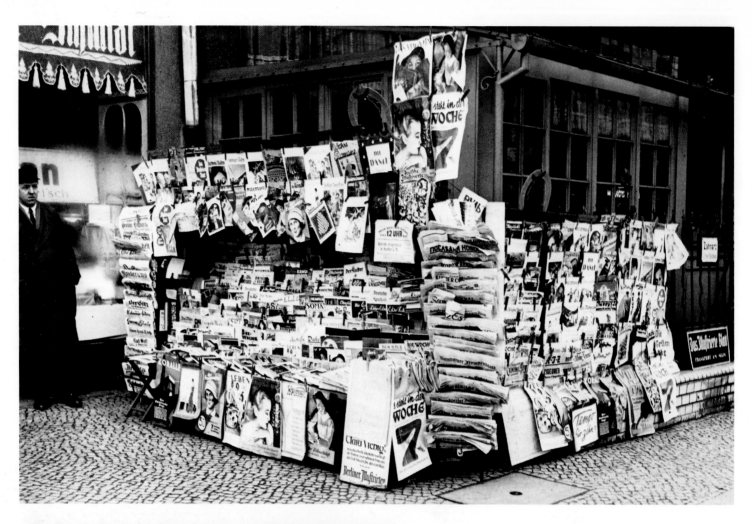

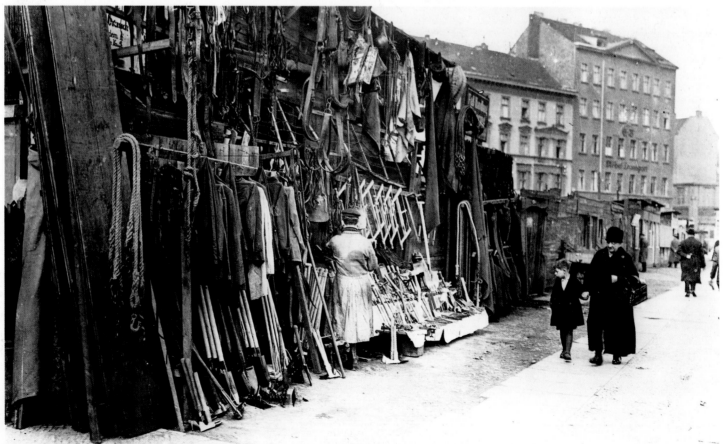

THIS NEWSPAPER KIOSK on Potsdamer Platz gives an idea of the vast range of magazines and newspapers on sale in Berlin in the early 1930s. The city's 'big three' newspaper publishers – Ullstein, Mosse and Scherl – produced not only high-circulation dailies but also extremely popular magazines which were read throughout the country as a whole. Scherl Verlag published *Die Woche*, a rival to Ullstein's *Berliner Illustrirte Zeitung*. Other successful magazines published by Ullstein included *Die Koralle*, *Die Dame*, *Uhu* and *Die Grüne Post*, although its new evening paper, *Tempo*, launched in September 1928, had greater difficulty finding a foothold. Apart from the publications of these major houses, small well-produced magazines also had a good chance of survival, such as the *12 Uhr Blatt*, a popular paper with a strong republican bias. 1932 (BPK Friedrich Seiden-Stücker)

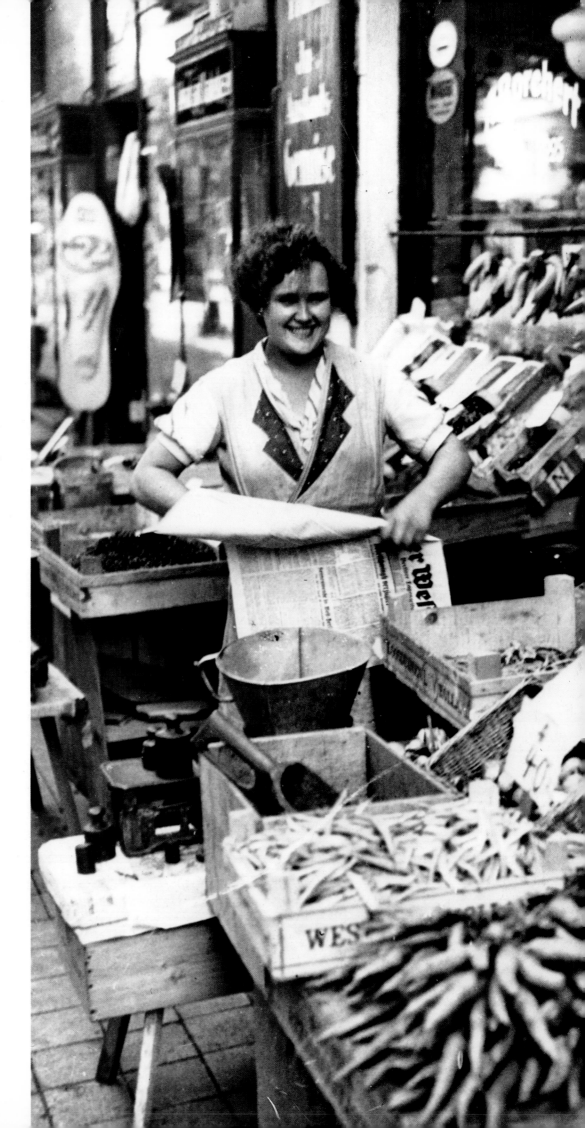

Rags and scrap iron are the main goods on offer at a 'poor man's department store' in the old Scheunen quarter of North Berlin, 1920. (ABZ/Willy Römer)

A friendly vegetable-stall holder in Wexstraße, 1928. (BPK/Friedrich Seidenstücker)

Man selling carp outside the central covered market in Dircksenstraße off Alexanderplatz, 1929. (BPK/Hans Casparius)

*A sign of the times: milk from a 'filling-
station' – the first in Berlin, c. 1931. (BPK)*

*A horse-drawn milk delivery cart n
Waisenstraße in the centre of Berlin, 1931.
The Bolle Dairy to which the cart
belonged was Berlin's traditional supplier
of milk. By 1930 they were beginning to
replace horse-drawn vehicles with
motorized transport. (LBS)*

Opposite: A modern, brightly lit shop window on the Kurfürstendamm, 1930. (BG/Osram)

The first escalator in Hermann Tietz's department store on the Alexanderplatz, c. 1925. (AKG)

A traditional 'colonial' grocer's shop, 1919. (BPK)

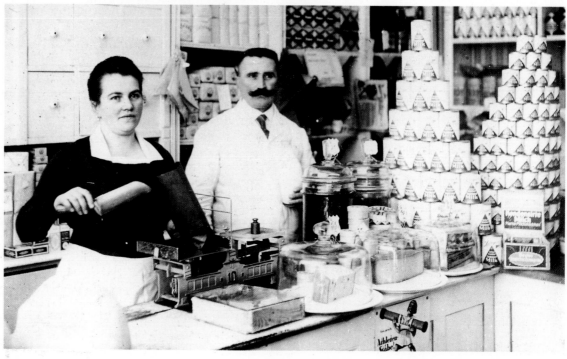

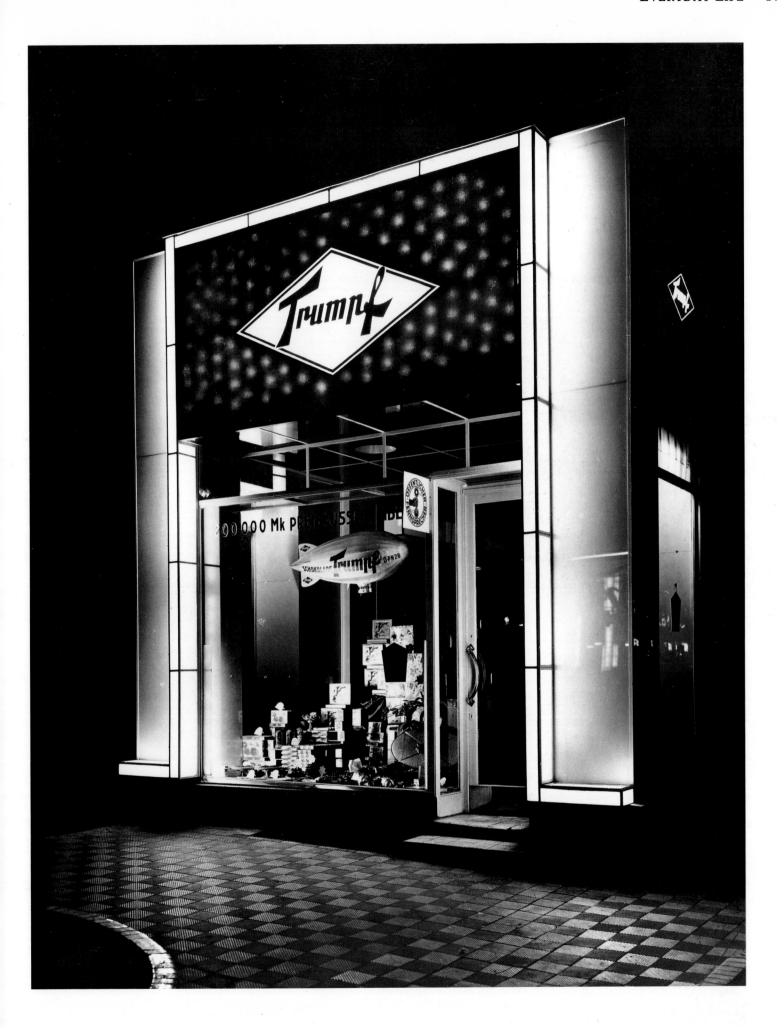

Opposite above: Business premises in courtyards off Alexanderstraße in the city centre, 1930. (LBS)

Opposite below: Making the most of the sunshine in one of the Hinterhöfe (inner courtyards), 1929. (Ullstein)

The front of a block of flats in Berlin, July 1924. To live at the front of a building was to enjoy a social privilege, and to decorate the balcony with flowers and plants was a matter of pride. The balcony was the most popular part of the flat during the hottest months of the year. (LBS)

Slum dwellings in the courtyard of the Stadtvogtei, one of Berlin's former prisons, 1932. (BPK/Carl Weinrother)

THE BERLIN HINTERHOF was a notorious architectural feature of the city. During the second wave of industrialization, huge blocks of tenements were built around a series of courtyards, some of which stretched back from the street frontage through up to three or four tiny yards, with an ever decreasing amount of light entering. The legal minimum area for a yard was 28.5 square metres, to allow the fire engines room to turn. It was not until 1925 that new legislation for the city prohibited the building of these Hinterhöfe.

A barrel organist in one of the city's inner courtyards, 1931. (BPK/Friedrich Seidenstücker)

Children fishing for treasure through basement grilles, 1929. (Ullstein)

Opposite above: An old woman dances for her supper on the pavement to the accompaniment of a wind-up gramophone, 1928. (BPK/Herbert Hoffmann)

Opposite below: Buskers in an inner courtyard, c. 1930. (BPK)

Cramped accommodation in the former Stadtvogtei, 1928. The motto reads, 'Through repentance's low door we attain happiness'. (BPK)

ACCORDING TO THE COUNTRY'S housing census of 16 May 1927, there were 1.21 million houses and flats in Berlin, which at this time had 4.03 million inhabitants and 1.3 million households. These bald statistics become somewhat more meaningful when we break down the total number of dwellings according to size and number of rooms. There were 62,000 very large apartments (seven or more rooms), 154,000 large apartments (five or six rooms) and 155,000 apartments with four rooms. The lion's share was taken up, however, with small two- or three-room apartments, of which there were 360,000 (29.7 per cent) and 430,000 (35.4 per cent) respectively.

A Lutheran nun engaged in welfare work, seen here looking after the children of a mother who is in hospital following the birth of her tenth child, 1931. This was one of a photojournalistic series on housing and social problems by Felix Man for Ullstein. (Ullstein/Felix H. Man)

Above: The living room in the apartment of the theatre director, Erwin Piscator (1893–1966), with furniture by Marcel Breuer. (Ullstein/Sasha Stone)

Left: Dining-room in the house of Walter Rathenau, in the fashionable residential quarter of Grunewald, c. 1922. (LBS)

Opposite: Dining-room in the apartment of the art-dealer Alfred Flechtheim with paintings by Max Beckmann and Karl Hofer, together with sculptures by Edgar Degas, Ernesto de Fiori and Aristide Maillol, 1929. (Ullstein)

THE FIRST OFFICIAL LIGHT-ENTERTAINMENT programme to be broadcast by a licensed broadcasting company in Germany was transmitted by the Radio-Stunde Company between 8 and 9 o'clock on 29 October 1923. A 1 kilowatt transmitter was used in the primitive broadcasting studios of the Vox Building at 4 Potsdamer Straße. By 1 December 1923 there were still only 253 radio subscribers in the whole of the area covered by the Berlin postal district, but the new medium soon caught on: by 1 October 1924 there were 107,000 subscribers and by 1 April 1926 522,000 (the total for the country was 1.2 million). In mid-January 1931 the organization, which had grown considerably in the intervening period and now comprised several separate stations and departments, moved into the newly completed Broadcasting House in Masurenallee close to the city's Exhibition Centre.

Opposite above: Summer's day on a roof garden with radio accompaniment, 1926. (BPK)

Opposite below: A family celebration with music from the radio, 1924. (BPK/Willy Römer)

Listening to the radio was the fashionable leisure activity of 1931. The model here is a Telefunken Type T.121. (BPK)

Bathtime at a Pestalozzi School for orphans. The clean and well-equipped institutional bathroom contrasts starkly with the conditions under which other children were living, 1925. (BPK)

A young girl with her nanny in the Tiergarten, 1929. (BPK)

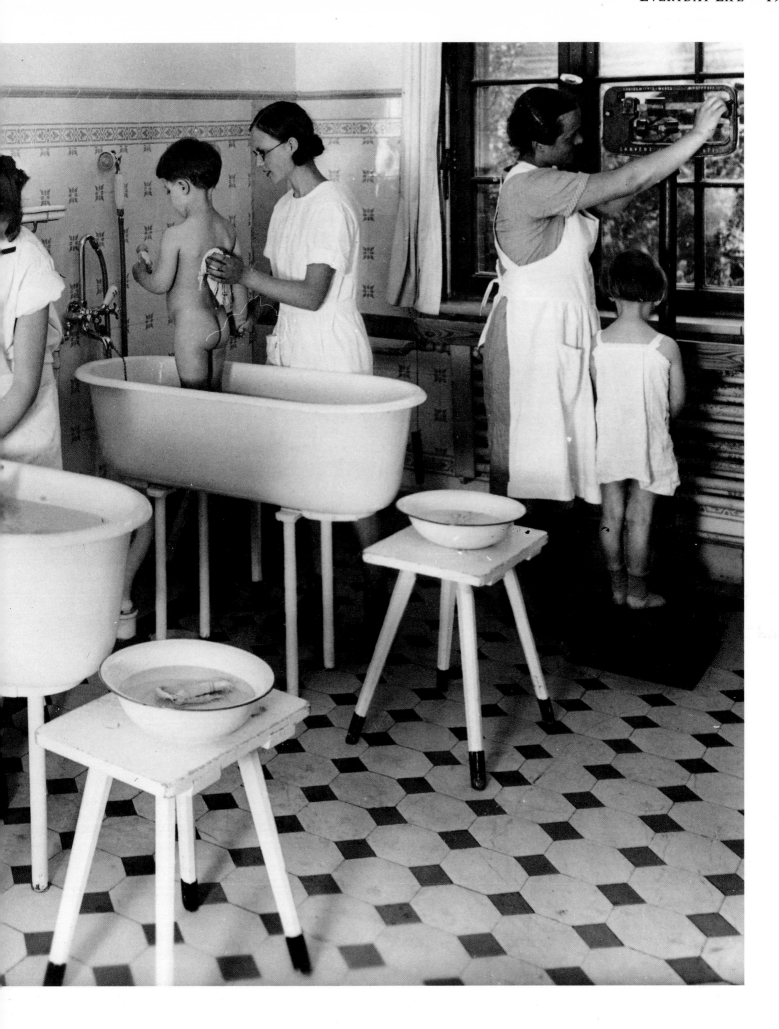

Part of the Luna Park pleasure ground, c. 1925. (LBS)

Street life in Berlin always offered some new entertainment – here, stiltwalkers hand out leaflets in an advertising promotion, 1925. (LBS)

FOUNDED IN 1904, LUNA PARK was Berlin's largest amusement park, situated on Halensee Lake at the edge of the Grunewald. 'In the summer months the prettiest girls compete here for the title of Queen of the Summer and on balmy evenings the most beautiful fireworks rend the night sky with their displays. Pleasure is mechanized. The cable railway is dressed up to look like a skyscraper. There are airborne carriages, water slides and automobiles which even those who are ignorant of the traffic laws can drive,' Curt Moreck wrote in his *Guide to 'Depraved' Berlin* of 1931. From 1927 the major attraction was the swimming-pool with its artificially induced waves which, like the park as a whole, was open until late at night.

A visiting troope with their Röhn-hoops pose for the photographers in front of the famous Wintergarten revue club in Dorotheenstraße, 1931. (BPK)

A firework display in Luna Park, 1930. (Ullstein)

The Adlon Hotel in Unter den Linden, c. 1928. (BPK)

A typical Berlin bar, c. 1925. (BPK)

THE ADLON WAS BERLIN'S best-known hotel. When the *Chicago Tribune* decided to set up its own offices in Berlin, the paper's Berlin correspondent was apparently instructed to use the Adlon as his office. 'For diplomats and politicians the Adlon is certainly the most suitable place to stay in Berlin,' Eugen Szatmari wrote in his *Buch von Berlin* in 1927. 'The Adlon's foyer is a story all to itself. If the head waiter were ever to write his memoirs, he would certainly have a valuable contribution to make to Berlin's contemporary history. There is a constant coming and going in the foyer where he works, visitors' cards are presented on silver salvers, and beautiful women pass through the room on their way to five o'clock tea.'

A lonely beauty in the Romanisches Café, a favourite haunt of theatre people, c. 1925. (BPK)

Inside the Café Uhlandeck on the corner of Kurfürstendamm and Uhlandstraße, c. 1930. (BPK)

Society ladies taking refreshment at the Rupenhorn Club on the Havel, c. 1931. (Ullstein/Alfred Eisenstaedt)

'THE RUPENHORN CLUB, situated so idyllically and conveniently on Heerstraße on the way to Schildhorn, has been substantially enlarged for the new season,' the *B.Z. am Mittag* announced on 16 May 1929. 'The clubhouse terrace has been substantially enlarged, the tennis courts are in prime condition and, with their fresh green grass, the remaining areas that have been set aside for land games of every description are every bit as alluring as the extensive bathing meadow with its attendant outbuildings.'

Opposite below: Members of the Wandervogel youth movement at a tram stop, 1930. The Wandervogel movement had started life in a Steglitz grammar school around the turn of the century and was the nucleus of a youth movement which sought to escape from what it called the 'decadence of city life' and return to nature. Berliners tended to describe such groups as Latscher, from the pejorative verb 'to traipse' or 'slouch along'. (BPK)

Two bikers checking their finances before heading off into the blue, c. 1930. (BPK/Friedrich Seidenstücker)

The Prinzengarten on the Müggelsee, a popular outdoor restaurant, c. 1930. (BPK/Friedrich Seidenstücker)

Bathing beauties on the terrace of the Wannsee beach resort, which was extended and developed in 1929-30. (BG)

Playing in the sand at Wannsee, 1929. (BPK/Friedrich Seidenstücker)

Opposite: Though the sign says 'out of bounds', the jetty provides a good place to sit at the Wannsee bathing beach, c. 1930. (BPK)

Opposite: Two of the city's allotment owners, 1930. (Ullstein)

A pigeon fancier, c. 1925. (LBS)

A campsite on the Havel near Kladow, c. 1930. (LBS)

Spectators at a football match in Frohnau, 1930. (BPK/Friedrich Seidenstücker)

Riders lining up for the start of the Six-Day Race in the city's Sports Stadium, 1930. (Ullstein)

Race day at the AVUS in 1921, the year in which it was opened up to traffic. (The letters stand for 'Automobil-, Verkehrs- und Uebungs-Straße' or 'Automobile, Traffic and Practice Road'.) At the steering-wheel is Fritz von Opel, the winner in Group

VIIIa. The AVUS was the first two-lane motorway in Germany and, as such, the model for the autobahns that were built in the 1930s. (Ullstein)

Opposite: A well-equipped race-goer, 1926. (BPK/Friedrich Seidenstücker)

On the terrace of the Wannsee golf club, 1928. (Ullstein)

A tennis tournament at the Red-White Club in Grunewald, 1922. (Ullstein)

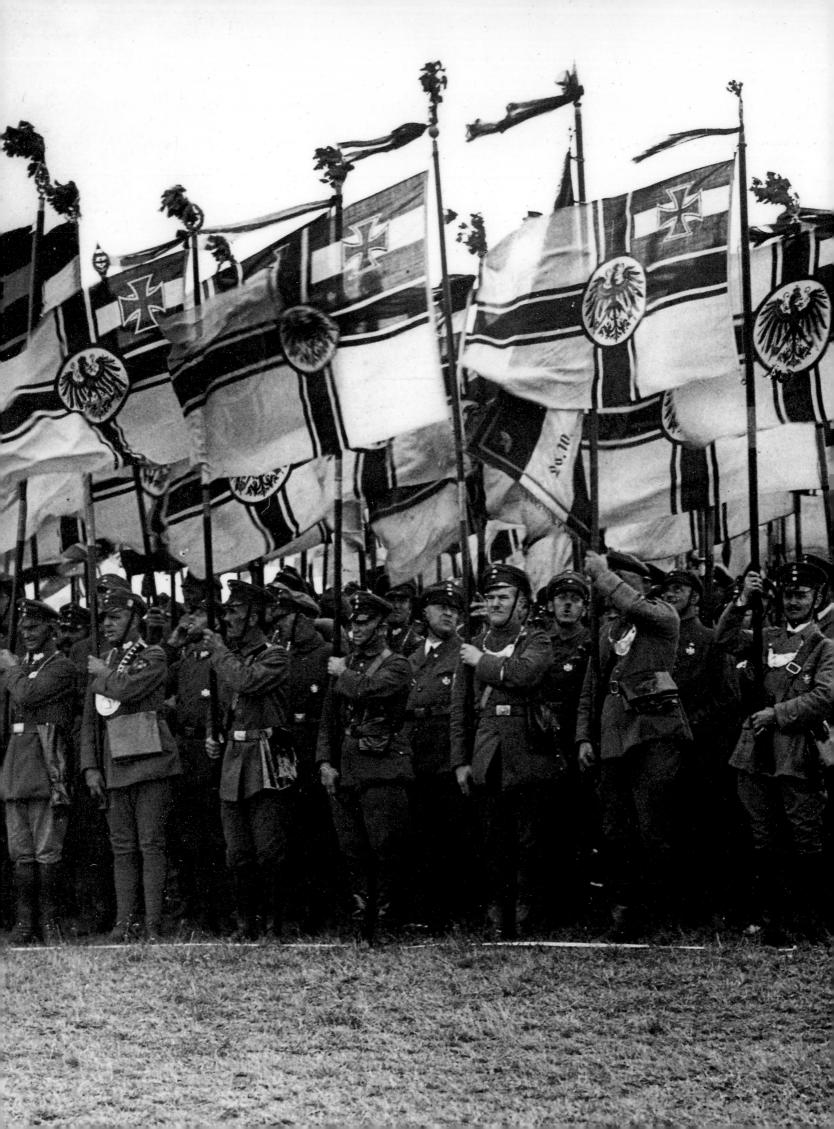

The End of the Republic

SCARCELY HAD GOEBBELS SET FOOT IN THE CITY in November 1926 when, as new NSDAP Gauleiter for Berlin-Brandenburg, he set to work on his plan to turn what was then an insignificant party into a force to be reckoned with. Right-wing extremism, anti-socialism and rabid anti-Semitism had long had a following in Berlin, but none had ever succeeded in leading more than a merely sectarian existence. In the elections for the city council in October 1925, the Nazis had formed a coalition with another nationalist party and still polled only 1.5 per cent of the votes, while yet another anti-Semitic faction had also polled about the same with their total of 27,536 votes. Since the end of the Reich in 1918, the German National People's Party (DNVP) had taken the leading role in nationalist right-wing politics.

In Berlin, in particular, the DNVP did better than average, winning no fewer than 385,324 votes (20.8 per cent) in the October 1925 elections, thus making it the second most powerful party after the Social Democrats on the city council, with the Communists only a short way behind. If the NSDAP was to triumph over its right-wing rivals and improve its standing *vis-à-vis* the German Nationals, a completely new tactical approach was needed, argued Goebbels: 'Red Berlin' would have to be defeated in battle, an aim which, as it turned out, was meant to be taken entirely literally. From now on the Nazis practised as they preached in Berlin, adopting a course of provocation, attack, violence and yet more violence! No wonder that Goebbels' journal, first published on 1 July 1927, was called *Der Angriff (The Attack)*.

By 14 November 1926 Goebbels was testing the water with a 'propaganda parade' involving several hundred storm troopers (SA) marching through the working-class quarter of Neukölln. The resultant brawl was part of a well-laid plan, a campaign of calculated provocation, the next stage of which took the form of rallies held in halls traditionally used by workers' organizations. A speech by Goebbels in the Pharus Rooms in the largely Communist quarter of Wedding on 11 February 1927 was inevitably followed by scenes of appalling violence between Nazis and Communists. But the first real climax of this 'civil war' was an attack by 600 members of the local Brownshirts, some of whom were heavily armed, on the twenty-three members of a military band belonging to the Red-Front Fighters' League. A well-planned affair, it took place on 20 March 1927 at Lichterfelde-Ost station and left six of the bandsmen seriously injured and ten others with

A wall covered in political posters encouraging Berliners to vote in the Reichstag elections on 14 September 1930. (BPK)

Previous page: Stahlhelm parade, 1932. (LBS)

lesser injuries. The Nazis then withdrew from the scene of battle into the inner city. In the course of their withdrawal, and during a subsequent rally, there were repeated attacks on passers-by whom the Nazis thought might be Jewish.

The events of 20 March 1927 and further assaults of a similar kind ensured that, within a matter of months, the Nazis were a household name in Berlin: the result was a sharp, if somewhat surprising increase in the number of their members and other sympathizers. It was as though a certain section of the population, albeit still only small in size, had been waiting for its cue to 'beat to pulp both the commune' (as the Nazis called the supporters of the German Communist Party) 'and the Jewish rabble', as Goebbels so elegantly put it. During the years that followed, these early attacks provided the model for countless assaults by the SA – or 'political soldiers', as they were known in the party – on Communists, Social Democrats and ordinary Berliners, who were, or were thought to be Jews. The earliest pogrom-like attacks on Jewish businesses and premises followed the NSDAP's remarkably good results in the Reichstag elections on 14 September 1930; even at this early date the windows of 'Jewish' shops in the inner city were already being smashed. The first deaths were reported shortly afterwards, when the Nazis started attacking officials and members of left-wing organizations, but it was not until 1932 that blood began to flow more freely, especially during the electioneering campaigns of the summer and autumn months. Systematically organized terror against the working-class movement and an active and aggressive anti-Semitism formed the nucleus of the programme of activities undertaken by the NSDAP in Berlin. It was this, far more than their party political manifesto, that distinguished the Nazis from rival organizations of a *völkisch* or extreme right-wing persuasion. Their violent ideology, with its sense of resentment and hatred of everything that they described as 'non-German', 'inferior' or 'of

Passers-by are searched for weapons in the working-class quarter of Neukölln, May 1931. (BPK)

Members of the Brownshirts playing in a brass band at a NSDAP rally in the Grunewald Stadium, 27 July 1932. In the elections four days later the NSDAP won 37.4 per cent of the vote, making it the single largest party in the Reichstag. Its share of the vote in Berlin was 28.6 per cent. (LBS)

alien race', raged not only in leaflets and newsapers; the Nazis also brought physical force to assembly halls and to the streets and squares of Berlin, seeking to annihilate all their political opponents even before their hands had grasped the helm of state. They created a climate of fear which all too often dulled all thought of resistance, and yet their openly flaunted militancy, their indefatigable activism and the SA's military chic had an almost magic appeal, especially on the young, whatever their social background. By 1930/31 more than a half of the country's students had been won over to the party.

The international economic crisis broke in the autumn of 1929 but even before its effects had been felt in Berlin, the Nazis were already a force to be reckoned with in the city, although they had yet to enjoy the large-scale support which the crisis was to bring them. In the city council elections, held on 17 November 1929, the party polled in excess of 130,000 votes or 5.8 per cent of the total, and, for the first time in its history, entered the city council with Goebbels at its head. To all intents and purposes the election campaign had been dominated by only a single issue, the bribery scandal surrounding the textile firm of Sklarek Brothers. As the NSDAP never tired of stressing, the so-called 'Jewish' businessmen had cheated the city of millions of marks, obtaining vast sums of credit from the City Bank and bribing countless officials on the local council. The Nazis used the affair to foment a propagandist attack not only on the 'Jewish-Marxist alliance' which, they claimed, was 'enslaving the German nation' but on every other victim of their conspiracy theories. Since Communists as much as Conservatives were involved in the Sklarek affair, their propaganda was bound to fall on fertile

ground, more especially in the case of those Berliners who had always thought the Weimar Republic the source of all the nation's ills. The city's mayor, Gustav Böß, though plainly innocent, handled the whole affair very badly and found himself obliged to resign once it became clear he had lost the confidence of the coalition of middle-class centre parties and Social Democrats to which he owed his position. With Böß's departure from office the city lost a political figure who had managed, as few others had done, to reconcile the divisions within the republican camp. In much the same way, the death of Foreign Minister Gustav Stresemann on 3 October 1929 robbed the country of a politician who, even if only a 'republican of convenience', had succeeded over the years in yoking a section of the Conservative camp to a form of republican state or at least to the policies of the national government.

And so it was that in the autumn of 1929 old rivalries broke out anew, and with renewed severity. The squabbles involving the principal parties in local and national government served only to discredit the parliamentary system *per se* in the eyes of many Germans who, inexperienced in the ways of democracy, felt only an urgent need for harmony. During these weeks and months the feeling grew that the balance between the political parties, already extremely fragile, was now beginning to crumble. The Berlin election campaign had shown that, thanks to their propaganda, Goebbels & Co. had found a sympathetic ear far beyond the confines of their party, even if many supporters regretted their 'anti-Semitic excesses', describing them as 'exaggerated' or, in the case of the educated middle classes, still treating the Nazi activists as merely 'common and vulgar'. It was at precisely this time that their greatest rivals for the right-wing vote, the German National People's Party, moved even further to the right. This move – initiated by Alfred Hugenberg, the owner of a newspaper empire and head of the powerful UFA film company – was undertaken in the face of some opposition from a small minority of its members. By introducing his petition for a referendum against the Young Plan, Hugenberg steered the party along the road to xenophobic demagogy and thus brought the influential paramilitary Stahlhelm (Steel

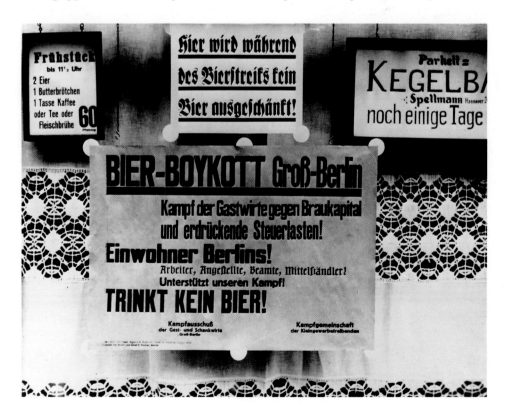

Posters and notices in a Berlin pub during a brewery strike, one of many strikes in 1932. (BPK)

Helmet) – a right-wing veterans' organization led by Franz Seldte – closer to the German Nationals. In their rejection of the Young Plan, Nationalists and Communists found themselves in broad agreement, albeit for wholly different reasons. The plan provided for German reparations to be paid to her former enemies in World War I at a level of two thousand million marks every year for the next six decades; the final payment of 900 million marks was due to be made in 1988. Discussion surrounding the Young Plan lent renewed topicality to a long-running theme, from which extensive mileage had already been extracted during the early post-war period by forces opposed to the Weimar Republic. The topic in question was the Treaty of Versailles, which demanded territorial concessions and a reduction in the size of the Reich's armed forces to an army of 100,000 men, with a resultant loss of prestige. The strength of feeling against 'the Versailles system', as it was called, encouraged millions of Germans to take up arms against the Republic.

These altercations showed once again how fragile the political basis of the Republic had been from the very outset. Critical writers such as the liberal journalist Theodor Wolff, editor of the *Berliner Tageblatt*, and the industrialist and politician Walther Rathenau had noted at an early date how shaky were the foundations on which the Republican state had been established after the revolution of November 1918. Never before had republicanism found a nation as unprepared as Germany was at the time when the Kaiserreich collapsed. The country was 'still completely entangled in the old threads', Wolff wrote in

A NSDAP band in an SA club in Gniesenaustraße in the Kreuzberg District, 1932. (LBS)

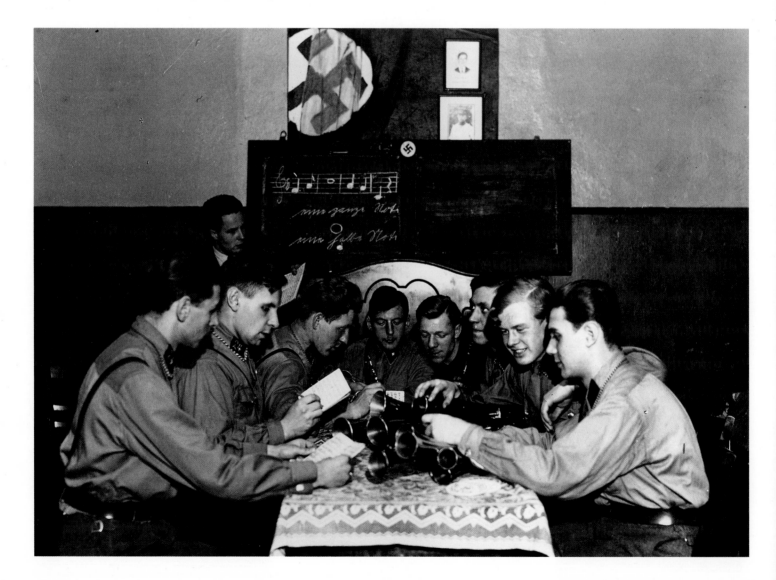

November 1919, while Rathenau noted the following June that the Germans were 'a wholly unpolitical nation' that had known only subjection to their ruler or to the constraints of party discipline. And now, on the very eve of a new political crisis, the old predisposition to accept authoritarian leadership reemerged more clearly than ever. More than a decade after the end of Wilhelmine Germany, large sections of the middle classes were still to be heard lamenting 'the good old days'. Of course, there was rather more to it than merely nostalgia for former glory or grief at the loss of bygone values. Even during the years of economic recovery after 1924, the material standard of living in Germany failed to return to pre-war levels. Wherever people had lost some of their social prestige and suffered financial ruin, their hatred for those they held responsible was all too understandable. Of course, the Weimar Republic had never inspired the same degree of devotion, still less of enthusiasm that the monarchy had enjoyed; and remarks about a 'republic without republicans' began to circulate freely once again. Sections of the Social Democratic party which, following the decline in liberal sentiment among the German middle classes, had been the Republic's staunchest supporters, grew increasingly disenchanted not only with the way their party was being led but more especially with the concessions that were made to their coalition partners in the government. Even the Communists, whose power was increasing in Berlin at the expense of the SPD, were scarcely to be seen when it came to defending the democratic rights and liberties which they had once enjoyed at the time of the Weimar Republic. The party's reputation as the vanguard of the revolution resulted in an influx of members whose hopes for social improvement within the framework of the democratic Republic had all but disappeared. They longed for a 'Soviet Germany' as propounded by the party's leaders and pinned their hopes on working-class power of a kind that seemed already to be realized in the Soviet Union. This dream of a fairer society is one that was shared by more and more artists and intellectuals, especially in Berlin, with its all too evident social conflicts: its realization, they believed, was only a matter of time. But the radical promises of the party leaders hid only the bureaucracy and political inflexibility of the party machinery. Social democracy and fascism were twins, Stalin had declared in 1924, a 'theory' that the 'Stalinized' German Communist Party (KPD) took over all too readily in the years around 1930. In turn, the Social Democratic leadership all too frequently equated the Communists with the National Socialists. In this way, the leaders both of the Social Democratic and Communist Parties contributed to the lack of an effective opposition to the Nazis programme of violence. Ironically, therefore, this ideological split in the workers' movement ultimately only served to bring the NSDAP to power, which, on its accession, wasted no time in destroying *both* wings of the workers' movement in Germany.

Into this curious mixture of hostility towards the Republic, surly acceptance of it or plain political indifference, the international economic crisis exploded with devastating force. Essentially, of course, it merely served to exacerbate trends already present in Germany's political life, but it required 'Black Friday' on the New York stock market on 25 October 1929 to precipitate the sudden rise of the NSDAP and, with it, the inglorious end of the Weimar Republic. If we earlier described the phase of economic stabilization in Germany in the mid-1920s as only 'relative', this was not least because it depended on the uninterrupted influx into the German money market of foreign loans amounting to thousands of millions of marks, especially from the USA. Given the instability of the German political system

and the state of permanent crisis since the outbreak of war in 1914, a threat to the foreign credit supply meant more than a simple economic risk. In Berlin, in particular, all the country's social and political conflicts suddenly came to a head far sooner than anywhere else, not least because the capital had run up debts of hitherto unknown proportions in order to fund its programme of local government reform: between the early 1920s and the beginning of 1930 some 1.2 thousand million marks had been borrowed by the city council. And, once again, it was the capital which was hardest hit by unemployment, even during the years before the international economic crisis. In 1927, for example, unemployment in Berlin was already twice as high as in the rest of the Reich, and by the winter of 1929/30 it had reached an order of magnitude that already gave an inkling of the scale of the social catastrophe which was to be experienced by the city in the following years.

In addition to the 293,000 men and women in receipt of national unemployment benefit or supplementary income support, there were 333,000 others who, out of work and entitled to welfare benefits, were supported by the city. These figures continued to grow until early 1933. In 1932, for example, average unemployment in the city stood at 640,000, and by the winter of 1932/33 some 22.4 per cent of the working population lived not from their work but from public funds. Berlin represented 10 per cent of the country's total unemployment figures, although the city's population made up barely 7 per cent of that of the country as a whole. Faced with the rise in unemployment, the national government reacted with an emergency decree that was altogether characteristic of its whole political outlook, involving, as it did, such drastic economies as cutting unemployment benefits and reducing the time for which such benefits were paid. More and more of the unemployed ceased to be eligible for state support and thus became a burden on the municipal coffers. Between 1929 and 1932 their number rose in Berlin from 32,000 to more than 300,000. By the early 1930s, therefore, hundreds of thousands of Berliners were living in abject poverty. At the beginning of 1932 the American journalist H. R. Knickerbocker was sent on a fact-finding visit to Germany by the *New York Evening Post* and, during his stay in Berlin, he examined the daily provisions that those on relief were receiving. It was barely enough to provide a frugal meal: 'To a certain extent it is possible to survive on it', Knickerbocker concluded, 'for it takes ten years to die from such provisions.'

It is often claimed that years of mass unemployment and the resultant sense of despair were among the principal reasons behind the NSDAP's electoral successes and subsequent rise to power. If this were true, Berlin, with its higher than average quota of unemployment, should surely have been a Nazi stronghold. In fact, the opposite was the case, since the NSDAP's share of the vote in Greater Berlin was always below the national average. When in September 1930 the Nazis became the second largest party in the Reichstag with 18.3 per cent of the vote, their share in Berlin was no more than 12.8 per cent. At the last 'free' Reichstag elections in Germany in November 1932, the Nazis won 33.1 per cent of the votes in the country as a whole, while polling only 26 per cent in Berlin. And even as late as 5 March 1933, a week after the fire that destroyed the Reichstag building, when a wave of terror and arrests was already rolling across the land and the SPD and KPD had been forced underground, the Nazi party received only 34.6 per cent of the votes in Berlin, as against the 43.9 per cent in the country overall. Five weeks after the transfer of power to Hitler, the Nazis had still not achieved the level of votes of the KPD and SPD in Berlin – and this in spite of

Charlie Chaplin was a popular role model for buskers. Here a father and son are dressed up as 'Jackie Coogan', as they sing for money in the courtyards, c. 1930 (BPK)

support from their German National coalition partners. While the NSDAP and the nationalist 'Battle Front Black-White-Red' (the colours of the Empire) polled 1.36 million votes in these final Reichstag elections (elections which were no longer free), the SPD and KPD received 1.38 million votes. The figures are even more revealing when we add the almost quarter of a million votes for the middle-class parties to those for the workers' parties. Notwithstanding all the crimes which, planned in Berlin, were committed there and elsewhere during the years of the Nazi regime, it should never be forgotten that a majority of the city's population still refused to swear an oath of allegiance to Hitler even after 'night over Germany' had fallen.

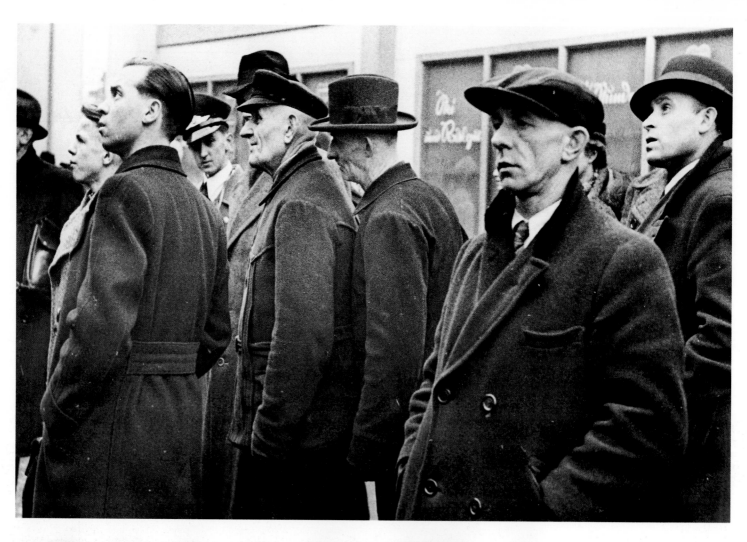

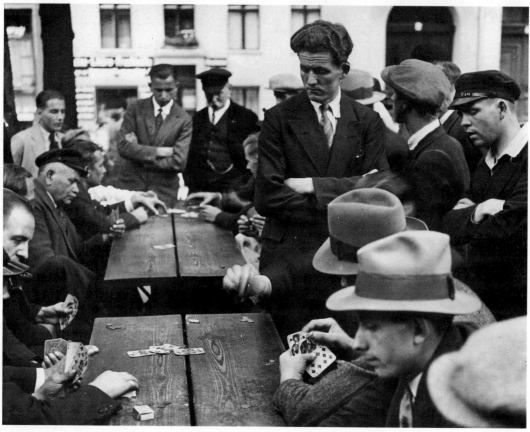

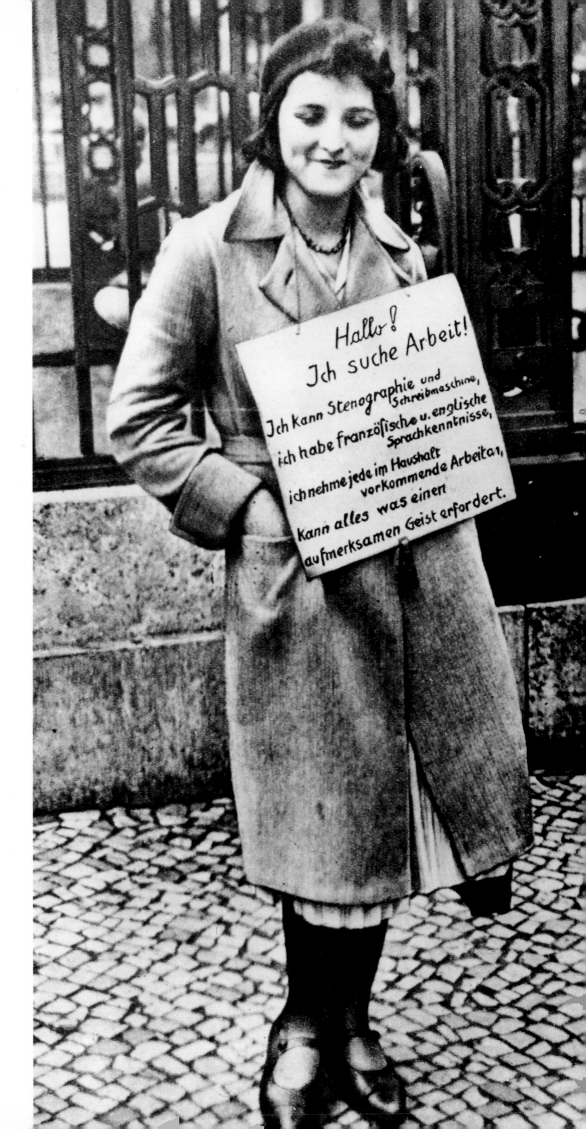

Opposite above: Unemployed men stand around on the street listening to 'Uncle Paul', the last of the German balladeers, c. 1928. (BPK)

Opposite below: No work – time to kill: unemployed men playing cards, 1929. (BPK/Friedrich Seidenstücker)

A young, unemployed secretary advertises for work to passers-by. 'Hello, I'm looking for work; I can do shorthand and typing, can speak French and English, will accept any type of household job and can do anything that demands an attentive mind.' (BPK)

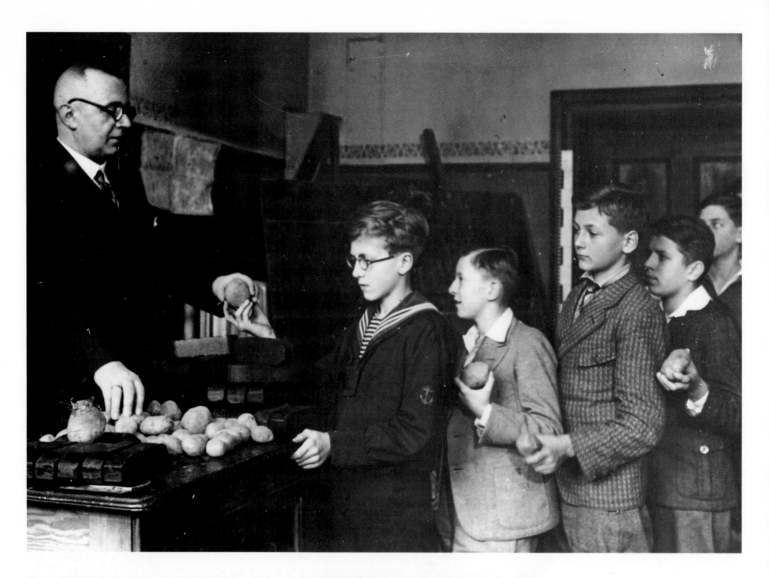

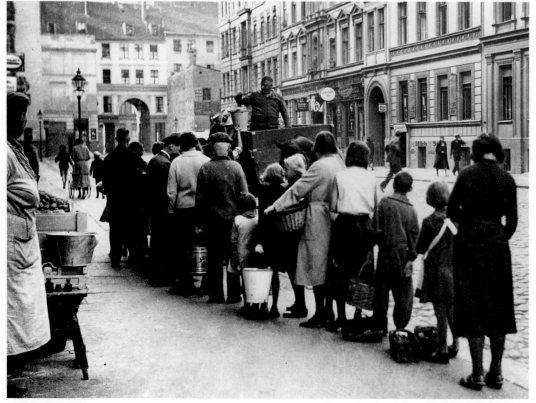

Winter charity programme in Berlin schools, 1931. To help the suffering population, collections were carried out in the schools. In the Kaiser-Friedrich-Schule in Charlottenburg pupils bring either a potato or a piece of coal to school every day. (ADN)

A street trader in Simeonstraße in the Kreuzberg district, exchanging firewood for potato peelings, c. 1930. (BPK/Carl Weinrother)

Early-morning scene at an employment exchange as current vacancies are read out. (Ullstein)

When the city's banks reopened on 16 July 1931 only wages and salaries were paid out: firms had to submit a list of their employees to the Berlin Chamber of Trade and Industry, where the lists were all cross-checked. (BPK)

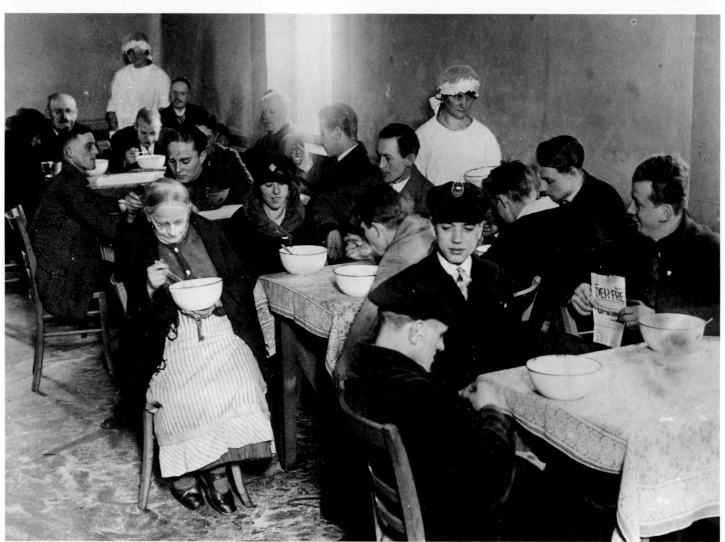

Children and elderly men and women gather up 'reject' fish from the gutter, c. 1930. (BPK/Friedrich Seidenstücker)

A soup kitchen for the unemployed, one of many organized by the municipal authorities, December 1930. (BPK)

Unemployed people outside the Southeast Employment Exchange in Sonnenallee in the Neukölln district of the city, 1931. (ABZ/Willy Römer)

ACCORDING TO FIGURES issued by the Neukölln Employment Exchange, the average benefit paid to an unemployed man with a wife and one child to support was 51 marks a month at the end of 1931. At least 32.50 marks, on average, went on rent, electricity, heating and other regular outgoings. All that remained to feed the family was 18.50 marks a month, which, translated into daily terms, amounted to half a loaf of bread, a pound of potatoes, 100 grams of cabbage and 50 grams of margarine. Three times a month each member of the family would be able to afford a single herring. In other words, each person's daily ration consisted of six potatoes, five slices of bread, a handful of cabbage, a knob of margarine and, for the child, half a litre of milk, with a herring thrown in on three Sundays out of four.

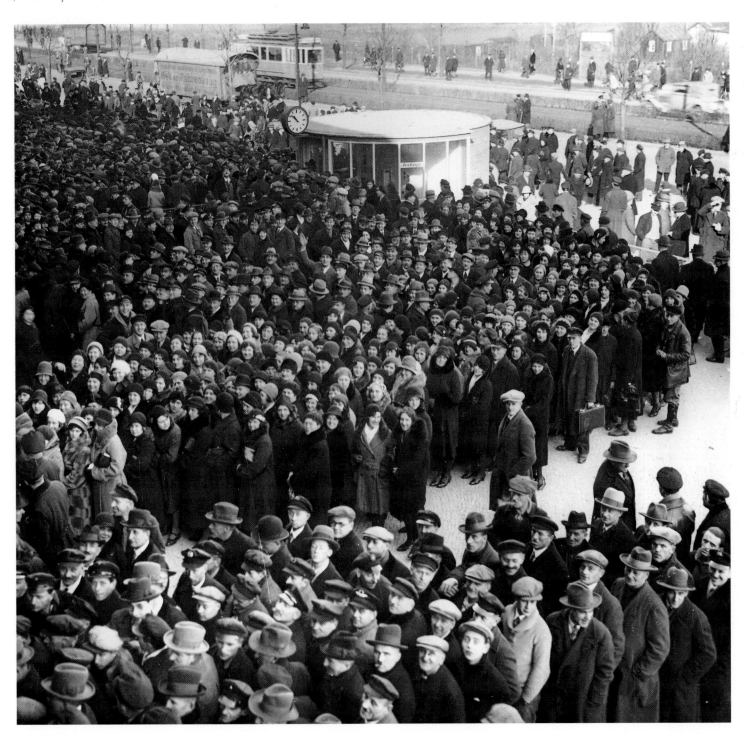

Demonstration during a strike organized by local schools in Neukölln to protest against the city's economy measures, April 1930. The banner reads, 'Working-class parents! Support the school strike in Neukölln', while the smaller placard reads, 'The 15th and 16th local school is striking in protest at economy measures introduced by the municipal authorities'. (BPK/Carl Weinrother)

Inner courtyard behind Köpenicker Straße in the city centre during a rent strike, November 1932. At the height of the crisis, these strikes became increasingly widespread since many families were no longer able to afford to pay their rent. Evictions were even more commonplace. The graffiti reads 'First food then rent'. (BPK)

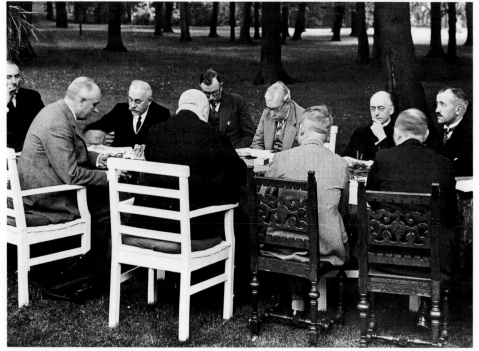

Hoardings outside the Social Democratic Party headquarters on Potsdamer Platz in the run-up to the elections for the Prussian Landtag (State Parliament), April 1932. (ADN)

The cabinet of Chancellor Heinrich Brüning (third from right) meeting in the gardens of the Chancellor's Palace in Wilhelmstraße, August 1930. (BPK/Erich Salomon)

1932 WAS THE YEAR OF ELECTIONS and government reshuffles. The first round of elections for the country's president was held on 13 March, with the second round on 10 April. Hindenburg was re-elected. In Berlin he received 48 per cent of the vote, compared to Hitler's 31.2 per cent and the 20.7 per cent of the Communist Party candidate, Ernst Thälmann. In the elections for the Prussian Landtag on 24 April, the Social Democrats were again the largest party in Berlin, ahead of both the National Socialists and Communists. Chancellor Brüning resigned on 30 May and the 'cabinet of barons' was formed under Franz von Papen. He was succeeded in turn by General Kurt von Schleicher, appointed on 3 December. In the Reichstag elections on 31 July the NSDAP became the most powerful party but suffered a loss of two million votes on 6 November, when it received only 26 per cent of the vote, in contrast to the Communists' 31 per cent and the Social Democrats' 23.3 per cent.

Posters for the German National People's Party, the Communist Party and the Social Democratic Party on an advertising column during the electoral campaign for elections to the Prussian Landtag, April 1932. (ADN)

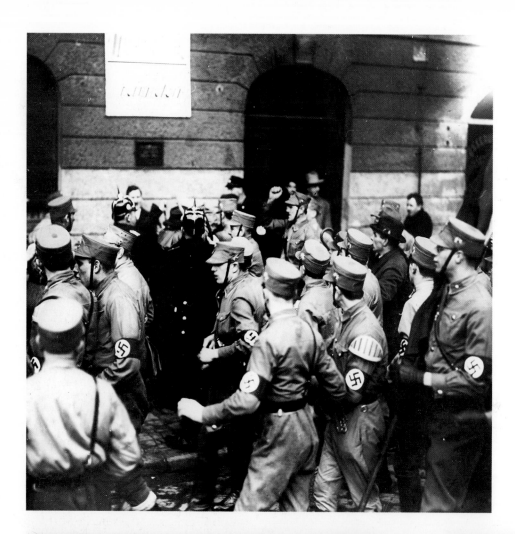

Opposite: The Reichstag in plenary session, October 1930. On the right are the NSDAP members in their SA uniforms. (BPK/Erich Salomon)

SA members fight with police, 1931. The SA, which first appeared on the scene in Munich in 1922, was the most important instrument of Nazi aggression in Berlin in this period, used to terrorize their political opponents. At the beginning of 1933, the SA district of Berlin-Brandenburg had over 30,000 members, of a national membership of about 420,000. (BPK)

National Socialist members of the Reichstag in their SA (Storm Troopers) uniform in the Reichstag restaurant, 1930. (BPK)

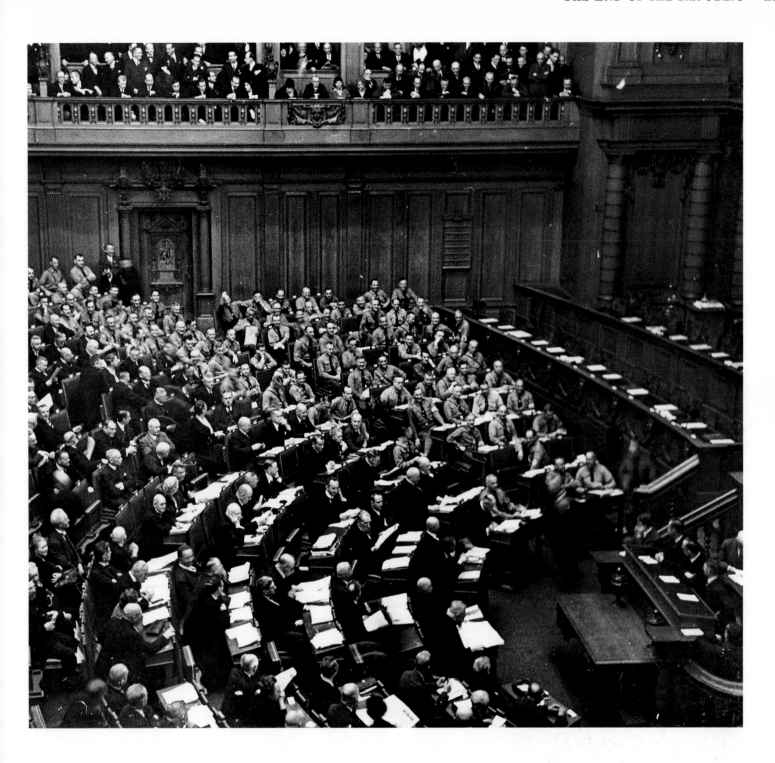

THE STAHLHELM (STEEL HELMET) or 'League of Front-Line Soldiers' was a paramilitary nationalist organization founded in 1918. By the end of the 1920s it had some 500,000 members but soon afterwards began to lose ground to the National Socialist SA. From the late 1920s onwards the Stahlhelm became increasingly identified politically with the aims of the German National Party. During the final years of the Weimar Republic, political life in general was more and more dominated by defence groups and paramilitary organizations. The right-wing activities of the SA and Stahlhelm were opposed by the republican forces of the Reichsbanner, whose membership was largely Social Democratic, while the 'Red-Front Fighters' League' supported the German Communist Party. The latter was declared illegal in 1929, although it continued to operate via various successor organizations.

Field Marshal von Mackensen arriving at the Stahlhelm-Day rally on 3/4 September 1932. Among the 195,000 participants were Chancellor Franz von Papen and Crown Prince Wilhelm of Prussia. (LBS)

Members of the German National People's Party on board the passenger boat Siegfried *during the campaign for the Reichstag elections on 31 July 1932, when the party managed to poll only 8.3 per cent of the votes in Berlin (220,000 votes in total). In the Reichstag elections on 14 September 1930 they had succeeded in attracting as many as 350,000 votes or 13 per cent of the total cast in the city. (ADN)*

Opposite: Marchpast of regiments at Tempelhof Fields on Stahlhelm Day, 3/4 September 1932. (LBS)

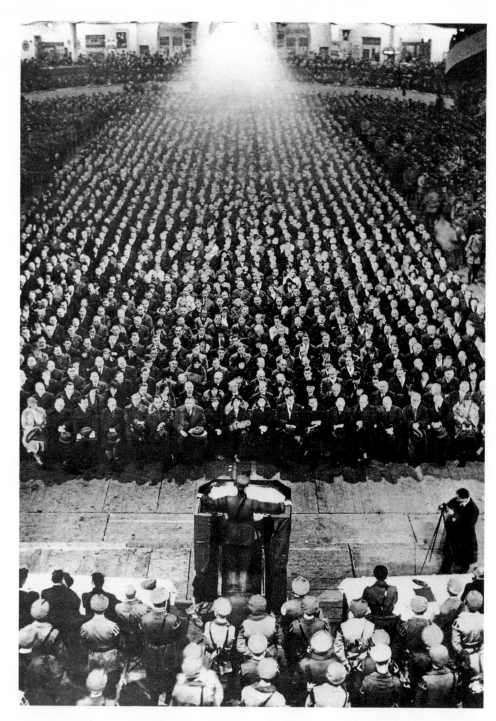

Reichsbanner Rally in the Sports Stadium on 2 December 1931 to protest against the NSDAP's plans, revealed at the end of November, to resort to terrorist methods once they had come to power. (BPK)

Rally to mark the seventh anniversary of the founding of the Reichsbanner organization, held in the Lustgarten near the Royal Palace, 22 February 1931. (LBS)

BUILT IN 1910, the city's Sports Stadium on Potsdamer Straße was rebuilt in 1925. It was not only the venue for sporting events, it was also used for revues and various official functions. With a capacity of around 10,000 people, it was also a popular venue for political parties of every persuasion. During the final quarter of 1931, for example, there were no fewer than five rallies by the NSDAP and one by the German Nationals, in addition to the Reichsbanner meeting above. Moreover, the Social Democratic Party met here on 9 November to commemorate the Revolution, and the Communist Party organized a 'Rally for Women in Work' on 22 October.

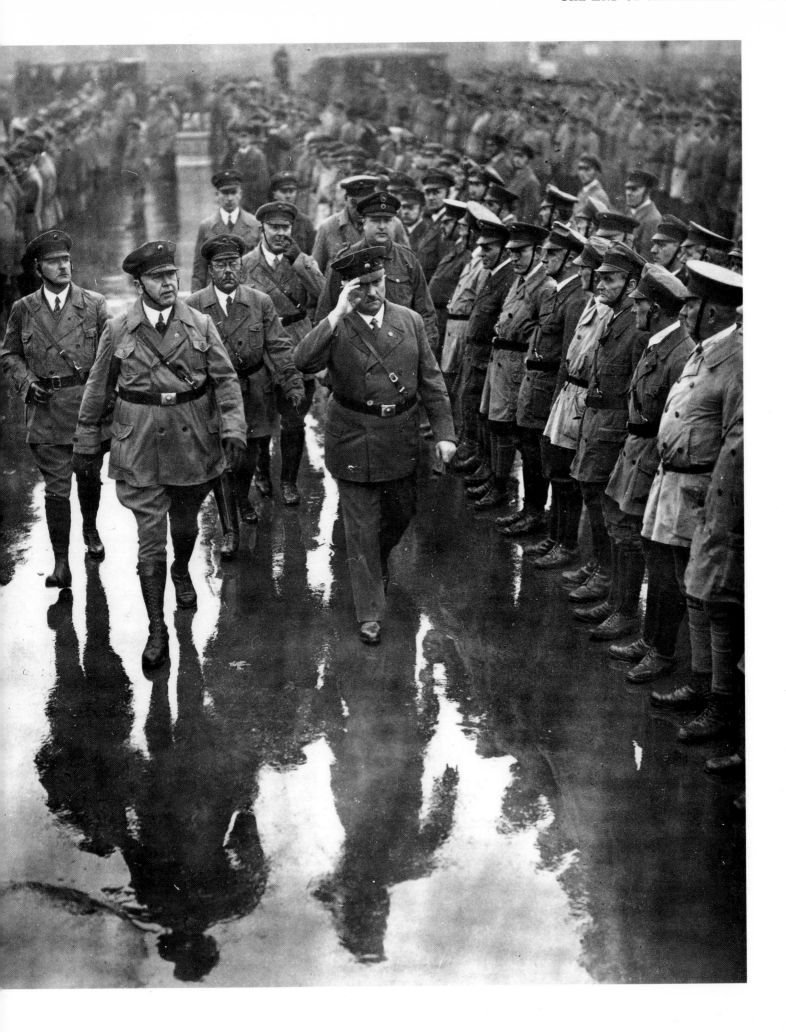

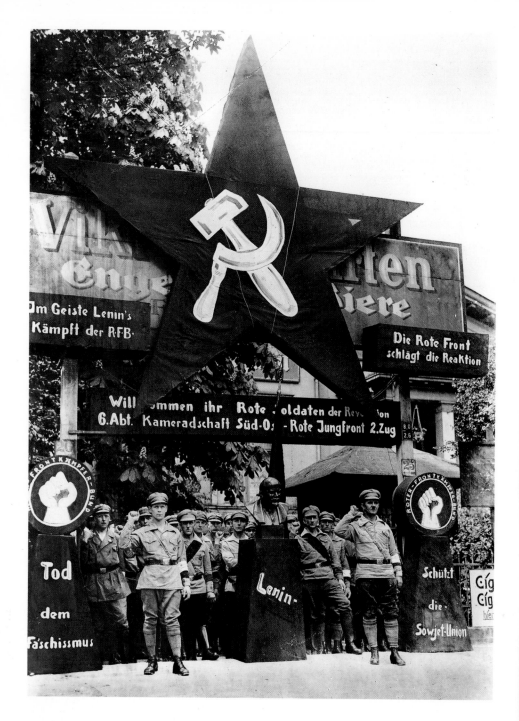

The entrance to Viktoria Park in Wilmersdorf during a meeting of the Red-Front Fighters' League on 27 May 1928. The Red-Front Fighters' League had been founded in 1924 and by 1928 had more than 100,000 members. Its meetings were held in Berlin until 1928, but in May 1929 the organization was declared illegal following riots which broke out in the city's working-class districts when the police shot and killed thirty-one people. (LBS)

Members of the Red-Front Fighters' League from the Wedding district, the citadel of Communism, on their way to a demonstration in the Lustgarten, 1 May 1928. The colonnades of Museum Island are visible in the background. (BPK)

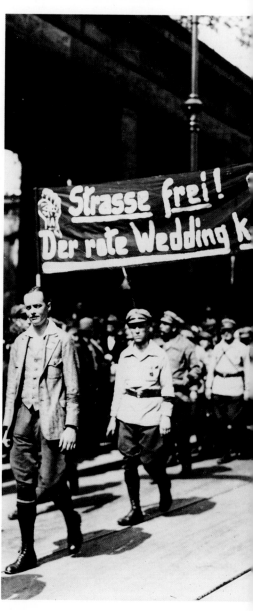

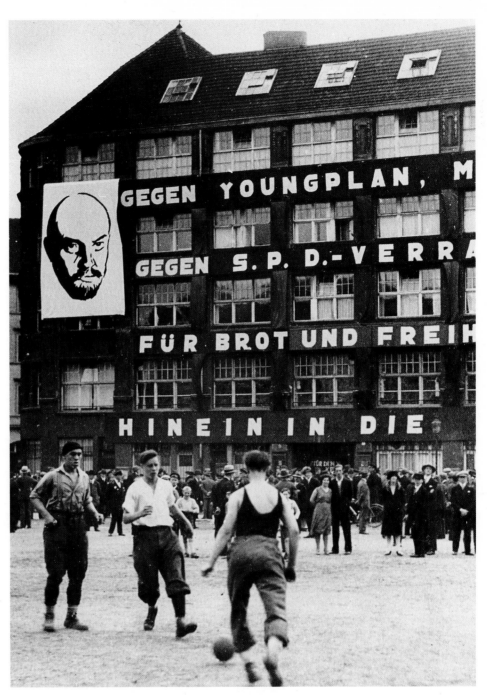

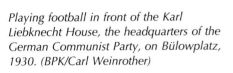
Playing football in front of the Karl Liebknecht House, the headquarters of the German Communist Party, on Bülowplatz, 1930. (BPK/Carl Weinrother)

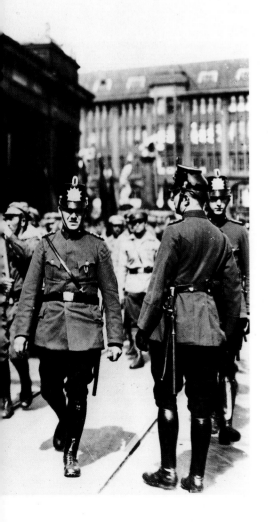

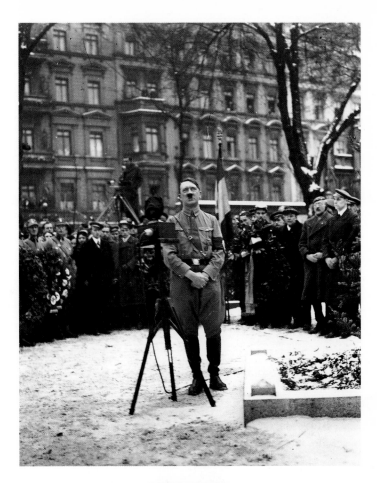

A picket line outside an underground station during the Berlin transport strike, 3–7 November 1932. It was a wild-cat strike, called not by the trade unions but by an 'unholy alliance' between the Communist Revolutionary Union Organization and the National Socialist Business Organization, directed at wage cuts imposed by the transport authorities. (ADN)

Adolf Hitler, in SA uniform, speaking on the occasion of the unveiling of a commemorative stone on the grave of Horst Wessel, 22 January 1933. Wessel (1907–1930), a 'martyr' to the cause of the SA, was buried at St Nicholas's Cemetery in the Prenzlauer Berg district. (LBS)

Armoured police vehicles being used during an SA demonstration on the Bülowplatz, 22 January 1933. The SA's action was a calculated provocation directed at the Communist Party headquarters situated in the square. The police cordoned off the whole area in order to avoid clashes with Communist counter-demonstrators. (BPK)

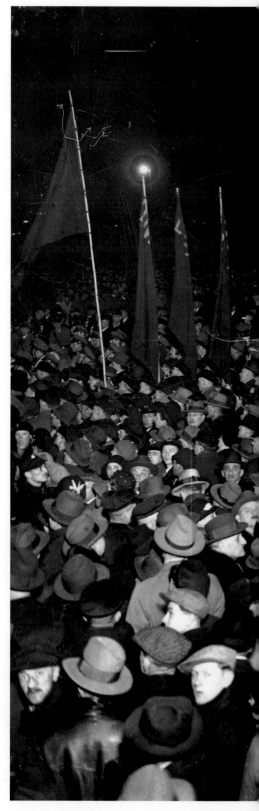

Members of the Iron Front in the Lustgarten near the Royal Palace, Summer 1932. (ABZ/Willy Römer)

Rally by the Iron Front in the Lustgarten, 7 February 1933. The Iron Front was one of the last remaining legal organizations to oppose National Socialism before the latter's systematic reign of terror. (ABZ/Willy Römer)

THE IRON FRONT was founded on 16 December 1931 by the free trade unions, the Social Democratic Party, a number of working-class sports organizations and the Reichsbanner organization, its aim being 'to continue the struggle against fascism with increased activity'. Encouraged by some of the younger Social Democratic members of the Reichstag and on the advice of the psychologist Sergei Chakhotin, the Iron Front developed an unconventional, 'activist' style of propaganda early in 1932. From June 1932 its symbol was three arrows, which were intended to cancel out the National Socialists' swastika. But in spite of their novel methods, the Iron Front activists could not prevail in the longer term over the weighty party and trade-union machinery with its bureaucratic leadership.

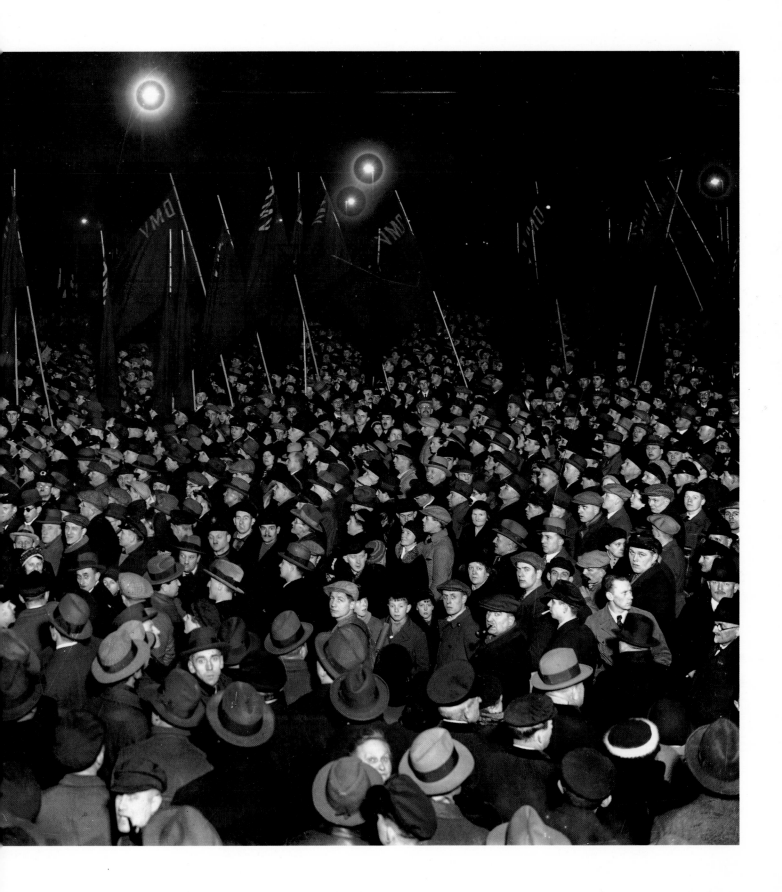

BIBLIOGRAPHY

AUSSTELLUNGS-, MESSE- UND FREMDENVERKEHRS-AMT DER STADT BERLIN (ed.), *Offizieller Führer für Berlin und Umgebung und Potsdam und seine Schlösser*, Berlin, 1928.

BAEDEKER, Karl, *Berlin und Umgebung. Handbuch für Reisende*, Leipzig, 18th edn, 1914; 19th edn, 1921; 20th edn, 1927; *Berlin und Potsdam*, 21st edn, 1936.

BEHNE, Adolf (ed.), *Berlin in Bildern. Aufnahmen von Sasha Stone*, Vienna and Leipzig, 1929.

BERLINER GESCHICHTSWERKSTATT (ed.), *August 1914: Ein Volk zieht in den Krieg*, Berlin, 1989.

BOBERG, Jochen, Fichter, T. and E. Gillen (ed.), *Die Metropole: Industriekultur in Berlin im 20.Jahrhundert*, Munich, 1986.

BUCOVICH, Mario v., *Berlin: Geleitwort von Alfred Döblin*, Berlin, 1928.

ECKARDT, Wolf von, and Sander Gillman, *Bertolt Brechts Berlin: A Scrapbook of the Twenties*, New York, 1975.

EVERETT, Susanne, *Lost Berlin*, London/Chicago, 1979.

FRIEDRICH, Otto, *Before the Deluge*, New York, 1972.

GAY, Peter, *Weimar Culture*, New York, 1968.

Griebens Reiseführer Berlin und Umgebung, Berlin, 59th edition 1918/19; 62nd edn, 1922; 64th edn, 1927; 66th edn, 1929; 68th edn, 1932.

HAXTHAUSEN, Charles W., and Heidrun Suhr (ed.), *Berlin: Culture and Metropolis*, Minneapolis and Oxford, 1990.

HEGEMANN, Werner, *Das steinerne Berlin: Geschichte der größten Mietkasernenstadt der Welt*, Berlin, 1930.

HERMAND, Jost, and Frank Trommler, *Die Kultur der Weimarer Republik*, München 1978.

HESSEL, Franz, *Spazieren in Berlin*, Leipzig and Vienna, 1929 (new edition Munich, 1968, and, under the title *Ein Flaneur in Berlin*, Berlin, 1984).

HÜTER, Karl-Heinz, *Architektur in Berlin 1900–1933*, Dresden 1987/ Stuttgart, 1988.

JAMESON, Egon, *Berlin so wie es war*, Düsseldorf, 1969.

JOHANNES, Heinz, *neues bauen in berlin*, Berlin, 1931.

KIAULEHN, Walther, *Berlin. Schicksal einer Weltstadt*, Berlin, 1958.

KOCH, Thilo, *Die Goldenen Zwanziger Jahre*, Frankfurt a. M., 1970.

KORFF, Gottfried, and Reinhard Rürup (ed.), *Berlin, Berlin. Die Ausstellung zur Geschichte der Stadt*, catalogue, Berlin, 1987.

LANDESBILDSTELLE BERLIN (ed.), *Verkehr in Berlin. Von den Anfängen bis zur Gegenwart*, Band 1: Nahverkehr, Band 2: Fernverkehr; Berlin, 1988.

LANGE, Annemarie, *Berlin in der Weimarer Republik*, Berlin, 1987.

LANGE, Friedrich C. A., *Groß-Berliner Tagebuch 1920–1933*, Berlin-Lichtenrade, 1951.

LAQUEUR, Walter, *Weimar: A Cultural History*, London, 1974.

LEDERER, Franz, *Berlin und Umgebung*, 2nd edn, Berlin (c.1930).

LEYDEN, Friedrich, *Groß-Berlin: Geographie der Weltstadt*, Breslau, 1933.

MIERAU, Fritz (ed.) *Russen in Berlin: Literatur, Malerei, Theater, Film 1918–1933*, 2nd edn Leipzig, 1990.

MORECK, Curt (i.e. Konrad Haemmerling), *Führer durch das 'lasterhafte' Berlin*, Leipzig, 1931; reprinted Berlin, 1987.

OSBORN, Max, *Berlin*, 2nd edn, Leipzig, 1926.

OSCHILESKI, Walther G., *Zeitungen in Berlin: Im Spiegel der Jahrhunderte*, Berlin, 1975.

PEM (i.e. Paul E. Marcus), *Heimweh nach dem Kurfürstendamm: Aus Berlins glanzvollsten Tagen und Nächten*, Berlin 1952.

RAVE, Rolf, and Hans-Joachim Knöfel, *Bauen seit 1900 in Berlin*, 6th edn, Berlin 1987.

Revolution und Fotographie: Berlin 1918/19, catalogue, Berlin, 1989.

RIBBE, Wolfgang (ed.), *Geschichte Berlins. Vol. 2: Von der Märzrevolution bis zur Gegenwart*, Munich, 1987.

ROTERS, Eberhard, *Berlin 1910–1933*, New Jersey 1982.

SCHEBERA, Jürgen, *Damals im Romanischen Café . . . Künstler und ihre Lokale im Berlin der 20er Jahre*, Leipzig, 1988.

SCHEFFLER, Karl, *Berlin. Ein Stadtschicksal*, Berlin-Westend, 1910.

SCHRADER, Bärbel, and Jürgen Schebera, *Kunstmetropole Berlin 1918–1933. Dokumente und Selbstzeugnisse*, Berlin, 1987.

STATISTISCHES AMT DER STADT BERLIN (ed.), *Statistisches Taschenbuch* (later *Jahrbuch*) *der Stadt Berlin*, 1st edn, Berlin, 1924; 9th year 1933, Berlin; *Berlin in Zahlen. Taschenbuch*, Berlin, 1947.

SZATMARI, Eugen, *Das Buch von Berlin*, Munich, 1927 (*Was nicht im 'Baedeker' steht*, Vol. I).

Der Traum von einer neuen Welt: Berlin 1910–1933, catalogue, Mainz, 1989.

VEREIN BERLINER KAUFLEUTE UND INDUSTRIELLER (ed.), *Berlins Aufstieg zur Weltstadt: Ein Gedenkbuch*, with contributions from Max Osborn *et al.*, Berlin, 1929.

WEISE, Alfred (ed.), *Unser Berlin: Ein Jahrbuch von Berliner Art und Arbeit*, Berlin, 1928.

Wem gehört die Welt: Kunst und Gesellschaft in der Weimarer Republik, catalogue, Berlin, 1977.

WERNER, Bruno E., *Die Zwanziger Jahre: Von Morgens bis Mitternachts*, Munich, 1962.

WILLETT, John, *The New Sobriety. Art and Politics in the Weimar Period 1917–1933*, London, 1979.

WILLINGER, Laszlo, *100 x Berlin*, Berlin-Westend (c.1930).

INDEX

Academy of Architecture 21
Academy of Arts, Prussian 109, *142*
8-Uhr-Abendblatt 111
Adlon Hotel *164, 194, 195*
advertising 90, *95, 164*
airports 59, 64, *104, 105*
Aktion, Die 108, 112
Albatros L 73 ('Flying Sleeper') *104*
Albers, Hans *124, 125*
Alexanderplatz *98*
allotment gardening 163, *163, 200*
Alpar, Gitta *129*
Angriff, Der 208
anti-Semitism 207, 209–11

Arbeiter-Illustrierte-Zeitung 110
Archipenko, Alexander *138*
art schools and colleges 109, *142*
Auguste-Viktoria-Platz 59, *59, 122,* 159
Avus Stadium *202*

Baden, Prince Max von 33
Baeck, Leo 74
Bayerisches Viertel (Bavarian Quarter) 77
Beckmann, Max 109, *186*
Behne, Adolf (quoted) 57
Behrens, Peter 78; *98*
Belling, Rudolf 116, *117*
Bely, Andrey 62

Benn, Gottfried 112
Bergner, Elisabeth *137*
Berlin: characteristics 60–1; founding of 14; 13th–15th c. 14–15; 17th c. 15–16, 24; 18th c. 16–17, 18, 24; 19th c. 13, 14, 17–18, 19–23, 24–5; 20th c. 23–4, 26, 61–5; formation of new municipality (1920) 58, 63–4; size 58–9; *see also* population
Berliner Börsen-Courier 111
Berliner Illustrirte Zeitung 109
Berliner Morgenpost 111
Berliner Tageblatt 34, 111, 157
Bismarck, Prince Otto von 25

Blue Angel, The 114, *122, 124, 125*
Bolle Dairy 177
Bootz, Erwin *129*
Borsig Works, Tegel *86, 169*
Böß, Gustav 64, *65*, 211; *Social Deprivation in Berlin* 55
Brandenburg Gate *12, 19–20, 32, 38, 42, 68*
Brecht, Bertolt 114, *132*; *Dreigroschenoper (Threepenny Opera)* 116, *132*; *Kuhle Wampe* (with Dudow) 114, *132*; *Man is Man* 133
Breitensträter, Hans *161*
bridges 14, *88, 108*
Britz housing estate 65, *96–7*
Bruck, Reinhard *134*
Brücke, Die 108
Brüning, Heinrich *152, 224*
Bülowplatz *134, 233, 235*
Burchard, Otto *138*
buses 59, 159, *164*

Cabinet of Dr Caligari, The 112, *113*
canals 59, *88*
Capa, Robert 110
Capitol Cinema *122*
cathedrals 18, 24, 25
Chakhotin, Sergei *236*
Charlottenburg district 22, 63, *79*
Chekhova, Olga *148*
Chicago Tribune 195
cinemas 114, *122, 123*
Cölln 14, 16
Columbus Building 67, *164*
Comedian Harmonists 117, *129*
Communist Party, German (KPD) 35, 208, 209, 210, 212, 213, *225, 228, 230, 233, 235*
Corinth, Lovis 108
Count Zeppelin (airship) *157*
Cremer and Wolffenstein *103*
Curtius, Julius *152*
cycle racing 161–2, *202*
Cycowski, Roman J. *129*

Dada 108, *138*, 159
dance schools *130*
Delbrück, Hans *152*
Dietrich, Hermann *152*
Dietrich, Marlene 114, *124, 125, 128, 138*
Dix, Otto 109
DNVP see National People's Party, German
Döblin, Alfred 111, *144*; *Berlin Alexanderplatz* 158, 159
docks 64, *65, 88*
Dudow, Slatan *132*; *Kuhle Wampe* 114, *132*

economy, Germany 27, 36–7, *37*, 62, 64, 210, 212, 213–14
'Ehrhardt Brigade' 36, *48*
Einstein, Albert *152, 153*
Eisenstaedt, Alfred 110
Eisenstein, Sergei: *Battleship Potemkin* 114
Eisler, Hanns *132*
elections: 19th c. 26; 1919 26; 1918 28, 34; 1919 35–6; *1925* 207–8; 1929 210, 211; 1930 77, *208*, 214–15, *228*; 1932 *210, 224, 225, 228*
'Elite' tours 58, *103*
Ephraim Palace 19
exhibitions 64, *83, 84*; art 109, *138*
Expressionism 108, 111–13, *113*, 116–17

Fasanenstraße synagogue *72, 74*
fashion design *84, 101, 148, 151*
Feuchtwanger, Leon 159
film production 112–14, *113*, 117
Fiori, Ernesto de *138, 186*
Firle, Otto: Grunfeld building *75*
Fischerstraße 99
Flechtheim, Alfred *186*
Friedrich I, King of Prussia 16
Friedrich II, Elector of Brandenburg 14–15
Friedrich II, King of Prussia 18
Friedrich Wilhelm, 'Great Elector' 15, 16
Friedrich Wilhelm I, King of Prussia 16–17
Friedrich Wilhelm II, King of Prussia 19
Friedrichstadt 16, 17, *18*, 23, 67, 160–1
Friedrichstraße 59, *103, 127*; Station *103*
Frommermann, Harry *129*

Gabo, Naum *138*
Garbo, Greta *122*
Gendarmenmarkt 18
George, Heinrich *118, 134*
Gerron, Kurt *124, 132*
Gessler, Otto *152*
Giraudoux, Jean 62
Goebbels, Joseph 65, *207, 208, 209, 210*
Goethe, Johann von 156
Gontard, Karl von: French Cathedral *18*
Götha, Eosander von *15*, 16
Gregor, Ulrich 113
Grenander, Alfred: station *158*
Gropius (Martin) building *41*
Grosz, George 109, *138, 141, 144, 145*
Grunewald 80, *186, 204*; racecourse 27

Harben, Thea von *118*
Harvey, Lilian *120*
Hausmann, Raoul *138*
Hausvogtei Platz *101*
Heartfield, John 110, *138*
Heckel, Erich 108
Helm, Brigitte *118*
Herzfelde, Margarete *138*; Wieland *138, 144*
Hessel, Franz (quoted) 155
Hildenbrandt, Fred 157–8
Hillinger, Franz: 'Carl Legien' estate *92*
Hindenburg, Paul von *225*
Hinterhöfe *181*
Hitler, Adolf *225, 235*
Höch, Hannah *138*
Hofer, Karl 109, *186*
Hohenzollern dynasty 14, 15
Hollaender, Friedrich *124*
horse-drawn vehicles 160, *166, 177*
housing 13, 18, 22, 23, 64–5, 87, *96–7*, 163, *181, 185*
Hugenberg, Alfred 211–12

Ihring, Herbert *134*
Independent Social Democratic Party (USPD) 34, 35–6, 63
industries 21–2, 59–60, *169–71*
inflation, 1920s 27, 36–7, *37*, 62, 64
International Modern Style 65, 78, *114*
Iron Front, the *236*

Jägerstraße *126*
Jannings, Emil 114, *124, 125*
Jessner, Leopold 114
Jewish population *74*; *see also* anti-Semitism
Jungfernbrücke *100*

Kaiser Wilhelm memorial *15, 24*; church 59
Kaiserplatz 75
Kapp-Lüttwitz Putsch 36, *49, 50, 53*
Karstadt department store *95, 158*
Kästner, Erich 111, 159; *Emil and the Detectives 75, 120*
Kayssler, Friedrich *116*
Kellermann, Bernhard: *Der neunte November* 62
Kerr, Alfred 111, 114, *161*
Kisch, Egon Erwin 111
Klein, James 117, *127*
Klemperer, Otto 69, *147*
Klingenberg power plant 64, *92, 170*
Kokoschka, Oskar 109
Kollwitz, Käthe 108, *141*
Köpenick district 22, 63
Kracauer, Siegfried 111, 113
Krauss, Werner *113*
Kreuzberg district 88, *147, 212, 218*
Kroll Opera House 69, *147*
Kurfürstendamm 25, *72, 74, 178*

Lamberts-Paulsen, Harry *129*
Lamprecht, Gerhard *120*
Landwehr Canal 88
Lang, Fritz 113–14, *119*; *Metropolis* 114, *118*
Langhans, Carl Brandenburg Gate *68*
Lederer, Franz 157
Leipziger Platz 17–18, *22, 67*
Leipziger Straße 22, 23, 25–6, *103*
leisure activities 65, *161–3, 188, 196–200*
Lenya, Lotte *132, 133*
Liebermann, Max 108, *108*, 109, *142*
Liebknecht, Karl 13, 33, 34, 35, *41*, 112
Liedtke, Harald *120*
Lindenhof estate 65
Litfaß, Ernst 90
Lubitsch, Ernst 112; *Madame Dubarry 120*
Luckhardt, Hans and Wassili *79*
Luna Park 116, *117, 120, 161, 190, 192, 193*
Lustgarten 20, 24, *25, 49*
Lüttwitz, General Walther *48*
Lutz, Friedrich *138*
Luxemburg, Rosa 13, 34, 35, 112

MacDonald, Ramsay *152*
Mackeben, Theo *132*
Mackensen, Field Marshal von *228*
magazines 109, 110–11, *175*
Maillol, Aristide *186*
Malevich, Kasimir 109
Man, Felix H. 110, *185*
Mann, Franziska *54*
Mann, Heinrich: *Professor Unrat* 114, *124*
Mann, Thomas *142*
Massary, Fritzi 117, *137*
Mehring, Walter 159
Mehringplatz 17
Mendelsohn, Erich: Columbus Building *67*; Dr Sternefeld's villa *79*; Universum Cinema complex *114*
Moabit district 31, 109
Moholy-Nagy, László 109
Morand, Paul 62
Moreck, Curt *192*
Munkacsi, Martin 110
Murnau, F. W.: *Nosferatu* . . . 113
Murray, Paul *161*
Museum, Old *20*

Napoleon Bonaparte 19–20
National People's Party, German (DNVP) 207–8, 211–12, *225*, *228*
National Socialist Workers' Party (NSDAP) 65, *74*, 77, *84*, 111, 112, 207–13, *210*, *212,214–15*, *226*
Negri, Pola *120*
Neher, Carola *122*, *132*
Neher, Casper *132*
Neukölln district 63, *80*, *95*, 158, 208, 209, *221*, *223*
'New Objectivity' ('Neue Sachlichkeit') 108–9, 112, 159
newspapers 60, 109–11, *169*, *175*
Nicholson, Harold 62
nightclubs *108*, 117, *126*, 161
Noske, Gustav 46
Novembergruppe 109
NSDAP *see* National Socialist Workers' Party

Opel, Fritz von *202*
Ossietzky, Carl von *144*

Papen, Franz von *228*
Pariser Platz *12*, 17–18, 59
Paulsen, Harald *132*
Pechstein, Max 116, *117*
People's Naval Division 34, 35, *38*, *41*
Petersen, Carl *152*
photography and photo-journalism 109, 110
Piscator, Erwin 114, 116, *186*
Planck, Max *152*, *153*
Poelzig, Hans 109; Broadcasting centre *84*; Capitol Cinema *122*
population: characteristics 156–8; statistics 13–15, 18, 22, 24, 58, 59
Post-Expressionism 108, 113–14
Potsdamer Platz 22, 24, 59, *60*, *68*, 159–60, *164*, *175*
Prager Platz *75*
Prussian Upper Chamber *23*, 26

radio broadcasting *84*, 160, *188*
Radio Tower, the 64, *82*, *83*
railway network 21, 59, 73, *103*, 156, 159, *164*, *166*, *169*; *see also* underground
Raschdorff, Julius: Cathedral *25*
Rathenau, Walther 14, 36, *186*, 212, 213
Red-Front Fighters' League 208, *228*, *232*
Red Town Hall *98*, *103*
Red-White tennis club *204*
Rehberge Gardens 65
Reichsbanner *228*, *230*, *236*
Reichstag, the *68*
Reimann School *148*
Reinhardt, Max 114, *116*, *120*, *134*, *137*
Reinickendorf district 63, *81*
Revolution (1918) 28, 31–3, *33*, 34, 34–5, *38*, *41*, 63
Roth, Joseph 111
Rowohlt, Ernst *148*
Royal Palace *12*, *15*, 17, *32*
Rupenhorn Club *196*

SA (Storm Troopers) *74*, 208, 209, 210, *226*, *235*
Salomon, Erich 110

Scala nightclub *108*, 117; girls *127*
Schacht, Hjalmar *152*
Schadow, Johann Gottfried: Quadriga 19, *68*
Schaefer, Philipp *95*
Schauspielhaus (Playhouse) *18*, *133*
Scheffler, Karl 24
Scheidemann, Philipp 33
Scherl Verlag *42*, *175*
Schillings, Max von *142*
Schinkel, Karl Friedrich 20; Academy of Architecture *21*; Old Museum *20*; gatehouses *22*; Schauspielhaus *18*, *133*
Schlachtensee, the *80*
Schloß Charlottenburg 16
Schlüter, Andreas 15, 16
Schmohl, Eugen: Borsig Works, Tegel *86*; Ullstein building *78*
Schöneberg district 22, 63, *76*, *108*, *127*
Schufftan, Eugen *118*
Secessionist Movement, Berlin 108, *108*, 109; Balls (1926, 1928) *109*, *148*
Seghers, Anna *144*
Sehring, Bernhard *103*
Seidenstücker, Friedrich *92*
Siegesallee (Victory Avenue) 24, *41*
Siemens *153*, *170*
Siemens, Carl Friedrich von *153*
Siemensstadt housing development *87*
Sintenis, Renée *137*
Social Democratic Party of Germany (SPD) 26–7, 34, 35, 36, *41*, 63, 110, 208, 211, 213, *214–15*, *224*, *225*, *230*
Spandau district 63, *86*, *87*
Spartacus League 33, 34; Uprising 35, *42*
sport 65, *151*, 161–2, *202–4*
Sports Stadium, Potsdamer Straße *161*, *230*
Stahlhelm *212*, *228*
stations, railway *see* railway network
Statistics, Office of 59, 158–9
Steglitz district 77, *197*
Stehr, Hermann *142*
Sternberg, Josef von: *The Blue Angel* 114, *124*, *125*, *128*
Straumer, Heinrich: Broadcasting Studio *84*; Radio Tower 64, *82*, *83*
Strauss, Richard *147*
Stravinsky, Igor *147*
street entertainment *182*, *192*, *215*
Stresemann, Gustav 211
strikes: 1918–20 28, 35, 36, 45–7, 50, 52–3; 1930 *223*; 1932 *211*, *223*, *235*
Sturm, Der 108, 112

Taut, Bruno: Britz 'Horseshoe Settlement' 65, *96–7*; 'Carl Legien' estate *92*
Tempelhof Airport 59, 64, *105*
Thälmann, Ernst *225*
theatres 114, 116; Apollo *127*; Berliner *134*; Deutsches 114, *137*; Großes Schauspielhaus *129*; Königstadt *98*; Theater am Schiffbauerdamm *132*, *134*; Staatliches Schauspielhaus *18*, *133*; Variety *127*; Volksbühne am Bülowplatz *134*: theatre criticism 111
Tiergarten *13*, 24, *69*, *190*
Tietz (Hermann) department store *103*, *178*
Tiller Girls, the *108*, 117
Tissot, Victor 61

Titania Palace *122*, *123*
Toeplitz, Jerzy *124*
Toller, Ernst 116, *144*; *Hinkemann* 134
tours and tourists 57–8, *58*, 59, 61
trade and industry 21–2, 59–60, *159*, *169–71*, *175–7*
traffic *156*, 159–60, *164*
trams 59, 159, 160, *164*
transport, public 158, 159–60; *see also* buses; railways; trams
Tucholsky, Kurt 59, 158

Uhlandeck Café *72*, *195*
Ullstein, Louis *153*
Ullstein Verlag *78*, 111, *175*, *185*
underground railway *92*, 158, 159, *164*
unemployment, 1920s and '30s 36, *53*, 114, *214*, *214*, *217*, *219*, *221*
Universum Cinema 114
Unter den Linden 11, 16, 58, *103*, *164*, *194*

Valetti, Rosa *132*
Veidt, Conrad *113*
Versailles, Treaty of 212
Victory Column *69*
Volk und Zeit 110
Vollmoeller, Karl *122*, *124*
Vorwärts 35, *42*

Wagner, Martin 65
Walden, Herwarth 108, 112
Waldoff, Claire 117, *129*
Wallot, Paul: Reichstag *68*
Wandervogel youth movement *197*
Wangenheim, Gustav von *134*
Wannsee resort 65, 162, *162*, *198*, *204*
war loans 27
Wedding district 31, 65, 208, *232*
Wegener, Paul 116
Weigel, Helene *134*
Weill, Kurt *132*, *133*
Weimar Republic, the 36, 37, 62, 111, 116, 211, 212, 213, *228*
Wertheim department store 22, *23*, 26
Wessel, Horst *235*
White Mouse Cabaret *126*, *129*
Wiene, Robert 112, *113*
Wigman, Mary *130*
Wilhelm I, monument to *15*, 24; church 59
Wilhelm II, Kaiser *12*, 12–13, 14, 24, *25*, 27, 28, *32*, 33
Wilhelmstraße *18*
Wilmersdorf 63, *75*, *114*, *120*, *130*, *232*
Wintergarten revue club 117, *193*
Winterstein, Eduard von *134*
Wolff, Theodor 34, 212, 213
women, employment of *171*
World War I 11–13, 27–8, *27–9*, 31–2, 34, 36

Young Plan, the 212

Zeller, Magnus *109*
Zille, Heinrich 109, *141*
Zuckmayer, Carl *124*, 155; *Der fröhliche Weinberg* 134